# MODERNISM, POST-MODERNISM, REALISM

A critical perspective for art
by
Brandon Taylor

# MODERNISM,
# POST-MODERNISM,
# REALISM

A critical perspective for art
by
Brandon Taylor

*Winchester School of Art Press,
Park Avenue, Winchester, Hampshire*

Acknowledgements

This book was written during a sabbatical term in 1985, and revised at certain intervals since. I am grateful to my colleagues Robert Radford and Annie Richardson for commenting on an earlier draft, and to Peter Townsend for encouraging me in the later stages of the work.

I am also grateful to the Winchester School of Art Research Fund for a grant in aid of typing expenses, and to Anne Gorst, Kathleen Fleet and Teresa Gillam for their help in the preparation of the text.

The editors of Winchester Studies in Art and Criticism gratefully acknowledge the financial assistance of the Southern Arts Association.

First edition published in the United Kingdom 1987 by:
Winchester School of Art Press,
Park Avenue,
Winchester SO23 8DL
Hampshire

Designed by Rachel Hodge, Hampshire County Council Design Unit
Printed by Lyndhurst Printing Company Ltd

British Library Cataloging in Publication Data:

Taylor, Brandon
Modernism, Post-Modernism, Realism: a critical perspective for art.
(Winchester studies in art and criticism)
I. Art, Modern — 20th Century
I. Title        II. Series
709'.04        N6490

ISBN 0 9506783 6 8

# CONTENTS

# NEW PROBLEMS
# FOR CRITICISM

In the critic's hurry to respond to this week's exhibition or
last week's art-world event, it is perhaps inevitable that
little attention is paid to the overall drift of contemporary
art or its connection with the wider society in which it
exists. My intention in these pages therefore is to try and
correct this partial vision; to summarise the condition of art
in the late 1980s, and, by looking backwards a short dis-
tance at the modernist examples which preceded it, to
assess the chances of a healthy and vital artistic culture in
the years that lie ahead.

In artistic circles today, a debate is raging about the
legacy of what is termed 'modernism', and the viability of an
alternative position known as 'post-modernism' which has
been under development in fits and starts since the late
1950s and early 1960s. Post-modernism, it is claimed, rep-
resents a vantage point from which a substantially new sen-
sibility can be developed, one that at the very least 'reflects'
the circumstances of life in the later part of the twentieth
century in the capitalist West. The point of this develop-
ment, it is argued, is to supplant a fading modernist culture
which no longer 'corresponds' to the type of existence we
now have.

Of course, the problem presented here is at least
threefold. Firstly, what is, or was, modernism? The
answers given to this question by art historians would
occupy a book by themselves. But other types of theory are

also relevant. Philosophers link modernism with the Enlightenment and the rise of science. Feminists associate it with maleness and patriarchy. Certain American critics associate it with a narrow paradigm of 'flatness and auto-nomy' in painting. Some Marxists associate it with indivi-dualism; other Marxists link it with élitism; others with the negation of nineteenth century bourgeois culture and the artistic and cultural patterns that went with it. Obviously you can be a modernist in several different ways. Some clarification of the 'core' of modernism is obviously essen-tial for any examination of the virtues and difficulties of a post-modern phase.

Secondly, post-modernism's claim to 'supplant' a previous modernist period is by no means straightforward either. For one thing, the term 'post-modernism' now has established usages within architecture, within film, within music, and within literature; which are defined in partly parallel but partly diverging ways. These need to be examined. But the scope of 'post-modernism', too, is wider than the arts alone. Some people claim it to be present as a kind of 'atmosphere' or 'force-field' in areas such as mental health and the theory of the subject. Here, it is claimed that new perceptions of the disorientated or schizophrenic con-dition, or of experience itself, contradict those made earlier in the century when 'modern' society was in its youth. Industry too may be post-modern, according to others, in so far as capitalism enters into a 'third' or 'late' stage — of information processing, electronic communications and planned unemployment. Some adjudication of the *way* post-modernism supercedes the modern is part and parcel of the question.

And then, thirdly, one wants to assess whether the post-modern 'revolution' in art is consistent with the development of socialist culture as an effective alternative to capitalism. That part of my question will take us beyond the narrow margins of art to aspects of wider culture such as the role of the media, broadcasting, museums, admini-stration and technological development.

To take the question of modernism briefly first. In attempting to fix on some stable core in the definition of the term, I have sought to concentrate particularly on the ques-tion of subjectivity. Many critics agree that modernist art is often subjective — by which is meant private, inward-looking, relevant only to the artist or his group, and so forth. Perhaps it is also implied that modernism was *only* about 'inward' experience, about purely autobiographical concerns. Certainly a great deal is heard in this connection about 'bourgeois subjectivity' — the essential inwardness

7

and unknowability of certain modernist work. But in the early parts of this book I ask in a more searching fashion how this element of 'subjectivity' was actually achieved in the modern art-work; how it manifested itself; in what languages; and what its effects may have been both for the producer as well as for the typical consumer of the work. And I raise the inevitable question of how much that was valuable in modernism can be preserved from the extraordinary artistic experiments of seventy or more years ago.

On the question of post-modernism, a central issue which I address is that of value. How much or how little of what is presented as 'post-modern' is politically or socially progressive? In fact, what does 'progressive' mean in our present circumstances? On the face of it, the gains and losses of post-modernism might seem to be fairly equally divided. On the one hand, post-modernism in most of its forms is undoubtedly a vigorous and even critical manifestation. It takes a hard look at some of the doubtful assumptions of modernism and attempts variously to undermine them. To that extent it may seem to be at least a vigorous, critical art.

In other ways, however, it seems a disconnected, even alienated art form. Andy Warhol became post-modern at the point where he stopped making images about the world and began making images about other images instead. 'New expressionism' became post-modern when it began recycling images of previous expressionism rather than actively engaging with the world. New American artists like David Salle in painting or Kathy Acker in literature become post-modern when they collage together incompatible source materials as an alternative to choosing between them. Conceptual artists are post-modern in so far as they abandon individualistic methods of painting for the anonymity of the photograph or the text. Pastiche and second-hand borrowing are post-modern in becoming distanced from the actual world behind a screen of other images, other cultural patterns, other discourses within the culture of art. The question here is simply whether post-modernism can be defended against these apparently damaging accusations.

Figure 1

Figure 2

The third major theme of this book is the wider environment of today's society in which these debates take place. And here, I emphasise repeatedly that the conditions of both the production and consumption of art are utterly different from those which obtained at any earlier moment. This is a fact which no account of art in our time can afford to ignore.

Firstly, the post-war period with which we are mainly concerned in this book has witnessed the most extra-

1. David Salle, *Tight as Houses, 1980*

ordinary expansion in electronic media-forms — television and radio, and latterly video — ever known to mankind. We tend to forget the stern statistics of this exponential growth — and we tend to neglect the effects of this expansion upon other cultural forms which depend also upon the optical channel, particularly visual art. To take but a single example: the United Kingdom saw a rise from zero television sets in 1945 to three hundred thousand in 1950, rising to almost thirteen million in 1965 and nearly eighteen million by 1975. The United States' total was 3.9 million sets by 1950; 46 million by 1960, and some 73 million by 1975 — well over one television set per home and by far the largest concentration of television receivers per head of the

9

population in the Western hemisphere.[1] Television is now by far the largest industry for the production and distribution of meanings, for every age-range of the population, on every geographical, political, sociological and cultural subject known to man. According to recent figures, the average American viewer watches the flickering screen for seven and a half hours every day. The figures for the European nations is below this level — but constantly increasing with the expansion of television output to larger segments of the day and the gradual increase in the number of channels from one in 1950 to four in 1980 and the prospect of multi-choice viewing with the onset of cable.

2. Julian Opie, *A Pile of Old Masters*, 1983

What I call 'television culture' is more than the literal existence of television sets and the programmes that go with them. It includes the habits, expectations and mimetic actions of its (now) almost world-wide audience. The impact of television culture is necessarily impossible to summarise in a short book — even if the facts were known — but includes a vast range of presumably beneficial but also negative effects. On the one hand television means information — information in unprecedented quantities, which can instruct and educate populations in ways that were unimaginable half a century ago. Secondly, television can transmit images of far-off times and places which were infinitely less available a couple of generations back; in both cases promising an expansion of experiential possibilities which is presumably to be encouraged. On the other hand, television has radically transformed the landscape of entertainment, social relations, consumption and social control in ways that we are still scarcely able to describe. It has all

but eradicated previously stable forms of social bonding such as participatory sport, music and theatre. Television is now also the prime medium for both the selling of goods through advertising and for the dissemination of news about public events, and must be accounted ideologically as a major instrument of coercion and persuasion. It also depends upon a marked degree of passivity in its audience in order to both instruct and control.

An even more alarming prospect is that, in spite of its beneficent image, television may have helped to normalise violence and war as the 'natural' condition of mankind. Certainly it leaves unquestioned the fact that preparations for war — in the form of escalating spending on arms research and manufacture — consumes the largest single slice of the economic effort of all the advanced nations of the world in terms of jobs, production, consumption, and gross budget. Representations of sport on TV function as images of conflict precisely in tune with militaristic attitudes. Clashing gangs of football supporters or even individual rivals locked in combat on the tennis court replicate exactly the 'fight to the death' aspect of the modern image of strategic struggle in the ideological sphere. Sporting contestation is no longer merely entertaining; but functions increasingly as an image-book of how humans can and do behave.

This reference to television's role in the normalisation of military conflict brings us conveniently to that other great upheaval in the period of post-modern culture, the manufacture of nuclear arms. It needs no argument to show that the technologically advanced nations of the world are now stock-piled with enough surplus destructive potential to eradicate the whole of the species within a matter of a few minutes, should an accident or a conflict spark off a nuclear war. Further, we know that no nuclear conflict can ever be won by the warriors of either side. 'Mutually assured destruction' is the prospect that faces the ideological stalemate which now exists between the capitalist West and her so-called adversaries, with no signs emerging that any real commitment exists on either side — but for different reasons — to arms negotiation or reduction.†

These facts may seem to have little to do with 'art'. And yet the art forms of the future — forms which, I argue, must possess a certain realist dimension — will not begin to fulfil their true potential (indeed will not even exist) unless they first recognise, and then understand, how our thoughts and deeds are shaped progressively by the vastly expanding media and military environments in which we live.

Early modernism took account of the photograph, after all; became aware of the cinema; and cast an eye in the

11

direction of business, technological development, and — in a limited but still significant way — the great military tragedy of the First World War. This art flourished, according to a recent analysis, in the historical juncture created by the intersection of three significant forces: the persistence of aristocratic and landowning classes and the academic aesthetic practices they supported, and which supported them; the key technologies of the second industrial revolution, including telephone, radio, photography, and the like; and the imaginative proximity of social revolution.[2] But these conditions have now disappeared. The first condition has been replaced by an overlay of bourgeois democracy; the second by successive phases of industrial expansion, the last of which is the media explosion and the electronic communications systems they depend on; and the third has simply disappeared as an active and believable hypothesis in the political systems of the West.

Modernism and the decline of modernism, within this conjuncture, raises difficult and pressing problems. Given that earlier modernism has run its course, and that post-modernism represents only a problematic gain in the development of new aesthetic and artistic forms, then what chances are there for a vital or unsettling artistic culture in a period likely to be defined by the exponential expansion of consumer hardware, media infiltration into everyday life, and militaristic over-production — the later 1980's and beyond?

It needs no argument to show that Western artists

---

†      In 1985 the strategic force of the United States comprised some 11,000 warheads with a total yield of 3,000 megatons; that of the Soviet Union some 8,000 warheads with a total yield of 6,500 megatons. Expected casualties from unrestrained nuclear war between the two superpowers are estimated to be around 76 to 165 million for the United States and around 50 to 100 million for the Soviet Union. All-out global nuclear conflict would result in the immediate death of the order of 1,000 million people, according to the study by Peterson and Hinrichsen in *The Aftermath*, Oxford 1982, and also according to J. Rotblat, *Nuclear Radiation in Warfare*, London 1981. For extended discussion and statistical analysis see *Unit 4, The Effects of Nuclear Weapons and Nuclear Wars*, and *Unit 5, Nuclear Weapons Technology*, components of *Nuclear Weapons: Inquiry, Analysis and Debate*, Open University, Milton Keynes, 1986. Recently — in October 1986 — the much hoped-for summit negotiations between President Reagan and First Secretary Gorbachev failed to reach agreement on potentially far-reaching nuclear reductions because of the unwillingness of the American side to abandon its notorious and costly Strategic Defence Initiative, nicknamed 'Star Wars' after the Stephen Spielberg movie. This calamity is widely regarded in both the West and the Warsaw Pact countries as having been caused by the reluctance of the American side to resist the enormous pressure brought to bear on Congress by the military and business interests in the United States to continue to escalate an already reckless militarist path.

working internationally today — those in receipt of sub-
stantial state support and widely touted in the prevailing
institutions of art — show no interest in the nature of the
monetary, media or the technological environments in
which we live. Nor is much interest being expressed by
Western artists in the nature of the West as a political,
social and demographic entity, especially its post-Second
World War character as a 'bloc' defined in opposition to the
Warsaw Pact countries. No serious analysis has been
undertaken by artists of the human and social conse-
quences of this status quo, in comparison with the type of
world we might have had, or might even have. There are
some minor exceptions to this condemnation, and we shall
come to these in due course. But in the main, it has to be
admitted that the kind of art in which 'real' artistic accounts
can be provided of the important issues of living in an
advanced and apparently expanding capitalist economy —
this art, and the sort of interventions it might make
possible, is scarcely anywhere to be seen.

The word 'real' here, and its implication of a 'realist'
art which is superior to both modernism and its post-
modernist successor, is obviously contentious. What
meaning can we give to 'realism' which does not wholly
adopt the vantage point of nineteenth century realism —
Courbet, Zola, Repin and so forth — and which yet, in
becoming germane to the concerns of late twentieth cen-
tury art, does not completely duplicate either the worst
subjectivism of modernist experiment or the most shallow
'dispersal' effects of post-modern culture? The question is
obviously an urgent one. At this point, one simply needs to
note the sheer preponderance of mystical, crankish, solip-
sistic or vacuously unaesthetic ravings which pass for 'art'
in our over-liberal and over-productive culture — the
majority of which pay no attention to the processes and
forms of our collective life. The reasons for this collective
myopia must be one of the first tasks of criticism to
uncover.

I might remind the reader that the country in which
this book was written has a tradition of relative impervious-
ness to artistic modernism, and fosters a sceptical attitude
to certain types of theory which are associated with both
modernism and its post-modern replacement. Britain had
no original modernist revolution in art of the scale of those
seen in France, Germany, Italy, Russia and later America
— a fact which is to be mourned in certain senses as indi-
cating a parochial isolation from world events. But equally,
the reticence of the British towards modernism is a sign of
the tremendous richness of the native British traditions
which might have suffered damage from too heavy an over-

lay of modernist culture from abroad.

Secondly, the 'continental theory' which has become fashionable in recent Anglo-American debates about art has little place in either my analysis or my method of thinking in this book — in fact somewhat the contrary. The persistent anti-humanism of the 'new' continental theory is a theme that will arise again and again in the course of these pages. Writers like Louis Althusser, who thought that individuals were mere 'effects' of ideology and that human agency was an illusion; or Jacques Lacan, who thought that feelings and desires were somehow the 'results' of patterns of language; or Roland Barthes, who argued for the 'death' of the artist as an expressive and creative being; these writers have little place in my analysis except where they can be used to show the truth or credibility of a contrary position. Writers of the earlier Frankfurt School, based on the Frankfurt Institute of Social Research in the 1920's, 1930's and after, are more difficult to classify, and their debates on such themes as literature, the theatre and mass culture often sharply divided one member of this school from another. On the whole, their interest in visual as opposed to literary or dramatic art was low, and few examples were analysed which relate specifically to modernist paintings, sculptures or architecture. And yet some valuable pointers remain. The experience of mass culture in the United States — especially that of Max Horkheimer and Theodor Adorno — provides an important stimulus to reflection on the tension between the products of the cinema industry and the aesthetic awareness of the individual, which bears indirectly on the present situation of television in relation to the arts. Jurgen Habermas, too, like Horkheimer before him, has recently been sympathetic enough to the programme of modernism as a 'high' art to welcome a continuation of the modernist project, albeit in altered forms. And the theories on realism in literature developed by Georg Lukács seem to me to bear upon our present aesthetic predicament precisely because of the *denials* of ordinary reality that much of our contemporary art appears to want to promote.

Thus my sources are mixed, even eclectic. Among English writers, my list of intellectual creditors is also a short one. As already noted, Britain was never a fountainhead of modernist thought. It may even be a symptom of the British intellectual's unwillingness to be impressed by modernist and post-modernist 'theory' that there have appeared relatively few analyses of the problems of twentieth century art from the British left. However I must acknowledge those that have appeared: in particular to the writings of Raymond Williams, John Berger, Perry

Anderson and Peter Fuller. Without their examples I would not have known where to begin. For any misinterpretations or disagreements, I offer my apologies.

# MODERNISM AND SUBJECTIVITY

I propose to begin my argument with a defence of the pro-
position that modernism in art, and subjectivity, are inti-
mately connected.

On the face of it, this could be taken to mean various
things. It could be taken to mean that modernism is an art
of flights of fancy, of wilful and obscure distortions of
nature, of manifestations of the artist's whim. It could be
taken to mean that a modern artist's style is somehow 'per-
sonal'; that it originates with him and means anything only
to him — is a mark, indeed of 'the artist' himself. It could be
taken to mean that 'the artist' is the only person relevant to
the interpretation of the work, and that unless we 'know
what he meant' the work has no meaning for the spectator
at all.

Something like this position is the one that critics of
modernism have often taken. Some Marxist critics, in par-
ticular, from Lenin to the present day, have found in
modernism only a 'bourgeois' ideal, serving a bourgeois
concept of subjectivity, meaning an overly private or whim-
sical art, showing awareness of the developments within
wider culture and having no relevance to the interests of a
revolutionary class.

In this re-examination of modernism I want to argue
that these formulations are slightly over-simple. Indeed I
propose to reveal the subjectivity of modern art on a differ-
ent basis than hitherto, or an expanded one. This entails
describing this subjectivity, not as a wholly bourgeois

16

form, as perhaps Marx would have thought if he had wit-
nessed it; nor as a wholly emancipatory form, as for
example Herbert Marcuse thought it was; but as a prime
term in any discussion of how modern art came to be *made* ;
as a necessary term in the elucidation of the techniques, the
languages, the manipulations of the artistic medium that
were used in the opening stages of modernism, and inter-
mittently ever since.

Subjectivity, of course, does have other meanings.
There are plenty of autobiographical references in the
literal content of modern art, and these can be teased out
with the aid of collateral writings of the artist or accounts of
his life; but they are not primarily what I have in mind in
referring to the subjectivity of technique. There are also
numerous objective references in modern art that sit in
some cases uneasily alongside the subjective markings of
the pictorial surface. But the emphasis on technique or *fac-
ture* is central to my account; and supplies us with the cen-
tral discourse of modernism in its developing stages.

In retrospect it may seem odd that modernism's sub-
jectivity should come to reside in its surface, in its method
of being made. The uncovery of 'subjectivity' in a wider
sense, indeed, was a cultural task of some proportions —
and it is into this larger historical framework that modern-
ism ultimately fits. Like other terms which are central to
cultural debate today, the contemporary meaning of sub-
jective as 'relating to the thinking subject' (OED) is not in
circulation before the middle of the eighteenth century, and
becomes current only towards the end of the eighteenth
century in philosophical and aesthetic discussions.

Coincidentally, of course, the artist in the Romantic
period was elevated to a particular status, different in kind
from other occupations and endowed with potentialities for
insight into the motions of the soul — human as well as
social. Artists came to be regarded as spiritual, gifted and
intuitive; in contact with nature, in dialogues both of intro-
jection and projection, in which natural forms would first
strike a chord of sympathy in the perceiving mind, and in
which the mind would in turn throw its own illuminating
vision back onto nature. 'Nature' for the Romantic artist
thus became a kind of symbol of the interior life; and the
artist became a sensitively tuned instrument who was cap-
able of responding and reacting in particular ways, often
spontaneously, usually enthusiastically, like a piece of
nature herself. Precipitated by the stirrings of the Indus-
trial Revolution, and in particular by the idea that man was
becoming entrapped by the march towards standardis-
ation, wage-slavery and mechanisation, Romanticism
enshrined for the first time a notion of the artist as a being

17

largely *outside* the historical process; as one who transcended ordinary social life and material and economic processes.

As a new paradigm for Individual Being, this shift of emphasis in the Romantic era has had vastly important consequences for virtually every department of life in the last one hundred and fifty years. All the great structuring concepts of the last two centuries owe their origin to the Romantic period at the end of the eighteenth century and the beginning of the nineteenth: not only the idea of Nature, but also that of Experience and of the Self. These last two concepts particularly are worth examining in more detail. As a generalisation, we can say that before the Romantic period, it was infrequent for Experience as such to be spoken of at all, whether in philosophical, artistic, diaristic or medical texts; although it would be impossible to deny that men *had experiences,* either of themselves or of the outer world. The contemporary German philosopher Hans-Georg Gadamer now assures us, for instance, that the modern word 'experience' (in German *Erlebnis* ) is a late nineteenth century formation; that it is found not until the 1870s, and then, significantly, only in biography.[1]† He also argues an important connection between *Erlebnis* and Romanticism, reminding us of Goethe's remark that all his poetry had the character of a 'great confession'[2]; proposing finally that Romantic *Erlebnis* was in fact 'inner experience', rather than experience of the outer world by the organs of sense.

Within this fragment of linguistic history, Gadamer argues that 'the aesthetic' came to represent the *essence* of experience — its summation and superior form. Furthermore what is experienced in the work of art itsef came to be removed from all connection with actuality insofar as this content was framed (and hence marked off) from reality, and was thus seen as ontologically separate from it. It follows from this, Gadamer says, that so-called *Erlebniskunst* (the art of experience) appears as the true and only art of the Romantic 'moment' of the nineteenth and early twentieth century.

But Gadamer also reminds us that this rise in the

† According to Gadamer's analysis, our word 'experience' carries the sense of 'erleben', which signifies that something was experienced, but also that of 'das Erleben', which connotes the permanent content of what is experienced, its lasting residue or significance (op. cit., p. 56). Gadamer says this usage was employed in describing the works of artists and poets by nineteenth century writers like Dilthey (writing on Schleiermacher), Justi (writing on Winckelmann) and Grimm (writing on Goethe).

importance of *Erlebniskunst* was accompanied historically
by a decline in the value of allegory. While *Erlebniskunst*
developed into an art of the symbol, and of the nature-
symbol in particular, the allegorical mode of the eighteenth
century — a fixed system of meanings in which signs
pointed to something beyond themselves - fell into relative
disuse as an inappropriate vehicle for the Romantic idea.
The nature-symbol of *Erlebniskunst* establishes an 'inner
unity' between the image and its meaning, Gadamer says,
while the allegory is a merely traditional intellectual con-
struction.

To this account we can add that in nineteenth century
aesthetics in Germany this bond between the mind and
Nature became known as *Einfühlung*, or empathy. Kant's
contemporary Novalis speaks of a capacity for 'feeling one-
self into' nature, people and things.[3] Following him, it was
Robert Vischer in the 1870's who, in following K. A.
Scherner's little-known book on dreams of the decade
before,[4] speaks of a 'second self' which can be projected
into objects and then recognised there, creating what he
calls a 'remarkable unison of subject and object'.[5] In fact
Vischer follows these assertions with the thoroughly
modern proposal that the artist perceives his subject never
only with his organs of vision and calculation, but 'with the
whole of his free, ideal, well-tuned personality'. The artist,
Vischer concludes, 'is the content of the work'.[6]

The idea of empathy is continued once again in
Theodor Lipps' writings around the turn of the century.
One of Lipps' important ideas not to be found in Vischer is
that aesthetic pleasure derives from the ease with which
the soul (Lipps compares it to the strings of an instrument)
will vibrate in response to aesthetic stimuli[7] — a metaphor
developed later by Kandinsky. And like Seurat and his circle
in France in the later nineteenth century, Lipps was
interested in establishing correspondences between spe-
cific visual elements such as types and directions of lines,
and emotional states. These were by no means the only
origins of the modernist connection between visual style
and artistic temperament — as we shall discover shortly —
but they all played their part in establishing that connection
in the late nineteenth century in the sphere of aesthetic
thought.

If 'experience' and 'empathy' are nineteenth century
pre-modernist notions, then the idea of the Self, too, per-
haps, is also of recent historical origin. Although the con-
cept of the Soul goes back beyond Aristotle to the ancient
civilisations of the middle east, it seems plausible to say
that the rise of capitalism in Europe in the sixteenth and
seventeenth centuries helped create the distinction

between the inner mind of a person and the outer materiality of his body; only the latter could be sold on the labour-market or enslaved, while the mind could remain free and relatively unattached.[8] The *complete* detachment of mind from body which is presaged in this development was attacked by Marx in the 1850s as an impossible as well as an undesirable state of affairs — an argument we shall have to adjudicate in due course.

For now, it is sufficient to note the importance of this dualism of 'mental' and 'physical' to all philosophical and ideological discussion in the period dominated by Romanticism. Indeed this way of formulating the distinction between the mind and the body, which was developed between the time of Descartes in the early seventeenth century and that of Goethe and Schiller at the end of the eighteenth, was then subjected to even further development by a variety of philosophical, psychological and para-psychological researches during the course of the nineteenth century. Both Hegel and Schopenhauer, who were extremely popular with artists and the educated European public in the later part of the nineteenth century, persisted in viewing the artist as a person with special powers of insight and imagination, through the exercise of which the external mask of reality could be penetrated and elucidated. Moreover, the mind in general, particularly its involuntary productions such as dreams, visions and hallucinations, was exhaustively investigated in 'scientific' terms in the thirty years between 1870 and the end of the nineteenth century.

To modernist but also to humanist thought, the concept of the unconscious mind has also been central since the beginning of the nineteenth century. First mentioned by the early Romantics, the idea of the unconscious was then developed by physicians such as Beethoven's friend Ignaz Troxler. Troxler extended Goethe's metaphor of the life process as dynamic and evolving, concluding that it was an individual's inward feeling (*Gemüt*) — 'the hearth of his self-hood, the most vital centre point of his existence'[9] — that was the essence of self-consciousness. Later Romantic artists like Carl Gustav Carus extended the concept even further. He postulated in his book of 1846 an unconscious mind that contained 'the key to the knowledge of . . . the soul's conscious life'.[10] In these terms it was only a relatively short step to Freud's early formulation that dreams were the 'royal road' to the unconscious; that repression and denial played a vital part in the mental economy of man; that deep inside him were ungovernable instincts and sexual and destructive passions that co-existed with and sometimes conflicted with the 'principle of reality'; that sexually

and emotionally the child was father to the man. †

The late nineteenth and early twentieth century pic-
ture of the artist, at least that which was current among the
various avant-gardes of Europe, was broadly consistent
with these Romantic and neo-Romantic formulations. In
literature and philosophy, other important figures such as
Nietzsche and Dostoevsky brought into prominence a com-
plementary set of values and considerations that were con-
sequential, in their view, upon the new secular life of late
nineteenth century urban culture, and which played in-
creasingly on the self-image of the artist. Nietzsche's rejec-
tion of the Christian morality of charity and forgiveness
required the postulation of a 'superman' role-figure who
aspired to joy-through-health through the exercise of will
alone; who advocated the rejection of democracy, social-
ism, and tolerance for others. Dostoevsky was important
for a different reason: for articulating a paradigm of the
human animal as violent, murderous, resentful and hostile.
Dostoevsky's *Notes from Underground* is an image of rebel-
lion against reasonableness, justice and the purposeful life.
Its 'anti-hero' (as the protagonist describes himself) is a
complex, subtle, even perverse devotee of what Freud was
later — and in a phrase which stands as a sign for a whole
epoch, a whole style of thinking — to call 'unpleasure'.[11]

Thus it was that in the space of some five or six
generations the dominant emotional tone of art inspired by
Romanticism — that is, of art which seeks for truth in
feelings and experience — had changed from one of
ecstatic pleasure (Wordsworth's 'Joy, Lady! is the spirit and
the power, which wedding nature to us gives in dow'r') to

---

† A certain parallelism between late nineteenth century dream-
investigations and the growing assumptions of modernist artistic culture
may be interesting to record here. Scherner, who has already been
mentioned, postulated in the early 1860s a mechanism whereby somatic
stimuli were converted into pictorial or visual symbols, many of them
'concealed' symbols which have no obvious connection with their origins
— precisely Freud's point, or one of them. In Hervey de Saint Denis'
*Dreams and the Means to Direct Them* of 1867 we find not only an
anticipation of Freud's later concepts of condensation and displacement,
but an emphasis on the creative and imaginative aspects of certain
dream-images. Then, in 1875, Hildebrandt's study asserted that a
dream can have a function in the totality of a person's life — not merely
giving the dreamer an image of his moral position, but even revealing
the existence of an immoral thought of which the dreamer may not have
been aware. The dream-image is beginning to stand in the same relation
to the dreamer as the work of art stands to the artist. In each case the
subject creates them 'from within', without necessarily knowing their
entire significance, their full signification. The individual is the creative
medium through which the image in each case arises, while its final
meaning is increasingly referrable, in the last analysis, to the individual
himself.

one of morbidity, destruction and darkness; of late nineteenth century symbolism, decadence, perverse eroticism and pain. Coleridge and other Romantic poets who investigated the darkness of the soul were unable to imaginatively transcend the comforting staple provided by the theory of the Sublime, to the effect that the terrors of Nature could in the last reckoning be contained, even made spectacular, by the predominance of good and the safe vantage point of the artist. By the end of the nineteenth century the artist saw himself (and was seen by others) as an estranged, marginal being, not always compatible with the drift of rationalised bourgeois culture and definitely given access to regions of feeling where other mortals may not or could not go.

This change in emotional temper throughout the nineteenth century seems gradual, inexorable, even inevitable. And to this predominantly humanist image of the nineteenth century artist as an emotional traveller increasingly bent on descent into the maelstrom of feeling must be added the picture sketched by the early Marx and his anarchist and syndicalist successors, to the effect that man under the social division of labour was alienated; and would remain incapable of full individual freedom until the dominant forms of that society were surrendered to a more equitable order in which the old petty-bourgeois imagination of profit and caution was replaced by one of community and self-fulfilment. This Marx, too, was in several senses a Romantic; he speaks repeatedly, in his early writings, of the fulfilment of 'the whole man' as the goal of all social change.

Thus Romanticism, and the beginning of the modern temper in art, saw human society as a collection of relatively free agents who are capable of both self-consciousness and choice, who can act in limited ways on their environment and who by virtue of their self-consciousness are more than mere conduits through which impersonal historical forces pass — a viewpoint which will become increasingly important in later chapters.

There is a problem here, of course, about the *type* of subjectivity which Romanticism — and modernism — celebrated; about whether this was compatible with the strictures of the Marx of the *Grundrisse*, that 'the human being is in the most literal sense a political animal; not merely a gregarious animal, but an animal which can individuate itself only in the midst of society';[12] or the Marx of the *German Ideology* that 'only in the community . . . is personal freedom possible'.[13] Does modernist self-awareness hinder, or assist, the programme of societal self-awareness, the necessity for social change? Here, it will have to be accepted that, for better or worse, nineteenth

century 'emergent' culture† did much to explore the inroads into mental and affective life that Romanticism had already begun. Its consequences will be examined later.

The role of modern art in this transformation can at least be hinted at through example. The image of the artist as a man of privileged feeling, of experience, of vaguely articulated resistance to the norms of bourgeois life — this image was reasonably well entrenched, both in the artistic community and in its public — by the time of the avant-garde of the early twentieth century. For it was this avant-garde alone that was aware of the 'new' philosophical positions of Nietzsche, Schopenhauer, Hegel and Bergson, and that sought to find in these a new means of opposition to the 'normalised' life of the bourgeois middle class. Whether it was despair, erotic decadence, the illusions of perceptual reality or the forces of alienation and the hypocrisies of bourgeois life; it virtually *defined* this avant-garde to see itself and its supporters as custodians of these philosophies. The *Jugend Bewegung* (Youth Movement) that formed the background to Brücke expressionism in Germany relied explicitly on Schiller, on Nietzsche, on Hegel and on Schopenhauer. Stefan George — from whom Kandinsky and the Blaue Reiter took at least part of their direction — was immersed in the Romantics of a century before. The mythology of the avant-garde artist in Paris was formed partially under the aegis of Schopenhauer and Nietzsche.

For those who were either unacquainted with these concepts or uninterested in the translation of them into art, the possibility remained of practising what would now be referred to as an 'academic' manner; a term intended to reflect the origins of the practice in the teaching of the Academy. This style was broadly naturalistic in its technique: narrative, descriptive, restrained and often moralising in a petty-bourgeois manner. And few challenges were likely to be presented by this academic manner to the prevailing power bases of European society — witness the popularity of academicism with the royal and aristocratic families of Europe. As John Berger and others have pointed out, this academic language was not only consistent with,

---

† The phrase is from Raymond Williams: 'we have to notice residual meanings and values . . . which are essentially the result of earlier and different phases of living, phases of experience, phases of society . . . there is also an area of emergent meanings and values, that is to say of practices, extractions of significance, which . . . attempt to create new meanings, new significance, new values, new practices . . . by creating new conventions and new notations'; *Literature in Society*, in Hilda Schiff (ed), *Contemporary Approaches to English Studies*, London and New York 1977, pp. 33-4.

23

but also entirely supportive of, the optic of accuracy and restraint which so successfully served the ruling classes during the industrial and entrepreneurial phases of pre-modern capitalism.[14]

As already mentioned, however, it is in terms of *technique* that founding- or palaeo-modernism articulated a set of resistances to official academic culture of the nineteenth century — at least according to the humanist account of modernism here being developed. The meaning of the 'new surface' of modernist painting is admittedly still not adequately theorised. In his important new book on Manet and his followers, T. J. Clark frequently confronts the question of what the modern surface means; but produces a multiplicity of answers, most of them merely analogical. I noticed the following nouns or adjectives which cropped up in the course of his various analyses: speed, superficiality, sketchiness, abruptness of interval, casual, light-hearted, illusion of spontaneity, well-being, easy lucidity, openness, the taking of risks, a willingness to improvise, absence of gloom, artifice, blasé, plain, immediate, secretive, muffled, paradoxical, etc., — many of which, he says, characterised the *behaviour* and the *manners* of the new Parisian society in the age of Haussmann and the boulevards.[15] But these epithets do not always go easily together, and it is not always easy to see from Clark's analysis which qualities the paintings actually contain — as opposed to those they were *said* to contain by their numerous (and frequently inexpert) critics.

At the very least one can say that the developing modernist generation was intent on defining itself *by contrast* ; by implicit opposition to the optic of power and control possessed (or anyway claimed) by the academic tradition. Equally, one can be certain that modernism wished to present *freshness of technique* as a mark of the presence of the individual, as originator of the *work*. Not only the impressionists but all the neo-impressionist formations, from Seurat's divisionism, Gauguin's cloisonnisme, Pissarro and Renoir's ambivalent impressionism, even fauvism and cubism, all sought to assert the priority of *facture* in the construction of the modernist visual image. The pretence of academic naturalism to be able to affirm the values of the polished pictorial surface, rich in convincing illusion and smooth in transition from part to part, without rupture or sign of excess — this pretence became the principal butt of the members of this early modernist generation.†

Care needs to be taken here to identify exactly what is at stake in this assertion of concern for modernism's 'new surface'. There are Romantic precedents, after all, for a

degree of unconcern with smoothness and polish. Romantic poets and artists had already meditated on the concept of 'finish' in a way that had had psychological or autobiographical implications. Shelley had refused to polish his verses on the grounds that doing so would tarnish the flow of meanings that issued from the spontaneous mind. Wordsworth's characterisation of poetry as 'the spontaneous overflow of powerful feelings'[16] lies at the very origin of the idea of expression in its modern sense. Abrams tells us that even such a straightforward utilitarian thinker as John Stuart Mill defined 'natural poetry' — necessarily of higher value than cultivated poetry — as 'Feeling itself, employing Thought only as the medium of its utterance'.[17] Evidently it became established during the course of the nineteenth century that spontaneity was valuable in art and that polish could kill a painting or poem through artifice.

The transfer of the concept of spontaneity from poetry to visual art is admittedly not exact; but the precedent of the quickly executed sketch, previously reserved for note-taking only, seems a near equivalent to the poetic case. Constable had justified bestowing importance on the sketch, for example, on the basis that it 'showed the state of one's mind at the time'. The basic idea of graphology, too — a nineteenth century invention par excellence — is that un-selfconscious style, and the more so the better, is a sure index of character and personality. By the end of the nineteenth century, Dr. Johnson's idea that 'style is the man', which he had made a tenet of eighteenth century humanist criticism, had established itself firmly inside the body of art as a key term in the link between art and autobiography. 'Expression' as a term connected with the showing of feeling is apparently not in use before about 1830; Abrams gives Mill's 'poetry is the expression and uttering forth of feeling' of 1833 as an early example.[18]

In visual art, Symbolist critics and artists of the 1880s and 1890s were adamant in re-defining art as a principally subjective activity. This côterie was aware that Delacroix had said that 'the subject is yourself . . . your emotions

---

† One could also mention artistic *dress* as a sign of the altered allegiances of the artist under modernism. The custom of 'dressing down' to the level of the labourer or manual worker forms a sub-text for the whole of modern art, one that may some day be spelt out in full. Picasso and Braque are reported by Kahnweiler as suddenly adopting working-men's clothing around 1912, the time of their first contract with the dealer. Kirchner and the expressionists are also careful to abandon purely bohemian dress in their many self-portraits painted in peacetime. But early modernism presents contradictions here too — witness Matisse, or the early Beckmann, who posed in middle-class uniform for most of his pre-1914 self-portraits.

before nature';[19] and that Baudelaire had lauded Delacroix in terms that were unashamedly subjectivist. 'This is the principle from which Delacroix sets out, Baudelaire asserts; 'that a picture should first and foremost reproduce the intimate thought of the artist, who dominates the model as the creator dominates his creation'.[20] Zola too had individualised and personalised the work of art in his call for 'a man, not a picture . . . the name 'realist' does not signify anything to me who declares reality to be subordinated to temperament', Zola declares; 'Be realistic, and I applaud; but above all, be an individual and be alive, and I applaud louder'. And: 'I have the deepest admiration for individualistic works which are flung from a vigorous and unique hand'.[21] Octave Mirbeau, in an article on Van Gogh in 1891, said that this artist 'had absorbed nature into himself . . . forced it . . . to submit to those distortions (déformations) that especially characterise him'. He possessed that which 'distinguishes one man from another: style . . . that is, the affirmation of personality'.[22]

The centre of Symbolist thought in the hands of critics like Aurier and Bernard was that a work of art should not copy nature, least of all its fleeting impressions, but convey a universal idea by means of subjectively experienced forms and qualities.[23] The 'great' artist had special gifts of insight; he could construct 'correspondences' in form, shape or sound that would convey his subjective insight as if it were a universally understandable truth (the word *vérité* still means both 'inner' and 'outer' truth). The qualities of this art would include bright, non-naturalistic colour, flat or flattened surfaces, a certain icon-like appearance, and the use of subject matter not as documentary fact but as 'suggestive' or 'evocative' symbol.

In fact the suppression of detail in favour of the working of the whole has an ancestry that goes back far beyond Gauguin, even beyond Baudelaire; as has the well-known Symbolist analogy between painting and the effect of music; but both appear in the following remark of Gauguin, that 'there is an impression resulting from any certain arrangement of colours, lights and shades, which may be called the music of the picture. Even before knowing what a picture represents, as when you visit a cathedral and find yourself at too great a distance to make out the picture — frequently you are seized by this magic accord'.[24] Here, Gauguin seems to state an idea which is close to the way many people view a picture today. But Gauguin goes on to define another important premiss of the Symbolist aesthetic when he specifies the inward direction of this 'magic accord'. It addresses itself, he says, 'to the most intimate part of the soul'; provides a vital channel, that is,

to the most important emotional centre of the observer's
being. That the origin of this sense of 'accord' lies in the art-
ist, finally — the artist who implants it in the painting by
the devices of its style — Gauguin admits in saying that 'the
work of art for him who can see is a mirror which reflects the
state of the artist's soul'.[25] Thus the circle is complete
which binds style to the painting, the painting to the artist,
and the observer to all three. Only nature — the world — in
its direct representation, is excluded from the circle.

It should be understood that much other Symbolist
art of the 1890s — from which Gauguin was anxious to dis-
tinguish his own 'Synthetism' — continued to use a reper-
toire of motifs such as the *femme fatale*, the sphinx, the lily,
the snake, etc., mostly borrowed from literature, which
were depicted in a naturalistic manner of representation
which offered few if any innovations in terms of style or
technique. Odilon Redon, for example, who with Bresdin
was much admired by the Symbolist writers of the 1890s as
well as by the later surrealists, expressed this still basically
naturalistic method as 'putting the logic of the visible at the
service of the invisible'.[26] But Gauguin's ideas far more
nearly approximate to the sources of modern painting in
both a chronological and conceptual sense. The Synthetist
aesthetic as a defence of style; as a proclamation of inward-
ness; as a means of escape from legible subject-matter; and
as a vehicle for the formation and revelation of artistic 'tem-
perament', has dominated modern painting ever since. To
the next generation, those who came to artistic maturity
between 1905 and 1914, this outlook was crucial.

They, indeed, are the early modernist artists, the
generation of Matisse, Picasso, Kandinsky, Beckmann and
Klee. Here we shall consider just one of them — Matisse
— to show how the development of style as an authentic
expression of temperament was finally achieved.

Matisse is generally thought of as a relaxed, hedonis-
tic, even serene painter who wanted a painting to be 'like a
good armchair in which to rest from physical fatigue' — to
give once more his interminably quoted statement from
*Notes of a Painter.*[27] Popular books on Matisse still repeat
the same verdict; but they all miss the point of what the
emotional content of Matisse's art really was.

Far from advocating a kind of tranquilising principle
for pictorial art, Matisse was, I believe, investigating a cer-
tain sort of 'working-through' of the experience of chaos, in
the construction and perception of the pictorial surface in
his paintings; and it is this far more rigorous and testing pic-
torial manner, and not his fabled 'decorativeness', that
makes Matisse's style interesting as a modernist exemplar.

From the mid-1890s, Matisse had been plagued by

27

the problem of combining a kind of fidelity to nature with an 'expressive' method that somehow articulated the presence of the painter himself. His earliest teachers had reinforced this opposition. Bougeureau had advised copying from the cast; while Moreau and Carrière encouraged Symbolist methods of evocation and musicality. Moreau recommended withdrawing from outer nature in order to intensify 'inner' vision[28], although this did not prevent Matisse painting directly from the landscape in his Belle-Ile paintings of 1895 to 1897. By about 1895 an opposition had become established in Matisse's mind between nature and the inner world; what he later called 'the eternal question of the subjective and objective'.[29] He had a fluid, pre-Fauve period at the close of the century, then a divisionist style that came and went between the turn of the century and 1904. On the brink of the Fauve experiment of 1905 he seems to have discovered a greater confidence, a greater degree of personal courage with the possibilities of style. By 1903 or 1904, as he reported later, he had begun to learn that his painting was to be 'a meditation on nature, the expression of a dream which is always inspired by reality . . .'.[30] His Fauve work of 1905-6 was but the first major expression of this aesthetic; a high-keyed, dissonant style in which Matisse 'smashed everything out of principle . . . I was working as I felt, with colour alone'.[31] Certainly the style reflected something of the intense anxiety to which, according to his friends at the time, he was especially prone.[32]

By 1908, however, the critical success of the Fauve style had begun to wear thin. In paintings like the *Joy of Life* of 1905-6 Matisse had already begun to move away from the excitements of Fauvism, to try to capture the more enduring, perhaps more stable emotions, what he sometimes called 'noble pleasure'.[33] *Notes of a Painter*, published at the end of 1908, is partly Matisse's response to the need to defend his newer work — to explain to a doubtful audience what this 'noble pleasure', this 'harmony', actually was. This provides something of the setting for his famous statement about an 'art of balance . . . a calming influence on the mind . . .'. But Matisse probably had two paintings in mind from 1907 when he made this assertion. These are the *Music (sketch)* and *Le Luxe I*, both of that year. They provide a suitable context for examining how subjectivity is contained by technique in Matisse's mature painting style.

In these paintings, for the first time, Matisse's subject matter had begun to become opaque almost to the point of incomprehensibility. *Le Luxe I*, for example, shows some curious figures whose actions are obscure. Time and space have become indeterminate, ambiguous. Their faces are

Figure 3    Figure 4

28

psychologically unreadable. Their gestures have become
unclear. Yet the greatest investment is being made in the
technical *means* by which this and other paintings of the
time are being created.

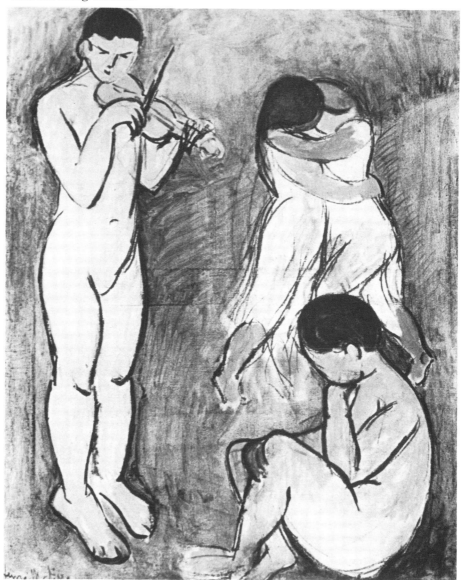

3. H. Matisse, *Music
(sketch), 1907*

In fact Matisse's technique around this time seems to
divide into two: there are 'first-time' paintings, which are
sketched in without second thoughts, and are then left
alone; and there is another group which contain a quite
opposite conglomeration of re-workings, erasures and

29

changes of design which are all left curiously visible in the surface of the work.

I believe that the first method, that of radical incompleteness — what Vallaton described, when he first saw *Le Luxe I*, as 'hypnotic, and broken draughtsmanship . . . waves of colour without representation'[34], offers something like an invitation to the beholder to fill in the remaining detail for himself. Like our responses to a mutilated body, our instinct is to somehow 'replace' the missing parts in any number of ways that seem available.

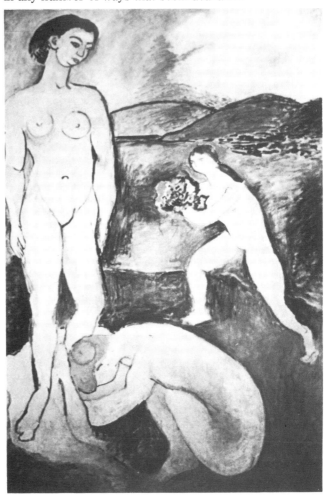

4. H. Matisse, *Le Luxe, I,*
*1907*

Matisse's second tendency, which is the converse of the first, appears on a grand scale in *Music*, the second of

the two panels commissioned by Shchukine for his Moscow house in 1910. According to the terms of the commission, Matisse planned this panel as a description of an activity that Shchukine said should be celebrated in the interior of his house. A standing violinist (possibly Matisse himself, in view of his attachment to the violin) leads a single piper and three singers, who sit, like notes on a plainsong melody, apparently engaged in a kind of primeval dirge. They seem to partake of a dark but elemental world where the instincts have been set free. But it is in technical terms that the picture breaks new ground. For here, Matisse takes the interesting step of dispensing altogether with a preliminary sketch such (as had been used for the slightly earlier *Dance* panel), now taking the liberty of simply *painting over* a previous design in order to bring the picture to a new state of realisation.

Figure 6

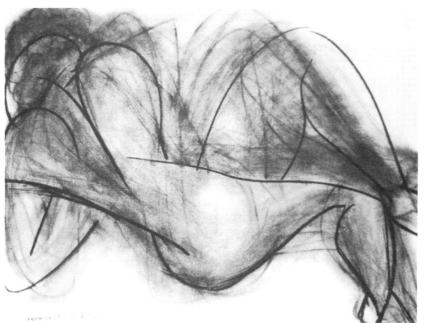

Matisse seemed aware that this process signalled a departure, for he took the trouble to have the painting photographed several times while he was working on it — something he had not done before. And we know from these photographs that the composition was altered radically between the first and second states; and from the second state to its final form, the last transformation eliminating entirely a sleeping dog and several bunches of wild

5. H. Matisse, *Reclining Nude Seen from the Back,*

31

flowers that had been there before.

The importance of this new 'layering' technique derives from the visible fact that Matisse leaves most of the previous work still dimly visible beneath, whence it shines through the uppermost layer like a fossil record of the pre-history of the picture. What this now signifies is that previous 'errors' in the painting have been *accommodated by change* rather than excised by banishment or destruction — they are now tolerated, loved, and given a life *within* the richness of the final surface; a compelling justification for the technical process that Matisse had in this way evolved.

Figure 7

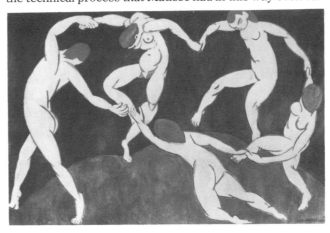

6. H. Matisse, *Dance, 1910*

Of course it is possible to find many paintings by other artists in which *pentimenti* occur; small changes which result from decisions the artist makes while the painting is being executed. But only in Matisse do we meet with such a sensitive and poised awareness of what this layering process could be made to mean. He would often describe, later in his life, how he would gradually move forward in the construction of a painting, often through a sequence of many failures, until something final and resolved is eventually achieved. At each stage, he said 'I reach a balance, a conclusion. At the next sitting, if I find a weakness in the whole, I find my way back into the picture by means of the weakness. I re-enter through the breach — and reconceive the whole.'[35]

I re-enter through the breach and reconceive the whole: the unintended references here to birth and pro-creation may tempt us to see Matisse's method as a kind of fertility rite which the artist had been conducting, as it were with himself, with his paintings as offspring.† 'At the final stage', Matisse says elsewhere, 'the painter finds himself freed and his emotion exists complete in his work. He himself, in any case, is relieved of it'. The rules by which nature

is thus transformed, come 'from me', Matisse asserts, 'and not from my subject . . . it is from the basis of my interpretation that I continually react until my work comes into harmony with me'.[36]

7. H. Matisse, *Music, (detail), 1910*

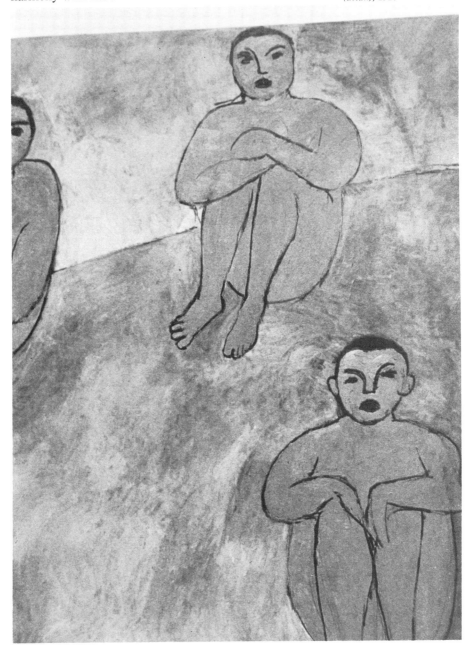

Thus the meaning of Matisse's early painting lies not in its subject, nor in the decorative qualities with which it is often attributed, and through which it has become popular; but in the artist's technique, and in his use of technique as an expression of subjective mental states. Matisse's modernism lay in his extension and deepening of the Symbolist aesthetic of 'style . . . that is, the affirmation of personality'.[37] This moment of high modernism — Matisse's paintings between 1907 and 1910 — contains much that is essential in how a modernist subjectivity born of Symbolism became entrenched in the art of our century.

In fact the example of Matisse demonstrates — and others such as Picasso, Kandinsky, Kirchner and the early de Chirico would support — that modernism in this incarnation consisted pre-eminently in a deepening and intensification of the Symbolist aesthetic of *recoverable meaning*. As an attitude towards the world, it took the form of assuming that reality was not legible in its ostensible forms alone, that its fundamental character was opaque to ordinary vision. As an attitude to the human personality it assumed the same: that character, the 'self', was not given, but lay hidden, to be uncovered only by patient and possibly painful investigation. Symbolism (especially Synthetism) connected these two concepts together so as to enable each one to buttress the other. Style, the point at which they met, became both the vehicle of temperament and a reading of the world. Modernism, from that point onwards, could endlessly vary the means of art in the name of an ever more searching criticism of the appearances of everyday life.

Figure 8

There may be one characteristic that summarises the tendency of much modernist art, from its subjective early statement right through to its later forms; and that is its potent charge of *optimism* for both an improved exterior and a more highly penetrated interior world. 'There is a mode of vital experience . . .' writes Marshall Berman, 'of the self and others, of life's possibilities and perils — that is shared by men and women all over the world today. I will call this body of experience 'modernity'. To be modern is to find ourselves in an environment that promises us adventure, power, joy, growth, transformation of ourselves and the

† The French text here is 'A la séance suivant, si je trouve qu'il y a une faiblesse dans mon ensemble, je me réintroduis dans mon tableau par cette faiblesse — je rentre par la brèche — et je me reconçois le tout'. Matisse's words are reported by M. Teriade in *Constance du Fauvisme*, Minotaur II, 9; October 15th, 1936, p. 3. The French 'brèche' does not translate into the English 'breach', except to mean a hole or an opening, usually a breach in a military rampart; but the sense of entry, even opportunistically, through a gap or fissure, remains.

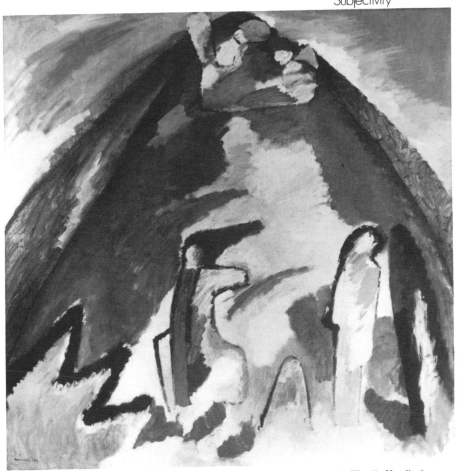

8. Wassily Kandinsky,
*Mountain, 1909*

world . . .'[38] Even apparently nihilistic literature in modern-
ism — from Kafka to Beckett — seems to be premissed on
the assumption that life can be changed. 'When the exterior
world is disgusting, enervating, corruptive and brutalising',
wrote Flaubert, 'honest and sensitive people are forced to
seek within themselves a more suitable place to live . . . the
soul, made to overflow, will be concentrated in itself'.

But it is the subjective and autobiographical impulse
that stands out in the modernism of the definitive early
phase — at least in visual art. Modernism, implied the
Freudian writer Ernst Kris in a still much under-valued
book of fifty years ago,[39] enables the artist to achieve a new
balance of forces as between the ego and the id. He does
this by allowing himself in the action of artistic work to reg-
ress under the guidance of an ego which itself remains
secure, to the point where deeper contents are mobilised

35

and brought into a strengthened relationship with the rational mind.

We saw inklings of these regressions in the case of the paintings of Matisse. More generally, the modern artist's tendency to 'scribble' and 'smear' his paint Kris considers to be regressive in a wholly constructive sense. 'The controlled regression that is implied in the scribbling style of the (old) masters', Kris writes, 'is only possible where representational skill determines the ordinary level from which the virtuoso can let himself drop without danger'.[40] Although true of masters like Rembrandt and Rubens, the insight is valid for the modern artists too, since they also began their careers from a position of relative representational skill, true to the training they received in the 1870s and 1880s; and kept that skill in mind thereafter as a datum from which to depart with ever greater daring. But, unlike the old masters where scribbling was confined to shading, background, or unimportant detail, scribbling in the modern artist is always allied firmly to the depiction of recognisable things, however much this depiction may be distorted by the application of 'expressive' principles.

The extreme distortions licensed by modern art, Kris suggests, represent the culmination of a development which began in the sixteenth century with the conversion of the artist from a manual worker into a creator. 'The work of art', writes Kris, 'is for the first time in human history considered as a projection of an inner image. It is not its proximity to reality that proves its value but its nearness to the artist's psychic life'.[41] This development, as Kris reminds us, coincides with the birth of caricature. Caricature then became important to the modernist artist because it licensed the distortions and deformations of nature that by then he had come to employ.

Kris also tells us that all caricature, whether ancient or modern, depends, like the old master sketch, on 'controlled regression'[42] — and that the purpose of caricature is to ridicule the victim 'under the influence of aggression' by altering the victim's likeness. In the modern phase, regression is merely less controlled. Since image and object are one, the agression is no longer confined to the aesthetic sphere alone but is really inflicted on the substance of the thing represented. Assimilating this artistic regression to the use of images in primitive magic and ritual, Kris writes of both that: 'the artist does not 'render' nature, nor does he 'imitate' it, but creates it anew. He controls the world through his work. In looking at the object he wishes to 'make', he takes it in with his eyes until he feels himself in full possession of it. Drawing, painting and carving what has been incorporated and is made to re-emerge from

vision, is a two-pronged activity. Every line or every stroke of the chisel is a simplification, a reduction of reality. The unconscious meaning of this process is control at the price of destruction'.[43]

Writing more recently of cubism, Anton Ehrenzweig offered the parallel proposition that its fragmented surface forms were held together by a deeper underlying structure — 'this hidden order redeems the near-schizoid character of the excessive fragmentation found in so much modern art'[44] — and analysed the action of the cubist artist as one of projection, integration and then re-introjection. In the initial stage, Ehrenzweig says, the artist projects fragmentary parts of himself into the work; the results frequently look accidental, unwanted and sometimes persecutory. Fragmentation in the first stage mirrors the fragmented personality of the artist. In the second phase the artist integrates the fragmented parts into a 'good' whole. Then in the third phase the unified aspect of the work is introjected back into the personality on a level of surface consciousness; and, as Ehrenzweig puts it, he thus 'enriches and strengthens his surface ego'.[45] The third phase of re-introjection is when 'the independent existence of the work of art is felt most strongly. The work of art acts like another living person with whom we are conversing'.[46]

The manipulative aspect of subjective modernism — the recovery of meaning through authentic style — was also hinted at more recently in the psychoanalytic theories of Hanna Segal and Melanie Klein. They traced most if not all 'creative' work — but it seems exemplified in modernism — to a working through of the 'depressive' position which Klein attributes to infancy. In the depressive position, the infant has to come to terms with the fact that the good and the bad aspects of the mother belong together in one object. This produces a mourning reaction at the loss of the totally good object; and a sense of guilt at having attempted to destroy the bad. Reparation ensues, in which the child tries to make amends for his guilt and restore order to his inner world by creating new or 'restored' objects in artistic activity. On the Kleinian account, the sort of modernism found in expressionism, fauvism, cubism and futurism represents a regression through style to the 'depressive' position of reintegration and acceptance of loss; which is also the point from which new worlds can be made through the manipulations of artistic technique.†
Early modernism, on this account, was subjective in being regressive but also reparative; based in experience but nevertheless autobiographical and existential. It established norms for artistic engagement that have only begun to disappear in post-modernism. It legitimated 'inwardness

through style' as the relatively permanent basis of modern-ist visual culture.

The question for the later twentieth century is simply how much of this programme can continue to be supported in a culture that is very different in crucial respects from the early days of 1905 or 1910. Revisions to this cultural order, in the 1960s, 1970s and 1980s, is the topic to which we must therefore now turn.

† A different psychoanalytical aesthetic for modernism has been put forward by Peter Fuller. Fuller adopts the position of the object-relations analyst and paediatrician Donald Winnicott, who proposed that a certain kind of illusion was created by the 'good-enough' mother when she offered her breast at precisely the moment when the child wanted it. The illusion thus created constitutes neither 'inner' nor 'outer' experience, but a 'third' or 'transitional' space; 'an intermediate area of experiencing to which both inner reality and external life both contribute'. (Fuller, *Art and Biology*, p. 15). The adult never tires of this desire to create a 'transitional' world, and the opportunity to do so in a good-enough environment constitutes healthy adult creativity, according to Fuller.

My main difficulty with this account is that it is put forward as a *universal* model for aesthetics; applicable to people of all times and places, and summarising the 'relatively constant' aspects of human biology — here Fuller defers to Sebastiano Timpanaro. But it seems to leave aside those experiences which may also be near-universal, such as grief, loss, the fear of death, political struggle, joy and fulfilment; and also de-historicises aesthetic experience to the point of neglecting any temporally limited — but still important — concern. Secondly, the results of Fuller's account seems odd. It appears to validate such disparate works as those by Bonnard, Cezanne, Rothko and the little-known American abstractionist Robert Natkin. Of these, Fuller says such things as that they 'affirm our potentialities, our possibilities for transforming ourselves and the world', (Fuller, *Art and Psychoanalysis*. London 1980, p.225), which again takes these artists out of the historical process and endows them with qualities which the artists did not know they had. See also the *Rocks and Flesh* exhibition curated by Fuller in 1985-6, almost a quarter of whose works showed actual nursing mothers and their babies, as if this somehow validated what was surely intended only as a metaphor.

# Chapter Three

# BEYOND
# POST-MODERN
# AESTHETICS

'Post-modernism' in its theoretical aspect claims to per-
ceive a 'break' in culture between its modernist past and a
range of new ideas that have come to the surface in the
period since 1945 — though the origins of this 'break' may
go further back, nearly to the origins of modernism itself.
Post-modernism in this sense claims the existence of a
major epistemic interval between an older twentieth cul-
ture and that of today — new ways of knowing and being
that substantially revise what was once taken as definitive
in the most 'progressive' culture of our century.

An eary occurrence of the word 'post-modernism'
was in a lecture by Leo Steinberg given early in 1968, and
subsequently included in his book *Other Criteria*, where he
describes the type of surface constructed in the late 1950s
and early 1960s by Robert Rauschenberg and Andy
Warhol. Steinberg defines Rauschenberg's 'flat-bed' sur-
faces of the 1950s, in which newspapers, chairs, beds,
photographs and paint-marks were mixed together, as
'post-modernist', because they departed radically from the
Figure 9  homogeneous, crafted surface of abstract expressionism.
The flat-bed picture plane, Steinberg says, 'makes its sym-
bolic allusion to hard surfaces such as table tops, studio
floors, charts, bulletin boards — any receptor surface on
which these objects are scattered, on which data is
entered, on which information may be received, printed,
impressed — whether coherently or in confusion. The pic-
40       tures of the last fifteen to twenty years insist on a radically-

new orientation, in which the painted surface is no longer
the analogue of a visual experience of nature, but of opera-
tional processes'.[1] Warhol conceived the picture as an
image of an image — thus a 'deteriorated' image which
mirrors the arbitrariness and confusion of the city exper-
ience. 'The all-purpose picture-plane underlying this post-
Modernist painting has made the course of art once again
non-linear and unpredictable', writes Steinberg at the end
of his discussion. 'What I have called the flat-bed is . . . a
change in the relationship between artist and image, image
and viewer. Yet this internal change is no more than a symp-
tom of changes which go far beyond questions of picture
planes, or of painting as such. It is part of a shake-up which
contaminates all purified categories'.[2]

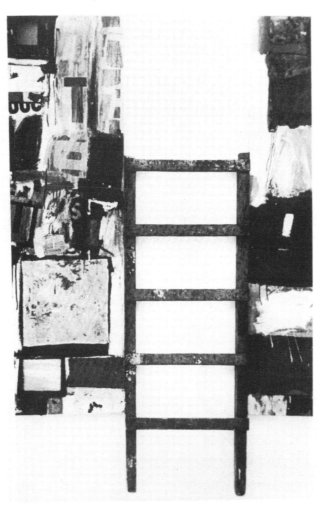

9. R. Rauschenberg,
*Winter Pool, 1959*      41

Independently, the term 'post-modernism' used regularly to describe a whole generation of architects by Charles Jencks, the architectural historian and critic. In an article in Architectural Design in 1978, Jencks attempted to distinguish post-modern from late-modern style.[3] Post-modern architecture is that architecture which reacts against the international 'high' modernist style of the steel-and-glass box, as exemplified, for instance, by Mies van der Rohe and the early Philip Johnson. Adding decoration, impurity, colour, asymmetry and perhaps a touch of populism as well, post-modernist architecture defines itself both negatively and positively at the same time; in challenging the older norms as well as offering different values from those that were prominent in urban (and predominantly commercial) architecture of the 1940s and 1950s. These buildings refer not to 'truth' or 'civic authority', but to other styles, to architecture itself. Post-modernists double-code their buildings, says Jencks, 'so that they communicate with their users as well as other architects, and it is this attempt which ties them to previous traditions — the classical language, Queen Anne Revival and Art Nouveau, to name three'. Philip Johnson's AT and T building in New York has a top storey like a Chippendale highboy or an eighteenth century grandfather clock. The main shaft of the elevation, says Jencks, 'might look like a modern, granite-sheathed skyscraper; or . . . like a work of Louis Sullivan, that is, 'Pre-Modernist'. The divisions and syncopations come directly from the classical skyscraper tradition — the Auditorium Building in Chicago of Adler and Sullivan. But behind this, in fairly strong contrast, is a traditional modern skyscraper trying to get out, or rather stay in . . . If the reticence of the side elevation is anything to go by then the building will start to approach the Gucci look, or better the Lanvin mode. It will be perceived as in the Fifth Avenue or Bond Street style, signifying fastidiousness and boredom . . . the skyscraper as elongated grandfather clock, as gigantic Lanvin perfume bottle, as Renaissance Chapel, as Neo-Fascist colonnade, as imprisoned Level building, or Rolls Royce radiator. The New Yorker may be well pleased to see these meanings come into his skyscraper, and delighted by the elegance with which the thirty foot pediment lifts up its ears, gently, at the ends'.[4] Regarding the A T and T building as a 'major monument' of post-modern architecture, Jencks actually lists thirty different parameters by which post-modern can be distinguished from modern: 'popular', versus idealist; semiotic versus functional; traditional versus Zeitgeist; complex versus simple; eclectic versus purist; metaphorical versus anti-metaphorical; humorous versus 'straight'; ambiguous

Figure 10

versus transparent; collaged versus integrated; mixed aesthetic versus machine aesthetic; and so on. The architect himself is described in Jenck's tabulation as 'representative and activist' rather than performing a saviour or a doctor role.

10. Philip Johnson, *AT & T Building, New York City, 1978/82* cover

Post-modern film, likewise, departs considerably from the high modernist classics in precisely *not* presenting a coherent and unified world-view — traceable ultimately to the craftsmanship or the creativity of a single individual — but in stitching together fragments of meaning drawn largely from previous films or from previous genres of the medium. Self-referential and often knowingly parodic, these productions appear to consist of open-ended, empty collages, referring at best to the materiality of film and hardly at all *through* the medium of film to the real world itself. Post-modernist films have 'no truth content', according to one theorist, but consist of 'sheer surface or superficiality'.

43

The writer here is Frederic Jameson — a major proponent and theorist of the post-modern — speaking about Godard. A similar analysis can be applied to literature. Here, says Jameson, one can see a change from the works of the classical modernists such as Proust, Faulkner or D. H. Lawrence to a new point of view which sees them simply as 'texts' which can be studied for their world-view and then simply dropped in favour of an alternative picture. Modernist writing used to function like a secular religion which could be learned, absorbed, valued and even worshipped as a special, even unique way of looking at the universe. 'One did not simply read D. H. Lawrence or Rilke, see Jean Renoir or Hitchcock, or listen to Stravinsky as distinct manifestations of what we now term modernism. Rather one read all the works of a particular writer, learned a style and a phenomenological world. D. H. Lawrence became an absolute, a complete and systematic world-view, to which one converted . . .' Then, says Jameson, came the crisis of modernism, 'when it suddenly became clear that 'D. H. Lawrence' was not an absolute after all, not the final achieved figuration of the truth of the world, but only one art-language among others, only one shelf of works in a whole dizzying library'.[5] At that point it became difficult to perceive the works of the modernists themselves as anything other than as *texts* which offer their truths in a strictly relative manner — relative to other texts, but also to the detriment old humanist assumptions about the 'personality' of the author and the camp-follower nature of the reader. In likewise fashion the writer could no longer assume the mantle of a prophet or oracle, under postmodernism; but at best could function only intertextually, that is, as a purveyor and redistributor of someone else's texts, as a *bricoleur* (to use Levi-Strauss's phrase) of images and experiences from elsewhere.

In the visual arts also, the post-modernist argument offers depthlessness and superficiality as the major qualities of the newer art; at the same time as proposing a revised valuation of earlier modernist art as an essentially hopeless or lost project. The chronology is much the same as for literature and film. Following Steinberg's analysis, most exponents of the post-modern now locate the decline and final termination of modernist art at the end of the 1950s in the United States; in particular the art of Rauschenberg, Johns, Warhol and their followers. Warhol, it is now generally argued, was the first artist to come to prominence who displayed markedly anti-modern attitudes both in his behaviour and in his artistic products. Warhol's cynicism, his well-advertised boredom, his obsession with trashy commercial products, his lack of interest in anxiety

as an appropriate response to urban life, even his *celebration* of alienation as a benign, even comforting condition — these attitudes have helped to elevate him to a position of considerable prominence in the more recent diagnoses of a post-modern cultural era. What has followed Warhol, according to this argument, namely New Expressionism, the Trans-Avant-Garde, the predominance of pastiche, nostalgia, a depthlessness amounting at times to an almost total loss of feeling, have all confirmed the basic 'post-modernist' diagnosis that culture turned a corner at around 1955 or 1960 in the United States, and has changed similarly in other parts of the West in slower or more gradual measure since. 'It's always interested me', says the post-modern artist Francesco Clemente, 'to see how far away from oneself and one's own tastes one can lead the work'.[6]

A recent exhibition in London of the works of Julian Schnabel contained six or eight types of painting within one relatively small display. Surfaces made of velvet, canvas, linoleum, animal skin, board, paper and wood were covered with no end of articulations, ranging from broken cups and saucers, antlers, burnt logs, gaping holes, chains and 'selected' detritus, not excluding painted quotations from old masters like Caravaggio, painted intentionally ham-fistedly on various parts of the surface.[7] An exhibition called *Colin Self's Colin Selfs* — in imitation of the 1981 *Picasso's Picassos* event at the Hayward Gallery — consisted of skilfully executed drawings and paintings in every conceivable style: realist, romantic, collage, caricatural, chocolate-box, abstract, surrealist, and what Self calls 'Women's Institute Evening Class style.'[8] Every product of low art such as matchbox covers, cigarette papers, sauce bottle labels, and designs for coins was included — Self calls himself 'the ringmaster of this 'People's Art' '. 'By the early 1980's', writes Self, 'I reached a point of view where I could appreciate all the periods of my life and work equally pleasurably . . . I explained to myself that what I wanted to do or explore was in fact perfectly alright, since I do have many interests and in fact *am* different people in different situations and that there's nothing wrong with that . . . anything, almost, came into my interest's focus'.[9] Or, as Jean-François Lyotard puts it in his book *The Post-modern Condition*, 'eclecticism is the degree zero of contemporary general culture: one listens to reggae, watches a western, eats McDonalds food for lunch and local cuisine for dinner, wears Paris perfume in Tokyo and 'retro' clothes in Hong Kong; knowledge is a matter for TV games'.[10] In Jameson's phrase, post-modernism is now the 'cultural dominant' of our era.[11]

Of the many themes that cross and overlap in this for-

Figure 11

45

mulation of a substantially new cultural 'force-field', one of the critically most contentious is that which concerns the artist himself. What post-modernism claims is that the humanist paradigm of the artist as a 'subject' who can 'act' on his environment is ideologically unsound, bourgeois, a mystification, a capitalist deviation, and so forth. Above all, the humanist and modernist concept of 'expression' has come under attack from virtually every side. 'Expression' assumes, according to the argument, the very distinction between the 'inner' and 'outer' mind that characterised the old bourgeois humanist conception of the subject as an autonomous a-social being. Secondly, 'expression' elevates the artistic style, trace or brushmark to a position of importance which it cannot in reality possess — since there can be no guarantee that the brushmarks of the artist give an *accurate* account of the state of his inner mind or character. This is an epistemological doubt. Thirdly, postmodernism proposes that the modernist's unique 'style', his particular method of marking the canvas or the paper, derives principally from the market itself. The market fetishises the individual artistic product, says this postmodernism; bestows rarity and singularity upon that which it wishes only to sell. As Walter Benjamin said in a classic paper of fifty years ago, the 'aura' of the painterly brushmark has been overtaken by the power of the photograph to record and display. Hence the survival of the brushmark within modernism — even its exaggeration — constitutes little more than an effort to recuperate something that history should have left behind.[12]

Feminists in particular associate painterly brushwork with male art, and hence male art with modernism. Postmodernism for them means that the 'myth' of individual male creativity (and hence patriarchal culture generally) can be finally and irreversibly abandoned. Renoir's (possibly drunken) remark that he painted with his prick, or Picasso's that he made pictures the way a prince makes children with a shepherdess, have confirmed for them the connection between male modernism and their subjection to a patriarchal order. Abandoning 'aura' as well as 'creativity', feminist artists see post-modernism as a victory of their own against the weight of previous male culture.

The classic formulation of the unimportance of artistic 'aura' was that of Roland Barthes in *Image — Music — Text*, published in French in 1968 and translated into English in 1977. Barthes' argument in *The Death of the Author* is that the category 'literature' relies upon the assumption that 'authorship' represents the expression of a unique personality who is speaking to the reader, and that the 'author' is the entity in whose character the meaning

11. Julian Schnabel, *Exile, 1980*

and value of the text is to be found. But a literary text can no longer be regarded as a coherent and unified entity, suggests Barthes. On the contrary, 'a text is made of multiple writings, drawn from many cultures and entering into mutual relations of dialogue, parody, contestation'; and there is one place where this multiplicity is focused but that place is the reader and not, as was hitherto said, the author.

Barthes says that 'A text's unity lies not in its origin but in its destination . . . The birth of the reader must be at the cost of the death of the Author'.[13] Michel Foucault followed the unstated conclusions of Barthes' hypothesis in claiming the author (and the artist) in our culture to be complex historical constructions with their own specific sorts of valorisation, such as the fetish of 'authenticity' and the overarching assumption of individualism, both of which came into play historically at specific moments for specific reasons. But Foucault goes further in claiming that we have no adequate method for identifying 'the work' of the author or artist in the first place; for how do we distinguish between his 'genuine' work of art and what Foucault calls the 'millions of traces left by someone after his death' — his notes, his erasures, his private letters, his doodles or even his laundry lists?[14] And why do we continue to submit to the assumption that the origin of a work's meaning — or of several together — is the 'consciousness' or 'creativity' of the artist? Doesn't this only serve to neutralise fertile contradictions within the work, to tie all elements together in a

47

unitary mode of 'expression' which is uniquely attributable to him? And finally, doesn't this restricted author-function based on the collecting principle of the name actually contradict that other assumption of bourgeois aesthetics, namely that the artist is a creative powerhouse, a perpetual surging of invention, a 'genial creator of a work in which he deposits, with infinite wealth and generosity, an inexhaustible world of significations'?[15]

Subsequently, critics on the left in France and the United States (and latterly in Britain) have been almost unanimous in associating the idea of a single, unified perspective which pre-exists and 'speaks' the literary text as the very hallmark of petty bourgeois fiction; capable, in reality, only of sealing over the cracks and rifts in the disintegrating 'individualist' culture of capitalism. Polyphonic writing, consequently — writing capable of representing multiple viewpoints and the 'dialectical character of the social process' — has become hailed as a far more progressive form. 'Today's writing has freed itself from the dimension of expression' writes Foucault; 'Referring only to itself, but without being restricted to the confines of its interiority, writing is identified with its own unfolded exteriority. This means that it is an interplay of signs arranged less according to its signified content than according to the very nature of the signifier . . . In writing, the point is not to manifest or exalt the act of writing, nor is it to pin a subject within language; it is rather a question of creating a space into which the writing subject constantly disappears'.[16]

The post-modernist thesis of the decentered, contingent subject has been supported more recently by advances within psychoanalysis itself. The radical reformulation of Freudian psychology by Jacques Lacan and his school represents the most far-reaching attempt to 'deconstruct' the humanist subject and return it to its supposed origins in language. What we call the 'ego' or 'I', according to Lacan, is in reality not a unity at all but a de-centred, essentially schizoid conglomeration that originates in what Lacan calls the 'mirror phase' of infancy — when the infant misrecognises himself as a host of other people, which he then identifies with his own mirror image. 'The mirror identification situates the existence of the ego . . . in a fictional direction, which will always remain irreducible'.[17] Lacan also says that the ego does not create language, because language exists socially before it does. Lacan — who by some irony appears to have been Picasso's former doctor[18] — proposed, in fact, that the picture we have of consciousness emerging *into* language is wrong. It is, on the contrary, formed *by* that language framework which pre-exists it and orders its being. Not only the first gropings

of consciousness but all the factors of humanist individual 'identity' such as gender, class and ideology come to be attached to the individual as *already given* facts of the language system: arising from and receiving their meaning from what the language permits the individual to say and the way in which it allows him to say it. The human subject is nothing more than 'effects in which are to be found the structure of language, of which he becomes the material ...'[19] Thus language is no longer the expression of thought, according to Lacan, but thought is an 'effect' of the language system.

An implication of this reversal of categories is that what humanists call 'individual identity' is no longer something there, waiting to be uncovered; but a cultural product produced by a man-made symbolic order — language itself. (In this, Lacanians anticipate the more extreme formulations of Louis Althusser, who thought that individual identity of any kind was a bourgeois myth — and that agency, the capacity for free intentional action, was an illusion.)

Giles Deleuze and Felix Guattari, in their vast and extremely controversial *Anti-Oedipus*, claim a reversal of that traditional psychoanalytic practice which traces all disturbances of the psycho-system to Oedipal conflicts stemming from the family group. They claim the primacy of a contrary process of 'schizo-analysis' — Guattari's term — which is a process of 'undoing' the neuroses from their base in the Oedipal triangle of father, mother and child; potentially redistributing desire and relationships of desire over a wide and perhaps even random social field. They want to free the individual, through an *exaggeration* of his schizoid tendencies, from exclusive enmeshment in the capitalist family structure, establishing heterogeneous, mobile relationships of an explicitly political nature in which the unconscious can act as a fund of new thoughts, new desires, new networks of social organisation and radical change. The delirium of displacement from existing norms and identities, the euphoria of weightless unattachment from permanent familial relationships and origins — these 'feelings of madness' are in fact the first signs of a revolutionary dispersal of psychic energies across the social field as a whole.[20]

The effect of Lacanian writings on the entire atmosphere of post-modern cultural theory has been considerable. A new emphasis on 'Difference' rather than unity is being sought in all branches of culture and cultural production: heterogeneity rather than unitary meaning, inversion of the anthropocentric assumptions of humanist modernism, and a 'subjection' (in Lacan's phrase) to the order of

language as the primary Reality. Lacan's emphasis on the patriarchal significations of existing cultural terms and the constructed (i.e. cultural) nature of gender differences have particular implications for feminist art. Feminists have to disengage themselves from the male-dominated languages of artistic practice as they presently exist, and re-situate themselves in a heterogeneous, discontinuous, anti-humanist discourse where representation can, they claim, be re-made. Equating language with the male symbolic order, and the male symbolic order with artistic modernism, women artists must contest the imperatives of modernism and find for themselves a different artistic language in which feminist consciousness can be made to reside. Feminist art above all is post-modern, according to this argument, to the degree that it colonises alternative spaces for theory and artistic practice.

It would be convenient for artists of many persuasions if these theories of 'post-modern' thinking could be accepted uncontroversially as somehow encapsulating the concepts whereby modernism could be quickly 'overcome' — supplanted without demur by new methods of knowing, being and feeling which had their origins solely in the theoretical field.

But no such easy convenience is to hand. For, arguably, a major weakness of the Lacanian position — both in psychoanalysis and in art — results from its inversion of the humanist theory of the relation between language and the world. Language, Saussure implied, was itself a system of differences, one in which meaning was generated not by the relations between signs and the world, but by the relations of signs with each other.† Lacan, in following Saussure here, implies that the real world itself and all its erstwhile inhabitants are but mere epiphenomena of language — what Lacan and his followers call 'the signifying chain'. Thus the Lacanian system abdicates any interest in the individual as a complex and even contradictory system of desires; seeking to reify the language system itself as somehow the location of consciousness, desire and belief. An individual subject does not speak the language, according to Lacan; *it* speaks *him*. The artist, accordingly, has no identity of his own; but assumes his 'identity' according to what the available artistic languages permit to be said.

Now the thesis that linguistic meaning resides purely in the play of differences between phonemes and morphemes in the spoken utterance has never found favour with those who view language as a human creation, dependent for its sense-making capacities on concepts like 'intend' and 'accept' — concepts which refer sense-making to the human subject. Indeed it is difficult to see how such

terms can be avoided in any plausible attempt to work out how people mean what they do. But an even greater weakness in Lacan's post-modernist position is the analysis it offers for the emotions themselves, particularly desire. For can it seriously be doubted that feelings, of both an inward and an outward nature, form a legitimate part not merely of art but also of human life as a whole? But Lacan

† F. de Saussure, *Cours de Linguistique generale*, Paris 1916; first English edition, New York 1959. A parallel formulation can be noticed in several other fields which bear a striking — though not I think ultimately trustworthy — resemblance to the category of recent post-modernism that is at issue here. Before and during the First World War Arnold Schoenberg had been a foremost 'expressionist' composer, closely identified during his pre-war years with Kandinsky and his theories of dissonance and 'contrast'. Here, as Kandinsky's enthusiastic report on Schoenberg's paintings tells us, Schoenberg was a 'true modernist' in our sense, insofar as his paintings 'let us see the complex of his soul under the imprint of his form . . . without an eye to the objective results, he seeks *only* to capture his subjective 'feeling', and for the purpose uses *only* whatever resources strike him as indispensable at that moment . . . In each of Schoenberg's pictures we recognise the artist's inner desire expressing itself in the appropriate form . . .'; cited in W. Reich, *Schoenberg: a critical biography*, London, 1971, p. 41. From 1917, however, Schoenberg began to work out the method of composing with twelve tones related only to each other, a method announced with the Suite for Piano, Op 25, of 1921 and constituting an apparently fundamental rejection of the imitative or referential systems of traditional harmony. Though in one sense a natural development of the early style of dissonance, the musicality of a twelve-tone composition resides not in what it describes but in the perceived relations of difference between the tones, all of them chromatically equivalent in importance. Similarly, Wittgenstein's early philosophy of language, published in the *Tractatus Logico-Philosophicus* of 1922, though written during the war, stands as the extreme example of a rationally-worked out philosophy of reference, in which atomic propositions refer to atomic facts and complex propositions to complex facts. After a long interval away from philosophy in the 1920s Wittgenstein's completely revised conceptions of the 1930s and 1940s, especially those of the *Philosophical Investigations*, 1945-9, published in English 1953, impelled him to say that language no longer referred to facts but consisted of 'games' in which the players manipulated the conventions for communicative purposes: 'Instead of producing something common to all that we call language, I am saying that these . . . (language-games) . . . have no one thing in common which makes us use the same word for all — but that they are *related* to one another in many different ways . . .' op. cit., para 65. This 'forms of life' philosophy permits multiplicity, eclecticism, diversity and even cultural heterogeneity. 'Don't ask for the meaning, ask for the use', Wittgenstein says elsewhere. And even these new paradigms have their ancestors. Schoenberg is delighted to find his technique presaged in Shakespeare — and Karl Kraus. (See his *Path to the New Music*, London, 1963, final chapter.) Wittgenstein finds his debts to Paul Ernst, Ludwig Boltzmann, Oswald Spengler — and Karl Kraus. The implications of this genealogy deserve pursuing further.

implies that just as individual identity is a result of the posi-
tion occupied by the subject in the signifying chain, then so
too is emotion and feeling. These emotions and feelings are
not 'inner' data which are then 'expressed' in language,
artistic or otherwise; but arise only insofar as pre-existent
language-expressions can be placed in a certain order in the
signifying chain. 'Even pain is a text', says one of Lacan's
followers here. 'The death or suffering of children comes to
us', the statement continues, not through the nervous
system of the body and not through the discomfiture of the
soul, but 'only through texts (through the images of
network news, for example). The crisis of the modernist
absolute comes not from the juxtaposition of modernist
works with non-figurative experiences of pain or suffering,
but from their relativisation by one another.'[21]

The reduction of pain *to a text*? The anti-humanist
implications of French structuralist and post-structuralist
thinking are nowhere more evident than in the conclusions
to which it can logically be pushed; and which are inscribed
within the writings of the theorists themselves. In post-
modernism, 'a particular kind of phenomenological or emo-
tional reaction to the world disappears', says Jameson in a
recent statement. The major psychological difference
between the modern and the post-modern 'is the change-
over from anxiety — the dominant feeling of intensity in
modernism — to a different system of which schizophrenic
or drug language gives the key notion. I am referring to
what the French have started to call *intensities* of highs and
lows. These have nothing to do with 'feelings' that offer
clues to meaning in the way. anxiety did.'[22] Along with
Althusser's theory (much claimed by post-modernists) that
individuals are not constitutive of the social process but
merely its 'supports' or 'effects', it becomes eventually
clear that French Freudianism provides an implausible
underpinning for 'new' directions in anti-modernist or post-
modernist art.†

It turns out, in fact, not only that post-modernism
seems confused about the 'modernism' it is supposed to
supplant, but that previous standards available though
humanist thought-patterns and beliefs may provide a surer
standpoint for analysing even those 'crises' or 'breaks'

† The problem seems to have set in with Saussure's strange
insistence that the signified as well as the signifier is to be viewed as
part of the sign. The implication is, to quote Baudrillard, that 'Reality
itself, entirely impregnated by an aesthetic which is inseparable from
its own structure, has been confused with its own image . . .'.
*Simulations*, trans. Paul Foss, Paul Patton and Philip Beitchman, New
York, 1983, p. 152.

within modernism that the post-modernists perceive.

The case of collage, for example, seems vitally important to the post-modern argument. Collage is already present in Rauschenberg, Johns, Hamilton and Dine in the post-war reaction against American expressionist — and hence modernist — art. Collage (together with 'collision') is the thirtieth of Jencks' categories in his summarisation of the post-modernist ethic in architecture, and is there contrasted with 'harmonious integration' in the broader field of design ideas; while 'hybrid expression' is counterposed against 'straightforwardness' in the larger field of stylistics.[23] In the field of visual art, it was precisely collage and other devices of anti-painting that first announced the idea of a break with modernism proper, according to post-modernism, as far back as 1912. Picasso in particular — by any standards a modernist of the pre-war generation — abandoned painting in 1912 to turn to an art of fragments, which Rosalind Krauss has called an indictment of the 'perceptual plenitude and unimpeachable self-presence' of modernism itself.[24] Poets such as Mallarmé, Lautréamont and even Joyce, insofar as they adopted a collage-like style as a method, have also been claimed as important progenitors of a post-modern sensibility.[25]

However, in presenting Picasso's collages of 1912 to 1913 as a 'break' with the modern, Krauss leaves unexplained why Picasso should have *returned* again to painting in 1914, in a manner which, though indebted to collage, was surely once again an art of perceptual plenitude and self-presence. A similar point could be made about Braque, whose renunciation of collage in 1914 was also followed by some sixty years of unquestionably modernist painting. (Equally, the *exclusion* of Duchamp from the modernist paradigm on the grounds of his departure from auratic painting in 1913 surely constitutes a reproach to surrealist painting in the 1920s and 1930s; since this too was opposed to the flat-surface art of 'expression', yet remains fundamental to the modernist project in its larger sense.)

Is collage a test case for post-modernism? If it is, then the following account might help us appreciate that it, too, can be theorised within the humanist psychology of 'expression' and the manipulation of materials — of 'regression in the service of the ego'. This is not the usual way with collage admittedly — and we must be prepared to abandon certain pre-conceptions here which traditional art history has supplied us in good measure.

The story actually begins in cubism. Some art historians have written as if little more was at issue in cubism — in the whole of cubism — than the elaborate working-out of a new way of making pictures flat, disjointed, sometimes

53

geometrical; with no other purpose *than* this flatness or disjointedness, this complex spatiality. The emotional, affective content of cubism has been presented, on the whole, as being virtually zero. (The stereotype of French 'intellectual rigour' versus Germanic 'expressiveness' has also played its part in this account). Picasso, however, as we know from his later work, was nothing if not an emotional painter, capable of an astonishing range of moods, styles and feelings. It might just have occurred to us before that his cubist period was unlikely to be an exception to this rule.

It is not difficult to show how unexceptional it in fact was. When Picasso began his series of aggressions on the female body — it starts with the portrait of Gertrude Stein in 1906, where the face is slightly separated from the head and shoulders — cubism as a category had not been heard of. Indeed for the whole of the 'cubist' phase we have very

Figure 12

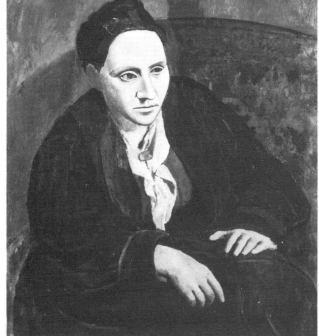

12. P. Picasso, *Portrait of Gertrude Stein, 1906*

little uncontested documentary evidence for what Picasso's conscious purposes were. But the visual evidence is compelling. In the early period of this aggressive, dislocated style — roughly from 1907 to 1910 — the female body is subjected to a range of violations which stand uneasily, to

54

put it mildly, with the seductive poses of several of the figures. Whatever meanings are to be assigned to individual figures in individual paintings (and the fatal dangers of venereal disease is but the latest in a long line of possibilities for the Demoiselles D'Avignon[26]) there is no escaping the fact that the angularisation of the torso represents more than just a sharpening of its literal form. Picasso appears to be endowing the female figure with persecutory attributes; or else is himself inflicting damage on the female form in retaliation, it would seem, for some real or imaginary pain caused to him.

Figure 13

A purely cultural reading of these figures (specifically a feminist one) receives these works as an example of 'the rock foundation of sexist anti-humanism — an attempted justification of the domination of women by men'[27] — at the very time, of course, when the Suffragette movement was making its first stirrings in the European countries, just as it was in Britain. One problem with such readings is that only a few such works have been analysed in such terms up until now — the Demoiselles is still the most frequently chosen case — and what feminists might have to say about the rest of cubism is so far left unsaid. But there is more in these works than meets the sociologist's eye alone. For one thing, there are immensely fragmented depictions of *nature* by Picasso from the same period which must be taken into account in our total interpretation of the work; suggesting an equivalence, indeed, between the terms 'Nature' and 'Female' in terms of the artist's approach to his subject. Secondly, the mother and child theme comes up not infrequently. But thirdly — and for our purposes crucially — the theme of the violated female body is taken up literally hundreds of times in the period of Picasso's work now under consideration. And almost certainly it yields an autobiographical pattern.

By 1910, for example, the aggressions perpetrated on the outside form of the female body give way to a superficially more abstract phase of work which can best be described by saying that the female body is now being rendered — and openly attacked — in terms of its insides. When Picasso returned to Paris from his trip to Cadaques in Catalonia in the autumn of 1910, with the canvases Kahnweiler described as having 'broken the closed form', little did his dealer realise that what had also occurred was a breakthrough in Picasso's work to a new level of affective feeling. Firstly, there is the opening-up of the closed form of the body. But then this *penetration* of the female body is followed, in 1911 and the beginning of 1912, by what are best called substitutions: in which the explicit form of the female body is all but abandoned in favour of other objects and

55

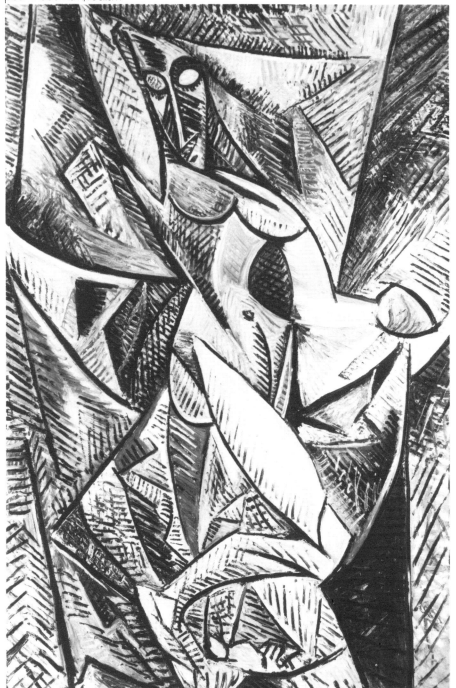

13. P. Picasso, *Nude with drapery, 1907*

qualities.

One fairly ubiquitous substitution for example, replaces the form of the head or the body with a violin, a guitar, or a mandolin. Of the several hundred images produced in the brief collage phase of early 1912 to mid 1913, there are many which rely upon an obvious analogy between the form of the guitar and that of the human head; in which the double-curve of the guitar becomes the cheek and forehead of a male head, echoing a similar double-curve in the ear,[28] or the features of a female head[29] which sometimes doubles as her wavy hair to the left or right;[30] in which the characteristic 'f' holes in the violin have become eyes and in which (in one case) the scroll of the violin becomes a curl of hair atop a singing face.[31] A variation on this theme makes the guitar mimic the form of the whole female body — either standing,[32] or recumbent,[33] or as an attribute.[34] In these, the double-curve of the musical instrument stands for the breasts or the buttocks, the sound hole for the stomach or the vagina, and the neck and scroll of the violin for the neck and head — sometimes embellished with a pair of keys which repeat the breasts in a manner which Picasso was to pick up again in his surrealist work. In fact it is extremely unusual for Picasso's papiers collés not to have *some* relation to the forms of the body. Even the well-known *Bottle of Suze*,[35] which contains no overt bodily descriptions, is constructed around a basic spine-like structure (sometimes called the armature of cubism) with a bodily mass at centre and internal organs within.

The concealment of the female body within the shapes and textures of the surface is nowhere more evident than in the well-known series of images which Picasso covertly dedicated to his mistress Eva Gouel. Picasso had met Eva at the Steins back in the autumn of 1911; but since his 'official' woman-friend was still Fernande Olivier, he had at that stage a good reason for keeping the dedications secret. The famous painting known as *Ma Jolie*, painted in the autumn of 1911 and now in New York,[36] is presumed to be the first covert reference to Eva in Picasso's work: the phrase 'ma jolie' is taken from a then popular song. The painting itself appears to contain a woman with a guitar (or possibly a zither), but both she and it are hidden in an impenetrable system of triangulations and indeed can hardly be seen at all. By the summer of the next year he was to begin to refer to Eva directly in his paintings; announcing to Kahnweiler by letter on June 12th, 1912 that 'I love her very much and I shall write her name on my pictures'. This he indeed does in the so-called *Violin: 'Jolie Eva'* of that summer[37] where a guitar lies horizontal with neck to the

Figure 14
Figure 15

Figure 16

Figure 17    Figure 18
Figure 19

Figure 20

57

14. P. Picasso, *Head of a Man, 1913*

15. P. Picasso, *Violin and Sheet of Music, 1912*

16. P. Picasso, *Violin and Sheet of Music, 1912*

17. P. Picasso, *Violin, 1912*

right; and in the better-known *Guitar 'J'aime Eva'* of the Figure 21
same period,[38] in which the curvaceous form of the guitar is
unmistakably female. Picasso wrote the words 'j'aime Eva'
on a gingerbread heart and stuck it on the picture below the
curves as a kind of pendant. Subsequently, in the main
phase of papier collé activity of the next year, the words
'Eva' and 'Ma Jolie' do not appear at all. However, the guitar
remains as a persistent theme, and explicit references to a
single woman are replaced by punning references to sex or
to the body. Well-known examples of this are the inclusion
of the letters JO or JOU, which pun not only on the French
*jouailler*, to play a musical instrument badly, but also on
*jouer*, to play, or *jouir*, to have an orgasm.

18. P. Picasso, *Musical
Score and Guitar, 1912*

It would be wrong to give the impression that all
Picasso's collage constructions contain references either to
his lovers, to woman in general, or to sex. They do not.
Indeed, even when these references can be teased out it is
their very inscrutability which is both striking and at the
same time perlexing to the viewer. Furthermore the
inscrutability of Picasso's method — the success of his con-
cealments — comes in degrees. Sometimes a sexual refer-
ence is virtually explicit, as in the *Man with a Violin* of
autumn of 1912,[39] which presents the violin in place of the Figure 22
genitals, with the double-curve as testicles; or the *Still-Life
au Bon Marché* of early 1913[40] in which the reference is to
sex purchased for money: a newspaper clipping at lower
centres says 'trou ici' ('hole here'), while a female figure
appears at the top with an underwear advertisement in
between. The words 'Facilités de paiement 20 mois' and
'massage' provide a heading above. In other cases, how-
ever, the submerged theme is all but invisible. An example
is the *Guitar* of spring 1913,[41] which suggests a couple

59

19. P. Picasso, *Woman with a Guitar*

20. P. Picasso, *Bottle of Suze, 1912*

21. P. Picasso, *Guitar, 'J'Aime Eva', 1912*

22. P. Picasso, *Man With a Violin, 1913*

locked together in lovemaking, but with irony added in the form of an advertisement for a 'Dr Casasas, specialist in genital complaints' which appears on the penetrating male member at lower left. Many another papier collé work contains a hint of a figure or two figures in half-formed images of erection or recumbency, replete with bodily organs both internally and externally displayed.

But what do such substitutions mean? Historians have tended to give them a place within a system of humorous puns that may have been typical of the studio manners of the artists themselves: their conversations, their jokes. This is all well and good, up to a point. But psychoanalytic thinking has a different proposal to make which goes further towards defining the nature of Picasso's own cubism in terms which make *human* as opposed to merely sociological sense and which also throws light on how one type of surrealism began.

Some years ago the neo-Freudian Marion Milner wrote a paper on symbol-formation in which she proposed, I think convincingly, that such substitutions in mental life can either reflect an experience of fusion between the two things concerned, as in pre-logical or 'primitive' thinking; or that (what is surely more likely here) they bring two dissimilar things together in order that one of them might be concealed lest it stimulate emotions which the artist wishes to hide.[42] According to a speculation of Melanie Klein, the identification of one thing with another is 'the foundation of all sublimation and every talent, since it is by way of symbolic equation that things, activities and interests become the subject of libidinal fantasies'.[43] It is a further remark by Mrs Klein, however, that throws such a strong light on the characteristic symbolisms of Picasso's collage phase. She says that the mechanisms of identification are set in motion by anxiety arising in the highly sadistic pre-genital phase, the phase in which the child attempts 'to possess himself of the contents of the mother's body and to destroy her by means of every weapon which sadism can command'. The child conceives a dread of these organs lest they retaliate with equal ferocity, and the resultant anxiety makes him 'equate the organs in question with other things; owing to this equation, these in turn become objects of anxiety, and so he is impelled constantly to make other and new equations . . .'[44]

Picasso himself was perfectly aware that these remarkable symbolisations went far beyond the significance of the studio joke — the in-humour of 'La bande Picasso'. He said to Françoise Gilot many years after the event that 'the sheet of newspaper was . . . never used literally but always as an element displaced from its habitual

Figure 23

61

23. P. Picasso, *Woman in a Chemise, Seated in an Armchair, 1913*

meaning into another meaning, to produce a shock between
the usual definition at the point of departure and its new
definition at the point of arrival . . . This displaced object
has entered a universe for which it was not made and where
it retains, in a measure, its strangeness'.[45] The symbolis-
ations were always more important than the materials by
which they were carried. In fact Picasso soon abandoned
collage as a method and continued his symbolisation sys-
tem within the language of painting — texturised and
immeasurably enriched, perhaps, but still painting.

The National Gallery picture *Bowl of Fruit, Violin and
Bottle* of autumn 1914[46] presents itself superficially as a     Figure 24
table with legs, loaded with a musical instrument, a news-
paper fragment, a bottle, and a compote carrying grapes —
but I doubt whether anyone will fail to see in this picture a
well-articulated human presence complete with head, legs
and torso: not an overt description of torso, arms and legs,
but a visceral interpretation in which the body is rendered,
once again, in terms of its insides. And it is surely these
human analogies which lend such presence to later post-
collage paintings such as the majestic Columbus *Still-Life* of
the winter of 1914-15, the *Guitar, Clarinet and Bottle on a*     Figure 25
*Pedestal Table* of 1916, now in Basle, or the *Guitar and Sheet-
music on a Mantelpiece*, also of 1916, in St. Louis. These
were among the paintings later admired by the surrealists,
when they claimed Picasso (together with de Chirico) as
founding fathers of their experiment. These paintings fas-
cinated the surrealists because they 'juxtaposed' elements
in a psychically disturbing way. Their 'substitution' method
was partly given birth in the collage period by Picasso, in
the course of which he pushed to its limits a series of des-
tructive fantasies about the body of the mother, about an
almost ageless conflict between 'good' and 'bad' exper-
ience. The point is that for Picasso if not for other cubists
who depended to a large extent upon the fragmentation
style, cubism was an *affective* rather than a formal method,
proving capable of articulating his conflicts in a visually
quite novel form: and that his stature as an important artist
can be attributed, here as elsewhere, to his ability to reach
back to infantile modes of thinking in a compelling and
authentic way.

If I dwell deliberately on the example of collage I do so
only to demonstrate that the humanist (and also modernist)
narrative of objects and instincts, developed primarily
within British neo-Freudian psychology, can explain even
those activities that post-modernism regards as definitive.
What Krauss calls the 'perceptual plenitude' and 'unim-
peachable self-presence' of modernism proper is still pres-
ent in the case of collage with the benefit of a slight shift of

63

focus — from the surface of the work and its myriad forms (essentially the same object of analysis as in the old formalist methodology) to a centering of interest on the artist and his engagement with the work. And Picasso's own interest in the forms and processes of his world — those he described to Françoise Gilot on another occasion as 'not exactly reassuring' — are as relevant to our understanding of the 'pasted-paper revolution' as the subjective uses to which his new methods were put. The artist's human interests, in short, are more crucial to our reception of the works than their part in some imagined art-historical dynamic of modern versus counter-modern style.

24. P. Picasso, *Fruit Dish, Bottle and Violin, 1914*

I might also mention the fact that Rauschenberg and Johns' collage style, which Steinberg defined as Postmodern on the grounds of its attack on an earlier American definition of modernism, was described by Steinberg as 'a conception which guarantees that the presentation will not be directly that of a worldspace, and that it will nevertheless admit any experience as the matter of representation. And it readmits the artist in the fullness of his human interests . . .'[47] Rauschenberg's flatbed picture plane, writes

25. P. Picasso, *Still Life with Compote and Glass, 1914-15*

Steinberg, was a 'surface to which anything reachable-thinkable would adhere. It had to be whatever a billboard or dashboard is, and everything a projection screen is, with further affinity for anything that is flat and worked over — palimpsest, concealed plate, printers' proof, trial blank, chart, map, aerial view . . . It seems at times that Rauschenberg's work surface stood for the mind itself — dump, reservoir, switching centre, abundant with concrete references freely associated as in an internal monologue — the outward symbol of the mind as a running transformer of the external world, constantly ingesting incoming un-processed data to be mapped in an overcharged field . . . Rauschenberg's picture plane is for the consciousness immersed in the brain of the city'.[48] Steinberg's densely-packed prose here identifies post-war collage not as some-thing somehow knocked sideways by a theory of the missing subject, but as precisely the record of a subject faced with unmanageable information from an *external world* which lacks a coherent form or centre. It is the world that is de-centred in this post-modernism, not the subject itself.

It is important to realise, of course, that the present

65

atmosphere of confusion about the values of modernism will not be dispelled by theory alone, on either side. The fact that artists are now joined together in a crisis of confidence about the project of artistic modernity may be a sound enough reason for accepting that values are being gradually revised. And as a sign of the vitality of our culture, this fact is not to be sneered at. But theory also plays its part; and the problems here are significant.

At its most general, the severest fault in the idea of a post-modern culture which is at the same time anti-modern, lies in its theory of the artistic subject as a somehow 'de-centred' being who is less concerned with 'expression' and the 'inner life' than with the fragments of his culture (both past and present) and their absolute unrelatedness. Classical humanist psychoanalysis with its assumption of the centred Oedipalised self 'never gets beyond its home territory of familiarism and capitalism', writes Guattari,[49] identifying without demur the biology of the family and the social order of capitalism. The dispersed personality who can redistribute his libidinal energies beyond the family or the one-to-one transference relationship provides a revolutionary alternative to the monadic feeling agent of the pre-capitalist world. Judge Schreber's delirium which Freud 'reduced' to a parental theme was in fact 'so rich, so differentiated' as to carry an 'enormous political, social and historical content'[50] as a sign of radical libidinal adjustment on a personal level. These portentious formulations of Guattari's new psychiatry seem to auger an entirely new world, one of detachment from biology and the family, one of celebration of the delirious or euphoric state, and one of radical mobility across any and every relationship and role. His schizoanalysis requires us to recognise the constitution of the person not in a false unitary 'I', but in a multiplicity of 'desiring-machines' which originate socially and which can work independently, utterly detached from the capitalist family. The schizophrenic has superior knowledge of the reality of fragmentation which is everywhere in each of us. His example can return us to the facts and processes of micro-desire whose origins are always ultimately political.

But can it be merely an illusion, somehow induced by ideology, that consciousness appears relatively stable, unified and connected with the pattern of biological growth from birth through youth and middle age to death? Can it be merely an illusion that people have character dispositions, temperaments, proclivities and preferences which are theirs uniquely, accountable perhaps to the gene-pool rather than to the patriarchy and its shifting values? Can it be merely an illusion that people can and do feel, act and

speak about the world from a basis in a centred consciousness which is also experienced as real? Is it some sort of mirage that we have vivid evidence for the essential painfulness of pain?† And how, we might ask finally, does this 'de-centred' person become aware of his de-centredness without being precisely a consciousness capable of unitary reflection? The prospect of totally altered conditions for the identity and difference of persons, though nowhere spelt out clearly in the 'new' psychiatry, is the daunting and self-contradictory prospect to which we are drawn.

† It is here, particularly, that post-modernism takes alarming liberties with the evidence, on occasion. In the course of arguing that schizophrenia consists (like post-modern art and writing) in a 'breakdown of the signifying chain', Jameson quotes from the autobiography of a schizophrenic girl where she describes her first experience of unreality. Jameson says that the girl's account, although 'here described in the negative terms of anxiety and loss of reality . . . one could just as well imagine in the positive terms of euphoria, the high, the intoxicatory or hallucinogenic intensity' (*Cultural Logic of Late Capitalism*, loc. cit., p. 73). To establish his point about 'euphoria' Jameson quotes from the first paragraph of the opening page of *Autobiography of a Schizophrenic Girl*, with interpretation by Marguerite Sechehaye, New York, 1951. But had he referred to the later parts of Renée's account he would have found terrifying descriptions of her unreality states which could in no account be rescheduled merely as 'euphoria'. For example, 'People turn wierdly about, they make gestures, movements without sense: they are phantoms whirling on an infinite plane, crushed by the pitiless electric light. A wall of brass separates me from everybody and everything. In the midst of desolation, in indescribable distress, in absolute solitude, I am terrifyingly alone . . .' (p. 33). Or: 'I saw things, smooth as metal, so cut off, so detached from each other, so illuminated and tense that they filled me with terror. When, for example, I looked at a chair or a jug, I thought not of their use or function . . . but as having to lose their names, their functions and meanings; they became 'things' and began to take on life, to exist. This existence accounted for my great fear . . .' (p. 40). Inner voices and intense anguish accompany Renée's experiences of dislocation; together with, at various times, guilt, lethargy and helplessness. As she puts it at one point: 'a devastating tempest ravaged my soul' (p. 78) Deleuze and Guattari, for their part, attempt a distinction 'between the schizo procedure and the schizophrenic in the bin whose schizo procedure is either brought to a stop or left spinning in a vacuum. We did not say that revolutionaries should identify with mad people spinning round aimlessly, but that they should carry out their undertakings along the lines of the schizo process. The schizophrenic is a person who, for one reason or another, has become caught up in a flux of desire that threatens the social order, if only at the level of his immediate neighbourhood . . . It is the libidinal energy in the process of de-territorialisation that we are interested in here, not the stopping of the process.' (Guattari, *Molecular Revolution and Class Struggle*. loc. cit. p. 260) One notes here also the removal of this new narrative of 'flux of desire' from all contact with the older humanist account involving pleasure and pain. The schizo-process is likewise carefully interpreted from the *outside*, as a depthless 'phenomenon' of social dimensions alone.

In practice of course the situation is more complex than one that opposes a wholly de-centred subject to a wholly unified one. Some 'forgetting' of the metaphysical interiority of the bourgeois humanist subject may be necessary in certain social conditions in order to promote the activities of self-less revolutionary struggle. Mobile, free-floating functional agency appears precisely to be the character-type associated with Maoist or Situational — for example — revolutionary action. But, as Terry Eagleton has pointed out, this metaphor of the drastically emptied subject is at the same time too close to characterising what he calls the 'faceless functionaries of advanced capitalism' to be uncritically endorsed.[51]

Equally, post-modernism's de-centred subject constitutes not so much a practical critique of a historically outmoded sense of Being, as precisely the crisis condition into which late capitalism collapsed it — a 'dispersed, de-centred network of libidinal attachments, emptied of ethical substance and psychical interiority, the ephemeral function of this or that act of consumption, media experience, sexual relationship, trend or fashion'.[52] And within this conjuncture, doesn't the continued struggle for ethical, political and juridical coherence amount to a positively radical stand?

In practice, we may continue to live to some degree at the intersection of those two modes, pulled towards responsibility and coherent patterns of choice by our roles as parents, educators, and members of the electorate; while at the same time pulled antithetically towards dispersal, emptiness, inattention and unreality by our roles as consumers of absurd varieties of goods. At this intersection, modernism represents a continued search for depth, for interiority and for meaning; and is itself likely to prove unattractive to the blandishments of post-modern theory.

Modernism's continued striving for truth in a progressively fractured world may be a problematic, as well as a threatened programme. It may have rushed too rapidly from its earlier heroic attempts to represent contemporary life 'through a temperament' — to echo Zola — to embrace a headlong experimentalism that welcomed any and every private language for art. Its course since 1905 — or 1865 — may have become skewed, directionless, or overly pluralistic (it was pluralistic even by 1890). But the post-modernist abandonment of this still valuable search for inner meaning is on the whole an even worse alternative, one that consorts always too readily with the 'dispersal' effects of late capitalist culture.

68 In the next chapter I shall want to explore how the

final fate of modernity will have to be gauged by its recon-
nectedness with wider world processes in science, tech-
nology and morality — not just on the basis of debates
within the limited sphere of art.

One of these wider changes is 'late capitalism' — the
phrase belongs to Ernest Mandel — which is characterised
by the arrival in the post-war years of four new types of
automation which extend and enlarge capitalism into its
third and most developed phase. Citing a previous analysis
by Julius Rezler, Mandel specifies these processes as auto-
matic control, computer-controlled processes, measure-
ment devices, and data-handling systems; all of which he
says have 'opened up . . . the field of accelerated tech-
nological innovation and the hunt for technological surplus-
profits which characterises late capitalism'.[53] Late capital-
ism, according to post-modernist theory, bears a 'family
resemblance' to the idea of a radical break in culture in the
period immediately after the Second World War.[54] Rapid
information-handling and computerisation generally have
in some sense rendered obsolete the older humanist world
in which modernist art was entrenched. Jameson says that
post-modern culture is 'the internal and superstructural
expression of a whole new wave of American military and
economic domination throughout the world'.[55]

Refusing to the very last to be drawn on the moral or
cultural value of this 'superstructural expression', this
'family of resemblances' between art and the technological
field, Jameson says finally that we should attempt to view
the general situation of late capitalism dialectically: under-
standing post-modernist art-works as 'peculiar new forms
of realism . . . at the same time that they can equally be
analysed as so many attempts to distract and divert us from
that reality or to disguise its contradictions and resolve
them in the guise of various formal mystifications.'[56] We are
asked to think late capitalism itself both 'positively and
negatively at once: to achieve, in other words, a type of
thinking that would be capable of grasping the demon-
strably baleful features of capitalism along with its
extraordinary and liberating dynamism simultaneously,
within a single thought . . .'[57] This same late capitalism,
Jameson says, is itself a post-modern 'space' which pre-
sents certain liberating possibilities at the price of having
colonised formerly untouched enclaves such as Nature (the
Third World) and the Unconscious (the irrational mind).

Our objections to this programme arise partly from
its abstract nature; partly from its suggestion of a more or
less equal balance between the 'liberating' effects of late
capitalist production and its negative consequences; but
principally to its assumption that post-modern art-works

'express' or 'reflect' at a superstructural level the changes that are taking place at the economic base. Perhaps in some sense they do. But that may be their greatest shortcoming — if it means that increasing alienation, specialisation, de-humanisation and banality are also being sucked up into the art-work and enshrined there under the label of an important 'new' sensibility.

In any case, if modernism is to be moulded to our future purposes — if it is to be used constructively in the postulation of a socially useful art — it will also have to be analysed socially, in terms of the institution and personnel that support it and continue to determine its path. A truly post-modern critique must depend not upon theory — or not too much of it — but upon an examination of how modernism has flourished empirically, in the world.

We shall need to explain why — and how — such an art form could have been held in place socially in the period since around 1890; and how modernism became gradually elevated to the status of 'official' culture in the Western world in the period after the First World War. We shall need to see how patterns in the education and training of artists encouraged the growth of modernism in most Western countries in the age of mass communications. We shall need to see how the invention of the modern art museum favoured the elevation of modernist subjectivity to the disadvantage or exclusion of most other artistic forms. And we shall need to see how narrow the appeal of this artist-centred art in social and demographic terms truly was. For, in truth, only a minority and predominantly male audience has proved capable of receiving this art as its own. And we shall see in this examination that 'post-modernism', if it means anything, is not a new epistemic condition but a further and perplexing form of modernism itself.

# MODERNISATION AND SPECIALISATION

In order to reconnect the processes of modern art to the wider society in which they have existed, we need to remind ourselves of some simple but important facts. One such fact is that modernity itself — the impulse to renewal and improvement, has been characteristic of the whole of western society for at least two centuries — and may derive ultimately, if we are to believe the historian John Roberts, from the redemptive and utopian impulses of Christianity itself, the religion of the West.[1] In design and art, however, modernity in this sense was not always visible. The celebrated French historian Fernand Braudel tells us that until about 1100 in Europe, fashions had remained unchanged since the end of the Roman empire — that is, for some seven hundred years. The habit of long tunics for women and knee-length garments for men only began to change noticeably in about 1150, Braudel says, when men's tunics became longer, and then in about 1350, when they suddenly became shorter and immodest — as did the closer-fitting bodices for women. The mandarins of ancient China wore the same simple cotton clothes for close on a millenium. In India, Japan, and in changeless peasant societies, the drive towards modernisation was (and still is) entirely lacking below a certain threshold of wealth.[2]

The craze for fashion — that is, the constant modernisation of dress — was well established in Europe by 1700 by which date, Braudel says, fashion was 'all-powerful'.[3] In fact Braudel himself falls prey to utopian-

modernist thinking when he says that fashion pointed to the
'energies, possibilities, demands and joie de vivre of a given
society, economy or civilisation . . .', or that 'the future was
to belong (sic) to those societies fickle enough to care about
changing the colours, materials and shapes of costume, as
well as the social order and the map of the world —
societies, that is, which were ready to break with their tra-
ditions'.[4] The point, however, is not to congratulate the
prosperous nations of the developed world for their *joie de
vivre* and their willingness to break with the past, but to
comprehend the full implications of the modernisation pro-
cess in its distinct and separate spheres.

The analysis developed by Jurgen Habermas follows
Max Weber in separating cultural modernity into the three
separate spheres of science, morality and art. When the
unified world-system of religion and metaphysics began to
fall apart in the eighteenth century — the same date as the
establishment of the fashion craze — the problems in-
herited from these older world-views, writes Habermas,
'could be rearranged so as to fall under specific aspects of
validity: truth, normative rightness, authenticity and
beauty'. In turn, he says, each domain of culture could be
institutionalised: 'each domain of culture could be made to
correspond to cultural professions, in which problems
could be dealt with as the concern of special experts . . .
there appear the structures of cognitive-instrumental,
moral-practical, and of aesthetic-expressive rationality,
each of these under the control of specialists who seem
more adept at being logical in these particular ways than
other people.'[5] Indeed these three spheres comprise the
cultural and social revolution we know as the Enlighten-
ment. Each project intended, when their particular prob-
lems were 'solved', to abandon their esoteric and special-
ised forms and utilise their particular gains for the enrich-
ment of everyday life. Condorcet, for example, was con-
vinced that the progress of the arts and sciences would lead
not only to the control of natural forces, but also to under-
standing of the self, to moral progress, to justice and to
happiness for all mankind.

The point to be noted at present is not that modernis-
ation does not lead to happiness and self-fulfillment auto-
matically or without contradictory effects — that much is
obvious; but that the dream of eventual de-specialisation
has not and is not coming about.

A secondary problem is that the specialisation of art
which accompanied the birth of modernism (and which per-
sists, ramified, in post-modernism) is not of the same kind
as accompanies the other over-specialised fields. Indeed an
important observation on Habermas's system of the 'three

spheres' is that they are by no means identical. The tradition of art, as its occasional avant-garde movements have shown, is at least capable of self-criticism in the form of anti-art initiatives which attempt to summarise a tradition or bring it to an end — to dissolve art altogether in the wider stream of life.[6] But such avant-gardist activities are not *applications* of modernism — only attempts to show the pretentiousness of modernism's solutions.

A second observation is that the separation and expertisation of different value-fields is now far greater than Weber's three monolithic areas. Virtually every hobby now has its own quasi-professional structure which organises its activity — what used in Weber's time to be a simple recreational pastime — into something approaching a world-view. We no longer have the world of science, the world of art and the world of morality-cum-jurisprudence by themselves; but distinct and different 'optics' corresponding to everything from journalism to greyhound racing, farming to snooker, butchery, ballet, banking and bee-keeping, hairdressing, horticulture — the list is endless. Membership organisations, conferences, magazines, achievement-ratings, 'personalities', events, investments and marketing strategies now dominate each of these sub-spheres to a degree unimaginable in Weber's day, or even fifteen years ago, in Habermas's. Separation and expertisation have become the norm here too, apparently according to models provided by the larger value-fields of art, science and morality. Moreover, these sub-specialisations are now attracting individual commitment far beyond the old norms applicable to a trade or profession. A single symptom of this growth pattern is the number of educational facilities which now dispense and improve the available knowledge in any field. The distinction between a job and a recreational pursuit is now so blurred that almost any pastime can discover its own super-structure of officers, officials, organisations and specialists. Art, science and morality may remain as the three largest or dominant groupings of expertise and world-view, but these categories themselves now threaten to dissolve in an even larger pattern of fragmentation and expansion.

It may be argued that this diversification would not matter, provided it led to new groupings of interest and communication, new patterns of social pleasure in which greater numbers could take part. But expertisation causes distancing from the texture of everyday life, and also from other experts. The global phenomenon of specialisation in more and more sub-fields of culture is producing less and less interface with the 'life-world' from which they once originated. The 'life-world' becomes increasingly evacu-

ated and impoverished as specialisation proceeds.

In art especially, the phenomenon of expertisation which accompanies the process of modernisation is not stable, as Habermas implies, but is itself proving subject to exponential growth and complication. It is a commonplace that the public museum for art did not exist before 1750, and that it attempted to play a decisive functional role in alerting its public to the glorious achievements of the national State, to the point of identifying the State with the progress of civilisation itself. The Louvre in Paris, to take only the best known example of this type of specialised artistic display, was organised precisely to ceremonialise the experience of art and to endow it with values that had been the preserve of royalty or the church; subservience, excessive spirituality, and historical inevitability.[7] The profession of art history, too, was born in this moment of specialisation, as a body of expertise devoted to ordering, chronicling, arranging and rationalising the experience of art.[8]

The modern art museum is the successor to the great state museums of the nineteenth century and the latest testament to the specialisation of art culture. It too marches hand in hand with art history in arranging the 'story' of art as a coherent cultural experience. Its white box-like spaces intensify the experience of individual works as things set apart from life in a sphere of their own, as icons which celebrate the subjectivity of the modern picture and intensify the exclusion of realist or referential forms.   Figure 26

26. Saatchi Museum,
*London, 1986*

One might mention too the nature of the art-works themselves — those that have become absorbed by museum culture and organised into art history. Very early modernist works were easel-sized paintings on a domestic scale, easily transportable and easily made delectable as

decorations on a living-room wall. Even in 1905 most modernist art-works were conveniently scaled — though one thinks of exceptions like Seurat's *Grande Jatte* and Picasso's *Demoiselles* that take on an epic size as part of their challenge to the conventions of the large Academic commission or competition-piece. Indeed Academic painting, as well as royal and aristocratic commissions, had always been large in scale, reflecting the over-size architecture of the museum or royal palace. With the development of modernism in the twentieth century, however, paintings increasingly assumed the proportions demanded of them, not by the royal palace, but by the cavernous spaces of the modern art museum. Surrealism — true to its revolutionary nature — was domestic in scale. Post-war American painting and sculpture suddenly increased in scale to become an impossible hybrid of an easel picture for a spacious apartment, *and* a mural painting at the same time. Either way, its destination was the museum. Most contemporary art works have no other habitat *than* the museum — either the public art museum or the privately assembled collection.

Thus an absolute distinction is now in place between the museum picture, with all that this implies, and the domestic-sized production which could be consumed and admired at home. The absoluteness of this distinction is everywhere apparent: the art school and the museum are on one side; the amateur art club and the living room wall are on the other — only the first belongs to modernism, and partakes in its wealth and prestige. The second knows no fame and, given its demoralised and largely sentimental nature, perhaps deserves none.† But even its professional exponents such as Edward Seago and David Shepherd have become excluded from the official account of the artistic life of the nation — that which revolves around the specialised categories of modernism and the museum.

Statistically too the growth of modernism in art has been rapid and remarkable. Artists particularly have been subject to steadily increasing numbers. At the height of the academic tradition in mid-nineteenth century France, it has been estimated that perhaps 2,000 artists practised either in Paris or in the provincial orbits of the capital.[9] On the assumption of ten paintings per year, the total production for a complete decade would be 200,000 works of art — a

†     I myself happen to paint pictures of the domestic sort, which I and a small number of other people (I stress the small number) regard as 'good' paintings. Yet this 'good' and the 'good' ascribed to the latest museum purchases have little, if anything in common — a fact which surely acts to the disadvantage of both categories.

glut in search of a market that did not at that time exist. The survey that supplies these figures tells us that the cause of the decline of the French academic system was not the large percentage of rejections from official competitions, nor the physical problem of handling so many paintings, but 'the attenuation of both negative control and positive reward when these were spread over thousands of professional painters'.[10] Beyond the scanty official rewards, there was no systematic provision within the informal sponsor-protégé system of the earlier Academy to satisfy the career aspirations (let alone the economic and social needs) of three thousand painters. New experts in the guise of dealers and journalist-critics arrived to fill the communicational gaps in the system, supported by a Romantic-inspired counter-ideology of the unrecognised genius artist. The dealer could organise a market and attract foreign buyers, and the journalist-critic could represent favourable or unfavourable verdicts to a wider reading public. It was into this framework that an avant-garde Impressionist sub-group was to fit, and it was on the basis of this new dealer-critic institution that a new generation of 'modern' art practices was born.

It appears that, despite an appropriate statistical expansion, the major part of this structure of artist-critic-dealer has continued until the present day. The relations of artistic production, critical adjudication and dealer market-ing are still among the major driving forces of modernist and modernist-inspired art. Numerical increases here too, however, have caused their own structural changes to the absolute dominance of this basically triangular arrange-ment. The export of modern art from France to the rest of the world, followed by the cultivation of indigenous modernisms in the various developed countries, has been a gradually expanding pattern throughout the course of the present century, the period during which modernism became established as 'official' culture. The United States had little indigenous modernism before 1940 — a fact bemoaned by American intellectuals of the pre-war period. Even after 1940 in America there existed a mere handful of galleries catering to the new art of abstract expressionism, and perhaps only a score of artists who could be counted as regular exhibitors within them. (Indeed this was one of several demographic and economic factors that helped a single homogeneous avant-garde achieve recognition). But New York today has some 680 galleries; with some 150,000 artists who can claim to be working on a non-amateur basis, as possible candidates for a contract or a show; and by all accounts the number is expanding fast.[11] The number of galleries showing contemporary art in the

77

United States as a whole is well over 2,000, and the number of artists with solo shows in 1986 — the last year for which statistics are available — was just over 15,500.[12] On the basis of the Whites' estimate of ten art-works per year, this means a total of no less than 15 million art-works per decade from New York alone. It must be assumed that the artists working in quasi-metropolitan centres such as Los Angeles, Chicago, Denver and Boston would swell the number of art-works produced in a decade to a figure in the region of 25 million works.

Or take some figures from the educational statistics in the United Kingdom. Here, some 2,000 artists are trained each year in colleges and universities — the number for allied professions such as design, graphics and photography is some three times larger — of which perhaps half continue to practice artistically, according to the criterion of part-time involvement in the production of art. (This involvement is itself made possible by the availability of teaching posts within the education system.) Counting a generation as twenty-five years, this results in 25,000 artists producing perhaps two and a half million art-works within a single decade. But this is only the tip of a veritable iceberg of other personnel. The number of professionals that now organises, manages, curates, custodianises, edits, and pre-selects the activities that are to be pursued by practitioners — painters and sculptors — is now also at record levels. 'Arts management' is now no longer in the hands of artists, but subject to the manipulation and control of a relatively autonomous cadre of bureaucrats whose primary job is to allocate state funds in support of shows, projects or individual works of art.

Here is where reputations are made or lost; where ideas are successful or fade. And, since no single official can claim to know the contemporary work of a thousand artists (let alone ten thousand), much depends in the formation of bureaucratic opinion upon other factors such as friendship, influence and sheer novelty — as well as taste. What is remarkable about these custodians — the New Class, as Bakunin once called them[13] — is that in common with other experts they are accountable to no constituency of opinion other than their own.† And taste, as someone once said, is all but impossible to explain.

The art which emerges from this system of jurisdiction is, as we shall see, characterised primarily by quali-

---

† These people are called 'the cultural management class' by John House and Fred Orton in their respective essays on the Renoir exhibition of early 1985, in *Oxford Art Journal*, Vol. 8, No. 2, 1985, pp. 21 and 30 respectively.

ties it does *not* possess. Glossy, eccentric, amusing, sometimes incomprehensible — most of what entertains the taste of the New Class lacks any point of contact with any recognisable interest-group or population segment, except that of the New Class itself. The explosion in art activity in New York's East Village is only the latest and most notorious example of this trend. Literally hundreds of new galleries opened in the space of a handful of years in the formerly run-down district inhabited by addicts and drunks. Absurdly named galleries like New Math, Piezo Electric and Civilian Warfare progressed in the space of months from being hand-to-mouth adventures conducted by cynical young entrepreneurs 'having fun', to being serious multi-dollar businesses conducted by equally cynical art glitterati with an eye to quick — and essentially glamorous — profit. The characteristics of East Village art are its vibrant, eclectic mixture of kitsch, cartoon-style imagery and relentless cynical 'duplication' of older modernist masters like Léger, Picasso and Pollock. Admitted by most commentators to constitute a basically conservative trend in art, these paintings and sculptures seem to have no life of their own except in the restricted consumer cycle of the international investment market. They are surely the ultimate in meaningless novelties of the kind upon which capitalist markets depend.

But there is a further effect. For, since the specialisation of the art sector has now removed it from meaningful contact with the evacuated 'life-world' of the general public, the distance between the consciousness of art and that of the population continues to maintain itself at maximum levels. Indeed, what little is known about the picture-buying habits of the general public tends to confirm the extravagant distance which has opened up between the modernist and post-modernist cultural establishment and the life-world as a whole. Most people buy pictures or hang them on their walls because they evoke memories of people, places, experiences or things with which they were once familiar — or which they wish sentimentally to imagine.[14] One should bear witness to the 'popular art' shops which are now springing up in high streets, on railway stations and even in the form of designers' catalogues for home furnishings, for they can tell us much about the society from which they come. The prints voted 'Top Ten' in the Fine Art Trade Guild survey of 1986, for example, were unanimously geared towards the evocation of a sort of pre-technological Edwardian hey-day of happy children and unspoiled countryside, of shepherds toiling in the snow at dusk or of puppies cavorting in the hay.[15] The staggering popularity of such images may be regarded as a kind of

Figure 27
Figure 28

79

symptom of the types of popular sentiment. But their general ubiquity should be viewed less as an argument in favour of 'popular' art, than as evidence of the evacuation and impoverishment of the life-world itself. Most of these images are themselves impoverished and banal, and once in place over a mantelpiece or on a bedroom wall probably attract little more attention than an old newspaper or an unread book.

27. Joseph Farquharson,
*Shortening Winters Day*

A word should be said at this point about the contribution made to specialisation by the magazines and journals of art — itself a complex information network which does much to endorse or modify opinion, to cancel (by omission), or to further a reputation. Much could be said about the financial interests of advertisers, the circulation figures, the struggle by critics for column-inches, the considerable power of editors and regular contributors, and about the dialectical relationship between criticism and the market. But here it is instructive to notice how very few artists out of a profession which can be numbered in tens of thousands ever achieve genuine visibility through the actions of the art press. Like journalism in other fields, art journalism returns again and again to familiar figures, to familiar arguments, to familiar 'problems' — thus narrowing still further an already over-specialised field. Functioning at the very centre of an already-specialised domain, art magazines raise a few profiles at the expense of lowering hundreds more. Thus despite the decline of the post-1945 idea of an artistic 'mainstream', art magazines aid still further the dominance of a relatively restricted group.†

Intellectual culture more generally is heavily on the side of specialisation and the complexification that goes with it. In fact *theory* has probably seldom had such a powerful determining influence on art as it does today — guiding,

controlling and sometimes anihilating art with its own particular rhetoric and discourses. The dominant art rhetoric of the post-modern period has come from America, in fact, where historians and critics are often remote from the studios of artists, and where academics are separated by the Atlantic Ocean from native traditions — such as modernism — that first flourished in Europe. American artists too are increasingly remote. 'I see Europe as a small community of upright people living in a desert', says Francesco Clemente, who nevertheless comes from Naples: '. . . if I think of what is happening in European society, nothing appeals to me'. Naples, on the other hand,

28. David Shepherd,
*Muffin's Pups*

† 'Mainstream' appears to be a neologism invented precisely for the purpose of promoting a certain view of art. Certainly it scarcely exists before 1945. The 1976 Supplement to the Oxford English Dictionary lists a small number of earlier uses (in fact 'main stream') but clearly suggests the origin of 'mainstream' to lie in jazz criticism in the 1950s in America. Here its uses were two-fold: to separate jazz from 'the mainstream of American culture', and as a label for a particular dominant jazz grouping: Basie, Ellington, Armstrong. Transported from its negro origins, 'mainstream' then became 'normal' usage in American art criticism in the late 1950s and 1960s. Although it still has its two original connotations of (i) that which is being opposed and (ii) a dominant grouping *within* oppositional culture, these uses are now collapsed into one — entirely what one would expect given that the oppositional role of modernism has now become officialised.

81

is 'a suburb of New York'.[16] But it is ironic that much new American criticism feeds off the work of French intellectuals such as Barthes and Foucault, and off the work of the Frankfurt School theorists of the 1930s and 1940s.

British artists, too, although traditionally sceptical of advice handed down by 'theory', have now also become infected with the theoretical postulates of American University thought. Much specialised art criticism in the United Kingdom also now emanates from university departments of literature which are remote from centres of artistic production (the studios) — thus reinforcing a division of intellectual labour that has been of almost no benefit to art. Artists themselves no longer take any part in the theoretical process; and those that do produce merely theoretical art. An excellent example of this was the show entitled *Difference: On Representation and Sexuality* which toured to New York, Chicago and London in 1985. Purporting to focus on 'Sexuality as a Cultural Construction', it presented 'new' photographic and filmic work which even its curator recognised was strongly dependent on theory. Works by Barbara Kruger, Silvia Kolbowski, Yve Lomax and others conformed precisely to the post-modern formula of non-auratic, decentred, unfocused, montage-type panels; but to their further discredit remained propped up by written texts which played acolyte repeatedly to the cult of Barthes and Foucault and the specialised terms they require. 'The (gendered) subject' explained one text quoting yet another, 'is inscribed in the symbolic order through a series of psycho-social processes as 'the product of a channelling of predominantly sexual basic drives within a shifting complex of heterogeneous cultural systems (work, the family, etc.)' '.[17] Lacan-speak now dominates theoretial post-modernist art in a way that precisely reverses the previous (modernist) relation between criticism and art — as well as separates them. Although she had clearly spoken to the artists concerned, the author of this passage admits later on in her text that 'it does not necessarily follow that they would agree with all aspects of my account'.[18] Specialisation here increases the distance between its own language and that which it purports to describe. As criticism becomes even more remote, art itself flounders in a sea of unrecognition.†

Earlier, classic modernism was not exempt from these charges of over-specialisation either. The growth of art-criticism in the nineteenth century was premissed upon an ever-widening gap between the interests of the artists — impressionists, neo-impressionists, and so forth — and those of the 'public' whose tastes were being catered to elsewhere. Definitely, the culture of specialists and experts

which unwittingly distances itself from other experts and
from the life-world was well in existence by 1910 or 1915.
Kahnweiler writes in his memoirs that his gallery had no
secretary and no telephone in the heyday of the cubist
experiment over which he presided; but still he managed to
not only support his artists financially and morally, but also
write an early account of cubist art which was of great influ-
ence and sophistication.[20] Early inroads into the French art
market by American investors — inroads which led in-
directly to the creation of the Museum of Modern Art in
New York in 1929 — were undertaken on behalf of no one
except the investors themselves. Like all successful entre-
preneurs, these early tycoons sensed the existence of a
latent market and placed their cash accordingly.

On the level of subjective identification too, this early
modernism had an identifiable — but minor — appeal. We
have some clues here about the taste of the people to whom
early modernism proved attractive; that is, the taste of the
urban intellectual male around 1900. Here was a figure who
was immersed in the artistic traditions of the West almost
to the point of saturation; and who, as Gombrich pointed
out in one of his forays into the psychoanalysis of art, had
come by the end of the nineteenth century to expect a cer-
tain 'crunchiness' in which he consumed culturally. Or, to
put it another way, this sophisticated urban observer was
able, by the end of the nineteenth century, to take risks in
his perceptual attitudes, to tolerate the discomfort of the
aggressive component in perception in return for a new
kind of balance with an increasingly pleasurable subject-
matter. Rather than yield immediately to the seduction of
the obvious or the saccharine, he was now prepared to
make his own discoveries in perception, to risk his own
aggressive identifications in the consumption of the pic-
ture.[21] This appeal to the 'crunchy' rather than the 'soft' in
aesthetic perception explains precisely why the frag-
mented, unstable, highly-charged picture-surfaces of
modernism exerted an appeal beyond their mere market
desirability — and still do, witness the antlers and broken
saucers stuck to the surface of Julian Schnabel's paintings

† Cindy Sherman, too, an American artist who photographs
herself in different identities — as movie actress, as harlot, as
housewife, and so forth — has also been described by feminist
structuralist critics as being ultimately concerned with feminity, culture,
and the absence of any firm identity at the core of our stereotypes of
women. However, Sherman herself denies such readings as fanciful.
'They have nothing to do with why I made the work', she says; her art
'might have something to do with growing up in the fifties and sitting in
front of TVs for a long time, reading lots of magazines'.[19]

— but also why that appeal was limited, and still is, to sophisticated urban types of a certain level of education and expertise. When Schnabel says 'I'm a modern artist'[22], one part of what he means is that his surfaces, or some of them, are crunchy to the point of extending beyond the literal canvas into the onlooker's own space. But the onlookers to whom his work appeals is entirely metropolitan and *au fait*. Aggressive oral consumption is the mode to which his sophisticated broken saucer pictures aspire.†

The specialisation of art-criticism in both modernism and post-modernism is perhaps revealing of how the post-modern merely intensifies something that was already latent in the condition of the modern. But, further, the intensification of critical discourse in post-modernism seems intimately linked to what Jameson called the change-over from 'feelings' to 'intensities' — post-modernism's characteristic loss of affect.

A feature of the modern museum provides a final illustration of how this happens — an example which goes back to the very beginnings of the modern art museum in the eighteenth century. For, when the Austrian Imperial collection was re-arranged in the Belvedere in Vienna in 1779, for example, its new curator Christian von Mechel was clearly sensitive to a new distinction between functions: 'The purpose', he said, 'was to use this . . . beautiful building, suitable because of having many separate rooms, so that the arrangement should as far as possible be a visible history of art. Such a large, public collection, *intended for instruction more than for fleeting pleasure*, is like a rich library in which those eager to learn are glad to find works of all kinds of periods'.[23]

Embodied in von Mechel's statement is an early example of the modern distinction between the museum visitor's two roles: in one of which he is invited to receive pleasure, or be entertained; and in the other of which he is invited to receive only knowledge, that is, become a historian himself. But the ambiguity has been massively intensified throughout the succeeding two centuries. Gallery visi-

---

† In tracing the reasons for the appeal of the early modern picture, I might also adduce certain factors about the artists themselves. Most of them were at or about middle-age at the time their most adventurous work was done. At that 'moment' in 1912 when cubism, expressionism, and futurism were erupting, Picasso was 31, Matisse 43, Kandinsky 46, Malevich 34, Kirchner 32, Mondrian 40, and so on. According to E. Jacques, the mid-life point of an artist's career is particularly fertile for major changes and re-evaluations. See his *Death and the Mid-Life Crisis*, in *Work, Creativity and Social Justice*, London, 1970, pp. 38 — 63. On any account it is surely difficult to think of the early modern 'revolution' in art as the work of either very old or very young men.

84

tors today still do not know whether to study or to enjoy —
although more and more they are being urged to study, with
the aid of scholarly expositions in catalogues and didactic
displays. This reduction of art to the status of a 'text' was
accomplished only within the period since the second world
war — the period of the death of feeling in post-
modernism.

Indeed, post-modernism is in many ways completely
epitomised in the person of the contemporary museum
curator — a role which in its present form is substantially
new. In the old world of modernism there were relatively
few exhibition spaces and relatively few museums devoted
to the display of contemporary work. Many galleries were
private — Vollard, Kahnweiler, Rosenberg and their like
— and the curatorial task depended solely upon the seal of
approval of the owner. To this day — to judge by the exam-
ples of Leo Castelli and Leslie Waddington — fortunes are
still to be made from the imposition of a relatively limited
set of stylistic and art-ideological criteria. The interesting
departure in the post-war period however is the large,
public-funded gallery — the modern art museum or
smaller municipal gallery. Here, the curatorial job is to
show 'the public' — however notional — a 'cross-section'
of what is reasonably professional in the activity of contem-
porary art at any moment. It sounds innocent enough;
except that the curator must of necessity move from one
style ideology to another perhaps eight or ten times a year;
and believe, for the duration, in every single one. No occu-
pation more succinctly summarises the post-modern out-
look of pluralist tolerance, cultural diversity, and a failure to
adhere to a single preferred artistic type.

The other fields of modernisation which have rapidly
specialised themselves and thus established a distance
from the life-world of common understanding can only be
mentioned symptomatically here. Technology — itself a
paradigm of the cognitive-instrumental sphere — is pre-
sumably to be congratulated for having broken down bar-
rier after successive barrier in its search for instrumental
solutions to various human problems. The problems of
transport, of disease, of space exploration and of electronic
communication, are now to a large extent, and in principle,
'solved'. The cost of this revolution however is no less than
it proved to be in the first days of the Industrial Revolution,
when air became polluted, factories became a substitute for
slavery, and traffic accidents eliminated the first casual by-
standers of a machinery they did not understand. The inter-
vening century and three-quarters has a long and variable
but no less brutal history of effects, malpractices, disasters
and shortcomings. Now, we simply note that the

85

Enlightenment dream of progress and happiness for all through technological 'development' has only in certain limited ways come about. Instead, the planet now seems threatened — not by ideological differences, but by nuclear machines which can destroy us all — not by the over-production of goods and services, but by the ecological disaster which their manufacture seems to require. For reasons which are not entirely spurious, populations are now afflicted by widespread millenial expectations of catas-trophe and collapse.

According to Habermas's argument, the corrective to be made to this inexorable specialisation of culture is not to be sought in a series of negations — avant-garde ventures within the field of art — but in an effort to reconnect the severed bonds between the major cultural areas of science, morality and art: 'In everyday communication, cognitive meanings, moral expectations, subjective expressions and evaluations must relate to one another. Communication processes need a cultural tradition covering all spheres — cognitive, moral-practical and expressive.'[24] Habermas sees modernism not as a lost project, but one which needs retrieving from the alienated position it has been forced to take up. That is clearly one aspect of the problem.

Another aspect, once more, is to so de-specialise modernism as to preserve its constructive features — especially its shareable codes — for whatever realistic pur-poses we call upon our future art to fulfil. But first, we must be absolutely clear about the extent to which contemporary artistic production — particularly that which is supported by the organisations of the New Class — has become not merely over-specialised but also pervasively infected by the values of the new media environment. To return once more to Max Weber's thesis of the total separation of spheres, we need to observe that, correct though the thesis of over-specialisation was, the balance of power as between the three spheres is not equal, and becomes if anything less so as time goes by. Particularly, the cognitive-functional world of science and technology has far outstripped the influence and mode of operation of the other two, overflowing its for-merly identifiable boundaries and permeating the whole — or tending progressively to do so — in a totalising move-ment which has affected every department of life in the period of post-modernism. The media environment as symptom of the technological sphere always provided a foil to modern art, even in its beginnings. But today the culture of television, in particular, plays an especially important role in the formation of visual artistic codes that is all but unrecognised in the cultural comment of the day. An examination of this role is also, of course, part of that

genuine post-modernist critique of which we previously
spoke. It helps us once more to understand the fate of the
modernist project in art as bound up inextricably, not with
aesthetics alone, but with development within the other
spheres.

# THE IMPACT
# OF TELEVISION
# CULTURE

Matisse, at the time of his first theoretical statement on painting, noted that photography provided images that were not compatible with his art. 'Photography can provide the most precious documents existing', he wrote; 'and no one can contest its value from that point of view'. 'Photographs will always be impressive because they show us nature', he asserted. Photography should 'register and give us documents'.[1] And the photographer should not intervene, lest he give his work the appearance of a different process — art. But then, however, Matisse notes that photographs are not always documentary. Movement, when captured by a snapshot, is apt to 'remind us of nothing that we have seen'.[2]

This ambivalence with regard to a mechanical image-form like photography was perhaps typical of a certain type of modernism, one that wanted to achieve a synthesis of outward appearances and subjectively generated 'sensations'. Even as great a realist as Léger was not content to record the city as it photographically was. The painting should be dynamic, accelerated, it 'must embody the full force of life and movement', he said. 'Next to the painting, everything must be dull'.[3] Now, in the post-Second World War period that we incline to call post-modern, images from other media such as the poster or the photograph are inevitably less relevant to art. We now have television, and the meanings generated by television, as the immediate visual context for art — an alliance of technology and low

culture which has eclipsed the old forms of public imagery in ways we barely understand. What are the dominant relations generated by television culture which might play a part in establishing the conventions of the production of art?

In terms of the mode of reception of TV, there seems little doubt that consciousness has changed — or has been changed — dramatically. We remarked before how TV eradicates previously convivial activity such as theatre, sport, music or conversation. Raymond Williams has written of what he calls the 'mobile privatisation' encouraged by television, in which people increasingly live in self-enclosed, small units, surrounded by media signals generated elsewhere. He points out on the other hand that this privatisation is experienced as both pleasurable and intensely valued; but reminds us that it tends to reduce social relations to calculations of material improvement alone.[4]

The case against existing forms of television — centralised and expertised as they are — is on the face of it a powerful one. In fact for every beneficent effect that can be associated with television culture, there seem to be equal and opposite consequences which are far from desirable. We noted the educational possibilities of TV; but these are only gained at the expense of the sacrifice of the relationship between teacher and taught. We noticed the peace-keeping role of TV in being able to transmit news-stories globally and thus function as the 'conscience' of the tele-visually literate world. However, the very existence of TV does little to assuage the extremism of leaders in Iran or South Africa from which Western television crews are excluded. Nor did television's superficial 'gloss' on events do anything to penetrate the miseries of Galtieri's Argentina or Pinochet's Chile. Even disasters of transnational proportions such as the famines of 1985 in Ethiopia and the Sudan went quickly off the boil after the initial 'revelations' carried by television were placed on the screen. And, since news has to be 'managed' in order to be reported or reproduced, it comes as no surprise that no nation shares with any other its perception of what 'counts' as a globally important story. What parades itself as 'factual' is a highly edited 'story' devised by anonymous third parties whose processes of decision are never laid open to view.

Figure 29

It is in its depiction of human relations, however, that TV fails notoriously to establish optimistic and critical character-types that can serve as models for social action. Indeed its typical image of human personality tends to be wholly stereotyped and banal — with a few exceptions.

89

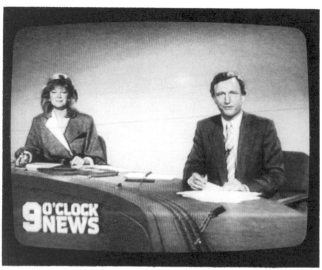

29. BBC, *9 o'clock news*

Prime-time 'soap' dramas of tremendous popularity pro-
ject human behaviour as predominantly strategic and hate-
ful, with the 'hero' now merely the most strategic and hate-
ful character in the plot. These turgid dramas of dominance
and financial 'fulfilment' establish both an ideal of human
behaviour and a set of 'needs' which go with it; needs for
consumption, primarily, and for the vicarious playing out of
roles. In the genres of action and adventure, massive
amounts of violence animate the screen as if murdering,
maiming or victimising an opponent was now one of the
ends of life itself. Chat programmes likewise now rely to an
equal degree upon an image of the individual as highly spec-
tacular; striving and successful in terms of narrow assump-
tions about 'fulfilment' and the ends of life. Rapid and
largely meaningless chatter about a personality's latest
show, film, marriage, holiday, etc. — in extreme cases
resembling cocaine-babble, the narcotic-induced speech-
pattern of a spoilt and anxious dinner-party milieu — has
come to dominate the late-night talk shows within even the
last few years. Outrageous guests, paid large sums of
money to behave obscenely, are virtually now *de rigeur*;
ostensibly conspiring to present new levels of subversion of
normally accepted codes, yet in reality reaching out for the
inattentive millions upon whom the audience-ratings
depend. These highly consumable but fatuous entertain-
ments not only strive to establish and endorse a debased
notion of success, but also *demand* it as a prior condition;
such that the media-visible 'personality' now provides an
ideal type for human behaviour within the consumer cul-
ture of the West, both establishing false needs and pander-

ing to their satisfiability in one pervasive and repeatable moment.

One might add various other deleterious effects of television culture. Notoriously, it projects an image of the *sporting hero* as an ideal type. Overridingly, he is no longer represented as playing a game for anything so simple as enjoyment or the exercise of skill. Television indelibly marks him now as one who lives his life exclusively in terms of superlatives: who pushes his body to extreme limits in the service of 'competition'. He is the most rapacious scorer; the fittest; the fastest; the highest; the strongest; or occasionally, for the sake of a limited irony, the most seriously injured or even maimed. Already thrown far beyond the innocent mechanics of 'glamorisation', he — for it is mostly 'he' — is now consistently predicated on the idea of the death or down-doing of his opponent, if possible in a manner that degrades his victim or otherwise adds to the spectacular nature of his heroic prowess and capacity for survival. Thus relationships of power and dominance are essential to the idea of sport as projected by television. But this fact is only symptomatic. As one pessimistic commentator put it recently, television caters for certain sensations and events far better than for others; for superficiality rather than depth; for violence rather than non-violence; for jealousy rather than acceptance; for anger and lust rather than satisfaction; for competition rather than co-operation; for the bizarre; for life-as-consumption rather than life-as-expression; for images of death rather than of life.[5]† As Max Horkheimer noted in regard to American mass culture in the 1930s and 1940s, the cumulative effects of phenomena such as the sound film were to bring about a 'disappearance of the inner life'. Under the regime of the mass media the community of the family no longer functioned as 'a kind of second womb, in whose warmth the individual gathered the strength necessary to stand alone outside it'.[6]

Horkheimer and Adorno also railed against the mass entertainments industry in the United States for having caused a wholesale loss of individuality in the American public: 'In the culture industry' they write, 'the individual is an illusion not merely because of the standardisation of the means of production . . . Pseudo-individuality is rife; from the standardised jazz improvisation to the exceptional film star whose hair curls over her eye to demonstrate her originality. What is individual is no more than the generality's power to stamp the accidental detail so firmly that it is accepted as such . . . the peculiarity of the self is a monopoly commodity determined by society; it is falsely represented as natural; It is no more than the . . . French accent,

the deep voice of the woman of the world, the Lubitsch touch.'[7]

Taking our cue from Horkheimer and Adorno, we may notice that the isolation of the individual has been visible in Western modern art for at least a hundred years. Certainly the gradual decline in the capacity of art to represent human relationships may be the most general form which the television effect can take — spreading across most generations since 1945 and across all nations where television has become established as a dominant cultural force. Indeed, the period when art and literature was interested in representing the nuances of human interaction — the significant look, the pregnant gesture, the well-timed movement, the full richness of expression within the human body and the human face — this period has been left behind by modernism in its widest sense.

In fact the antecedents of the 'post-modern' image of human unrelatedness go back before the Second World War to the beginning of the century or beyond. Gauguin and Van Gogh and Cezanne, for all their immense gifts, were able to give little attention to the niceties of human interaction, in comparison with nineteenth century realists such as Tissot or Bastien-Lepage, or the medievalising Pre-Raphaelite brotherhood — even in comparison with very early proto-modernists such as Manet or Repin. Gauguin and the later

Figure 30

---

† The most positive contemporary account of the television experience is Jane Root, *Open The Box*, London, 1986. Root's primary defence of the medium revolves around her admiration for soap opera and its inventive review of the 'ordinary imponderables' (p. 45) of everyday life: 'jealousy, romance, illness, the search for a perfect relationship, the best way to bring up a child . . .', while its regular audiences, she points out, develop a real affection for the drama on the screen which is reflected in rituals of gossip, expectations and initiate 'reading' of a scenario, which enable it to read small clues to the directors' intentions and predict the action in advance — one example of the 'creative' involvement by viewers in what is sometimes (as here) regarded as a passivising medium. Root also adduces some evidence for an intelligent pattern of interaction with TV, as opposed to the zombie-like submission to the schedule which other writers (also as here) allege. Admitting that 'a minority of viewers are passively slumped in front of their TVs' (p. 25) many of them fast asleep, she asserts that the rest 'engage in an almost bizarre variety of different activities in front of the set: we eat dinner, knit jumpers, argue with each other, listen to music, read books, do our homework, kiss, write letters and vacuum-clean the carpet' (pp. 25-6). The content of TV, which is what is at issue here, seems unaffected by this evidence, which in any event can be taken in many ways. Root is, moreover, even within the parameters of her generally sympathetic approach, scathing about the values pervaded by what is optimistically called 'news'. Her account, Chapter Four, passim, of the 'whole series of intensely ritualised conventions . . . to shore up the authoritiveness of the newsreader' (p. 82) is wholly in line with my argument here.

30. I. Repin, *Study for
Zaporozhye Cossacks, 1878*

Van Gogh apparently preferred to show the single figure placed in relationship to the viewer, or to his natural surroundings such as landscape or a domestic setting. Braque and Picasso's cubism also specialised — although not exclusively — in representations of the isolated object or single figure; and implanted the action of the artist, at the expense of psychological nuance, recognisability, or commonly understandable gesture. Other modernist male artists like Matisse or Rouault deliberately 'fudged' the expression of their individual characters; Matisse, particularly, by making the features and the actions of his characters almost entirely opaque, as most of his paintings and sculptures before 1915 show. It is all but impossible to tell what Matisse's 'reclining' nudes and other figures are either thinking, feeling or doing. Powered by the remnants of a Symbolist aesthetic still current in France around 1908-12, these paintings direct their attention to the surface and their method of working *by means of* the ambiguity of what they literally show. Abstract art was bound to endorse this exclusion of the depicted individual from the space of the picture. During the television age, all efforts to re-insert images of human relationships in the visual arts have

93

become outlawed theoretically, but for other reasons became well nigh impossible to achieve.

Ironically, the recent 'return of figuration' from about 1975 onwards has demonstrated this fact consistently and clearly. Among venerated senior artists in Britain, Francis Bacon's figures are physically mangled and psychologically desperate beings, unable to interact with each other except negatively — devoid of hope. Euston Road painters such as

Figure 31

31. Francis Bacon, *Left-hand panel for Triptych, August 1972*

William Coldstream and Euan Uglow have proved unable to endow even their more palpable human depictions with anything that might have passed for *presence* to Titian or even to Tissot. Uglow, particularly, has consistently reduced his naked females to expressionless lumps of reclining flesh, placed before the artist and the viewer alike merely as subjects of measurement or ratiocination. American figurative artists like Pearlstein or Alex Katz have also diverged from the possibility of representing nuanced human action; Pearlstein by 'cropping' his figures, frequently at the neck, and by focussing on leisure activities such as sunbathing in which little is expected to happen; and Katz, by limiting himself to stereotypes of suburbia or office life who can no longer respond imaginatively either to each other or to their surroundings. Of this generation,

Figure 32  Lucien Freud is almost unique in attempting to depict the

subtleties of human intercourse within the frame of the beleaguered contemporary picture. In Freud's art, as in that of Stanley Spencer or Andrew Wyeth before him, it is still possible to observe the enactment of that human drama *within* the picture which has disappeared from view under the occlusion of all depicted relationships by television.

Another feature of the art of the television era has been an astonishing parting of the ways in respect of technique: a division into the 'cool' camp of those who identify *with* the means of television — particularly its photographic 'link' with reality, its anonymous surface, its technical means of production; and secondly, those who identify *against* television's means of production, aiming to cultivate an image of hand-craftedness, 'action', and of radical unlikeness to the photograph. Formerly analysed as a symptom of some new 'pluralism' in which all styles could co-exist with each other in the climate of post-modernism, these two alternative attitudes to technique are more plausibly associated with standpoints of conformity to, and reaction against, the dominant methods of image-production in the culture of television.

The school of cool photographic production which became known as 'conceptual art' in the 1970s sought open conformity with television by asserting that photographic image-making generally had replaced painting or drawing

32. Alex Katz, *Trio, 1975*

95

in the art of the twentieth century; that painting and draw-
ing were now moribund pre-technical forms. Likewise,
conceptualism argued the importance of textual attach-
ment to the visual image on the grounds that this (or its
spoken equivalent) had become standard in still advertising
and in television itself; thus implying that the interplay of
image and text was a vital source of meaning in our culture
as it is, and that aesthetics must somehow follow suit.

The soundness of these arguments was open to
judgement;[8] but notice how far this branch of post-
modernism was prepared to *exaggerate* the coolness of the
photographic medium in order to make this association
with television clear. Its graphics are sparse, even austere;
never descending to informal or colourful typefaces for
fear, presumably, of impeaching the high 'seriousness' of
its didactic purpose. What was also evident was that the
anonymity of the photographic surface in conceptualism
was embraced as a sign of adherence to Walter Benjamin
and post-modern aesthetics generally; and also as a sign of
the artist's disappearance from the site of his work as a
necessary, even meritorious, effect. In this case aesthetic
theory joined hands with art in a dual movement of approval
of television's reproductive means.

On the other hand, it was precisely these photo-
graphic strategies that were actively resisted in the 'new
expressionism' that swept the television-saturated nations
of the West from 1976 to 1986. Expressionism as a cate-
gory is one of the most pervasive and recurrent of all
twentieth century art forms. (At the beginning of the cen-
tury expressionism included not only the German groups
associated with the Berlin, Munich and Dresden avant-
gardes; but also cubism and fauvism which originated in
France. Its subsequent narrowing to become a pre-
dominantly German form is largely an effect of discourses
within the institutions of modernist art.)[9] In that earlier
context expressionism constituted a language of resistance
to encroaching forms of technological and urban life: a cry
by the individual against the machine ideal of 'function with-
out friction' that state capitalism was imposing upon the
consumer societies of the West. In the 'new expressionism'
that co-exists with post-war television, however, the
nature of expressive stylisation has changed in important
and perhaps fundamental ways. The drawing styles of art-
ists like Chia and Cucchi, for example are deliberately
naive, deliberately misbehaved in ways that seem designed
Figure 33    to attract attention. Along with a host of other 'new expres-
sionists' they use colour and drawing in accordance with
the practice of untrained painters, schizophrenics or child-
96           ren. Others use a thickness of impasto far in excess of what

33. E. Cucchi, *Fontana
Ebbra, 1982*

Figure 34
Figure 35

used to be required as a signal of 'expression'. A German artist like Baselitz positively wallows in 'free' brushwork and extravagant gesture in order precisely to indicate his desired artistic pedigree. Faux-naif artists like Ed Paschke or Barbara Rossi in America deliberately recycle the stylisations of comic-book art in order to appear 'extreme', in rebellion against 'high art', alienated, fugitive, even lost.

34. Georg Baselitz, *Kreuz mit Herbstastern, 1983*

And the bizarre stylisations to be found in the new expressionism pass over directly into what might be called the content of this work. In contemporary European expressionism the tendency has developed to depict the human subject in 'extreme' situations of disorientation or absurdity in which the exact affective positioning of the body is neglected, on the whole, in preference for whatever mysterious predicament the subject happens to be in. Here, in Chia, one finds the absurdified subject involved in

98

Figure 36

a colourful nightmare of bodily functions. Germans like Dokoupil present hallucinogenic unrealities on a par with American drug comics like Zippy the Pinhead — whose pitiable subject shows himself to be bamboozled by the world in which he lives, and behaves accordingly. The 'extreme' situations sought by English new imagists like Paula Rego or Bruce Maclean are mitigated by a vein of modernist autobiography, perhaps; but still capitalise heavily on subjective experiences of massive disorientation in which the dramatis personae of art no longer engage in human activities with stability or meaning, but subsist in a nightmarish solipsistic zoo, while others (the audience) look bemusedly on.

37. Zippy the Pinhead, *by Bill Griffith, 1981*

35. Ed Paschke, *Meyamo, 1984*

Nor is this existential loneliness, in the manner of Giacometti, Buffet or Soutine — but a playing over of the confusions and contradictions of life in a booming consumer economy in merely their most harrowing and negative form. The German Rainer Fetting celebrates the sleazy life of male changing rooms, nightclub violence and homosexual bars. The Italian artist Salomé openly celebrates a life of homosexual promiscuity, transvestism and pain. The English artists Gilbert and George — though working beyond the confines of painting — mix their crudely 'hot' graphic style of garish colours and clumsy outlines with imagery that pertains to right-wing nationalist politics,

Figure 38

Figure 39

99

homosexual exploitation, football violence and reactionary
manipulative sadism on a personal level — all in the name
of something they believe to be 'art'. In line with explicit
sexual content mixed with violence on television and on
video films particularly, the newer art (and painting parti-
cularly) appears to strive for recognition in ever more
extreme ways.

36. Sandro Chia, *Successo
al caffe Tintoretto, 1982*

What makes such works collectable is, of course,
never clear. At any rate it is implausible to think that it is
their investment value alone. The 'new' paintings that will
go down in the popular art-history books of the future as
characteristic of the 1980s *may* depend for their media cir-
culation upon guarantees of increased monetary value; but
their content is surely vital as well. Why are the bizarre and
the unreal suitable subjects for the higher bourgeois taste
of the 1980s? What aspects of this sleazy or surreal subject-
matter makes it an apparently perfect foil for other aspects
of the interior design style of the day? The clue may be
found in quite a different kind of icon now being circulated
amongst the wealthy patrons of the West: namely the
glossy interior design photograph which advertises a style
of comfort, a range of textures and materials, and types of
furniture and eating arrangements which correspond to a
particular kind of life-style. The precise imagery of these

'higher' Sunday-Supplement icons require iconographical
analysis as much as, if not more than, the art works they
enclose. Here, something posturing as 'design' intrudes its
unseemly self merely as a vehicle for patterns of consump-
tion. The artistically extreme and the pictorially bizarre
may function partly as guilt-releasing mechanisms in
domestic environments already devoted to the maximisa-
tion of almost unbearable levels of bodily comfort and the
leisured life.

38. Rainer Fetting,
*Another Murder at the
Anvil, 1979*

The nihilism and extrangement of some modernist
and post-modernist art goes back to the beginnings of its
tradition — well beyond Jarry — but Raymond Williams
has noticed how this tendency, which originally belonged
only to minority culture, now animates popular culture as
well. Williams recognises the existence of homogenising
mass culture (TV and global entertainment); and he recog-
nises also the 'original innovations of modernism' which

101

39. Salomé, *Fuck II, 1977*

caused a profound shock to the old bourgeois order and its imperial-political power bases at the turn of the twentieth century. But he says that mass art and minority modernist and post-modernist culture (the two terms are for him continuous) are no longer opposed, but now part and parcel of each other. Modernism and post-modernism have now become 'normal', an establishment of their own. Mass culture, however, has absorbed the original perceptions of modernism into its own body: these he lists as 'human inadequacy, self-deception, role-playing, the confusion and substitution of individuals in temporary relationships, and even the lying paradox of the communication of the fact of non-communication'.[10] These, he says, are now given as 'self-evident routine data'; are to be found now inscribed *within* popular mass culture, in representations of crime, espionage, intrigue and dislocation in which competitive violence, deception and role-playing are standard contents. The choirboy who sings to an image of dreaming spires in the BBC's celebrated *Smiley's People* — itself a portrayal of deep inner betrayals and the 'inner filth of espionage' — is for Williams a perfect illustration of how mass TV culture contains not only the comforting adaptive nostalgia that now pervades all 'popular' culture, but also the disquieting propositions of an earlier modernist phase. What seems promised by the fact of this transfer is the further deterioration of popular TV under the impact of the more extreme

nihilism of post-modernist 'absurdist' art.

Further, Williams points out that the original per-
ceptions of earlier modernism, including psychological
alienation, the idea of relationships as inherently self-
seeking and destructive, the insignificance of history, the
fictionality of action and the arbitrariness of language —
these have become what he calls 'the routine diversions and
confirmations of paranational commodity exchange, with
which indeed they have many structural identities.'[11] For
Williams, the real forces which produced both homo-
genised mass culture *and* the current 'post-modernist'
establishment belong to the dominant capitalist order in its
paranational phase.

A further and more complex effect of television and
the media more generally upon the 'emergent' art of our
time, concerns history — and the survival of previous art.
Ever since the invention of the printed reproduction it had
been possible for artists to defer to another person's work
they had never seen — quoting it approvingly, varying its
codes to suit new purposes, in some cases revising it com-
pletely. In early modernism the balance between tradition
and innovation changes. In fact the evidence points to a
kind of double effect, in the majority of modern art before
the television age. Picasso's notorious *Demoiselles*, for
example, painted in the spring and summer of 1907, not
only refers admiringly to artists as diverse as Velasquez,
Ingres, Cezanne, Delacroix and Durer, but simultaneously
modernises them (and in that sense claims to surpass
them) by a range of distortions and licences which are
Picasso's own. Or take Kirchner's re-working of an Indian
fresco at Ajanta in his *Five Bathers at the Lake* of 1911. He too
begins from an attitude of deep veneration for the earlier
prototype, and attempts to transform it into his own idiom
only on condition that his source remains easily recognis-
able — the composition, the style of drawing, the colour.
The attitude of the modern artist to the past is a double one
of antagonism mixed with respect in which both are essen-
tial to each other.

As André Malraux noticed some two decades ago,
however, the rapid spread of publishing and the media was
having the effect of eradicating altogether the natural tem-
poral and geographical boundaries between cultures,
periods, and schools.[12] The totality of world art was sud-
denly available *simultaneously* by about 1960 or 1965 in re-
production form. Television, however, does more. It is the
first cultural medium in the whole of history to present the
artistic achievements of the past as a stitched-together col-
lage of equi-important and simultaneously existing pheno-
mena, largely divorced from geography and material his-

103

40. Gilbert & George,
*Hunger, 1982*

tory and transported to the living rooms and studios of the West in a more or less uninterrupted flow.

Malraux's pessimism with regard to the spread of culture was based on the publishing and photographic revolutions of the pre-television era — the revolutions that made libraries a fund of visual knowledge that could be scanned by any member of the public with half an hour to spare. Television, by contrast, requires no such active scanning, no pre-selection, no engagement. It itself posits a viewer who is a cultural nomad, who 'knows' all styles and periods

but who cannot choose between them; who no longer
understands 'relevance'; who has no need to distinguish
between the old humanist categories of fiction and fact.
Television also plays over previous time — or gives the
televisual illusion of doing so — as if history and past exper-
ience were somehow naturally *there* in the form of archive;
instantly retrievable and capable of being consumed over
and over again at the push of a button.

Television thus posits a viewer who shares the
medium's own perception of history as an endless reserve
of equal events. It is hardly surprising that during the tele-
vision age the artist's relationship to history has completely
changed. Most artists of the 'emergent' schools of new
figuration and expressionism enact a relationship to pre-
vious art that is parodic, even sarcastic, in its willingness to
make quotations from different styles and periods of the
past. One sees in the Italian Clemente quotations from
Raphael and from Leonardo; in Chia one sees quotations
from Giotto, Futurism and Malevich; in secondary figures
like Prol or Dokupil one notices raids on the poular imagery
of the cartoon or the Hollywood image. In the British artist
Stephen McKenna one notices quotations from Titian,
Rubens, and Courbet. Crowley quotes the American car-
toonist Robert Crumb. The Russian 'dissident' duo Komar
and Melamid (of whom more later) quote Soviet socialist
realism; and so on.

Something of the despairing and cynical attitudes to
art that are now coming out of New York — even as this
book goes to press — can be gleaned from the following
observations as the so-called geometric revival or 'Neo
Geo' cult of abstract painting that is now establishing a
presence both in Britain and the United States. Most, if not
all Neo Geo art is entirely lacking in the mystical or meta-
physical dimensions of original geometric abstraction, par-
ticularly that of Malevich. It plays with older cultural pro-   Figure 41
ducts in a detached manner that is mostly not even ironic.
'It's certainly fascinating for all artists to discover the radi-
cal statements in those artist's (Malevich's and
Reinhardt's) works', says the Swiss artist John Armleder,
'. . . but I really like the fact that radicality in art has abso-
lutely no consequences . . . who gives a damn whether
you're radical or not: its still the same thing, the same
painting, and the same people who play with it, its still art
and cultural bullshit . . . it's obvious that extremely radical
positions in art are in some way always cheap and shabby'.[13]
My paintings, says Armleder, 'escape all intelligent discur-
sive comprehension . . . what is interesting today, in con-
trast to Malevich's or Mondrian's times, is perhaps the fact
that what we're doing has little to do with what it's thought

that we're doing'.[14] Inspired by the Fluxus happenings of the late 1960s and early 1970s (Armleder used to be a performance artist), Armleder's works are designed to *seem* like purist paintings with a higher metaphysical meaning, but actually degenerate into cynical commentary on what he elsewhere calls the 'pointlessness' of the whole operation.

41. John Armleder,
*Untitled, 1986*

A side to Armleder's work which seems to portend yet another new 'development' for the future, is the tie-up between painting and design. The neo-expressionist artwork as part and parcel of an image of the new bourgeois interior has already been noticed. Armleder himself exhibits furniture such as chairs and light-fittings as essential accompaniments to his Neo-Geo paintings, though the intentions are possibly mocking and surrealistic —
Figure 42    'decorator's error' is what one reviewer called them.[15] The Italian group around *Studio Alchimia* in Milan, however, which has strong links to the fashion magazines *Moda* and *Domus*, is entirely serious in propagating the cross-over concepts of 'structural painting' and 'painterly design', in which artefacts may be designed around paintings, and in which paintings themselves are merely designed. 'The excessive accumulation of imagery and its way of infinitely multiplying reality to the point of *finally replacing it* is precisely what has made possible the idea of a painting of quotations', says one member of the group. 'The discussion you hear almost everywhere is that of the designer as artist and the artist as designer', says *Domus* editor Allessandro Mendini. 'There's a kind of man, no longer possessing strict values, who we might call a 'decorative human' and who has . . . achieved a kind of superficiality. It's for this sort of person that *Studio Alchimia* has worked . . .'.[16]

Although Mendini calls this superficiality an 'entirely posi-
tive effect', the consequences of this wholesale insertion of
art into the decorative world of design has consequences for
the romantic modernist idea that hardly anyone could fore-
see. Mendini's 'decorative human' may be nothing more
than the latest type of consumer in a market full of
attractive but pointless playthings — which, however, do
little more than divert attention from the actual reality in
which other people, hopefully less 'decorative', actually
live.

42. John Armleder, *Bureau
with Circular Mirror, 1984*

Although the existence of television and publishing is
a necessary and probably also a sufficient condition for the
quotational mode, it is noticeable that that mode itself is not
one that requires an artist's veneration of his sources, or
even that he takes much pleasure in them. Irritation or mild
amusement may be all that marks the passage of a Boccioni
figure into a painting by Sandro Chia. Chance or conven-
ience may be all that drives Clemente — who claims artistic
descent from de Chirico's brother Alberto Savinio — to
include a scene from Piero della Francesca in a work of his

107

own. Pure whimsy would appear to be sufficient to allow comic-strip drawing to enter the repertoire of a Jim Nutt or an Art Green, to name only two of the parodists of the notorious Who Chicago? school of painting of the 1970s. Images are now too plentiful, too cheap and hence too much devalued in a non-monetary sense, for choices between them to be the same as they once were. Sealed within the 'mobile-privatised' world of a post-modern (i.e. television) culture, it would appear to be now increasingly difficult for artists to break the circle of images — what is sometimes called intertextuality — and gain contact once again with the substantial world.

43. Jim Nutt, *Could it be yours?* 1985

The point is not that post-modern television culture *automatically* eclipses the individual's capacity for resistance, but that it presents him with extraordinary problems of assimilation and understanding. Always his consciousness is beleaguered by the images and products of a hyper-active market culture. Always his own artistic products lie prey to appropriation either by that same market culture or by the well-meaning representatives of Bakunin's New Class of cultural bureaucrats who determine and select what is to be valued. It is hardly any surprise, therefore, that the success of his project comes in degrees.

The examples of de Chirico and Picabia may be instructive here. De Chirico in 1919, aged 35 and already a leading light of the international avant-garde ('one of the

most interesting of the modern painters', as Apollinaire had already written about him[17]), found himself standing in front of a painting by Titian in the Villa Borghese in Rome when he experienced 'the revelation of what great painting is: in the gallery I beheld tongues of flame, outside, through the vastness of the bright sky, a solemn clangour echoed over the city, and trumpets blared announcing a resurrection'.[18] He becomes suddenly candid about his dislike of modern art; he soon quarrels violently with Breton and the surrealists; and by the time he came to write his autobiography during the Second World War he was convinced that he alone among his generation had discovered the path of true art. He reviles everything formerly loved by modernists: liberal values, fresh food, intellectuals and especially critics. Picasso and Soutine are suddenly 'daubers' who should sharpen their pencils and learn how to draw. Cezanne is suddenly guilty of 'filthy apples and crooked dishes'. He now defends old master painting, authoritarian values, nineteenth century virtues such as hard work and the refinement of skills; and comes to believe that art should abandon 'expression', and turn back to the cultivation of technique.

This return to 'craft' and what de Chirico regarded as the 'values' of the old masters was never in fact carried through in a literal form. Although his experiments with bases, emulsions, pigments and glazes were unremitting, the imagery he produced from around 1920 until the end of his life in 1973 was never a straightforward return to the tradition. Many paintings by de Chirico of the period before 1945 (broadly speaking the period of Italian fascism) come close to the type of figuration favoured by Mussolini: the classical temples, the horses on the beach, the gladiators and the other references to Greece or Imperial Rome. Also, Figure 44 de Chirico's admiration for the seventeenth century caused him to engage in baroque-style painting in an effort to capture the heaviness, the gravitas, what he called the 'mystery' of that period. But in spite of this, de Chirico never renounced the 'metaphysical' philosophy of his pre-1919 period, as the many copies and variations of those works show. He was still a surrealist in all but name in 1929, the date of his novel *Hebdomeros* ; and he continued until his death to look for ways of combining a deep veneration for early art with his fundamentally modern temper.

But what distinguishes de Chirico's style of quotation from the 'high art' referencing of Picasso or Matisse is its *look* of outright banality; its crudeness of drawing style, which is now frequently that of the comic book, and its high-pitched colour that is, after all, never found in Titian or Rubens or Velasquez. It is clear therefore that although

after 1920 de Chirico appears as an artist keen to abandon modernism, he was at the same time seeking a relationship to art history that was partly nostalgic and parodic. In adopting this 'post-modern' posture towards history, many of de Chirico's late works give an absorbing sense of how art itself reduces to banality under pressure from a hysterical market environment, but provide little comment on the causes or future direction of this tendency.[19]

44. G. de Chirico, *Horses with the God Mercury, 1965*

The case of Picabia is in certain ways similar. Picabia was a rich playboy whose entry into the avant-garde was governed by cynicism and playfulness, even in 1910. After his vast *Udnie* paintings of 1913 and his mechanical-metaphorical contribution to Dada, he likewise turned to a markedly different type of imagery after 1920. In fact it was in 1924 that his paintings changed decisively and Picabia fell out irreversibly with André Breton, whose surrealist move-

ment he misjudged to be another artificial experiment in art, and a minor one at that. From this point onward until his death in 1953 Picabia's paintings constitute an extraordinary mixture of historical quotations, sentimentality and kitsch, which, like the case of de Chirico already described, court banality in literally case after case. We may wish to remind ourselves that Picabia was a former Dada artist; and that his return to parody may be attributable to his conviction that anti-art has no authentic antithesis. As he said in 1924, 'I am the only one who, after the death of Art, has inherited none of it: all the artists who follow its procession . . . figure in its testament; me, it disinherited me, but it thus left me free to say everything that passes through my head and to do what pleases me'.[20]

Figure 45

Of the various explanations which offer themselves for the Picabia phenomenon, it is perhaps the lifestyle of the artist that presents the firmest possibility. An owner of several yachts, dogs and expensive automobiles (127 according to his wife), Picabia liked to play the casinos in Nice and socialise with rich friends in the leisure centres of the Midi or Paris; and within that milieu undertook several commissions for bar decorations which certainly attracted a parodic, light-hearted style. Within this wealthy international milieu, however, Picabia came to see himself as typical of a certain kind of modern person — able to buy anything, go anywhere, do anything. Although he constantly describes himself in articles and letters as painting his 'own nature', his own 'interior desires' (he says he wants a painting 'where all my instincts have a free course'[21]), those desires seemed to reduce, in his case, to a kind of free-ranging acquisitiveness of the kind that his paintings themselves contain. 'Life for an artist', he wrote in 1929, 'must be to work for himself without preoccupation for the results of his work . . . this story seems to me to express modern life: desire to acquire quickly, without control, something facile, something . . . of poor quality which sparkles'; and then he makes reference to the 'hybrid and inviable result' of the artist who works in this way.[22] Do we hail Picabia as an important progenitor of post-modern sensibility — like de Chirico — or do we see him as corrupted by the infinite possibilities for travel and acquisition which his wealth put in his way?

My third example may bring the question into somewhat sharper focus. In much of his post-Second World War work, when Picasso was in his sixties and beyond, one can see a curious loss of intensity, an inclination to repeat his own earlier devices of drawing and an increase in the number of works which seem flawed, even failed, in point of compositional or expressive power. In November 1945, for

111

45. F. Picabia, *Adam & Eve, 1941/3*

example, Picasso was introduced through Braque to the
studio of the great Parisian lithographer Fernand Mourlot,
and turned away from painting to the very different artistic
techniques of lithography, aquatint and dry-point etching.
Linocut he also began to handle as an alternative to the
action of paint on canvas — though he did not actually
cease to paint. The numerical majority of Picasso's images
from this period of graphic work turn out to be undeveloped
jottings which often repeat a motif found previously in a
painting, such as the seated woman or the portrait head;
meditative notations which are quickly abandoned as the
artist rushes on to the next idea. Indeed these jottings are
the antithesis of the deep autobiographical outpourings on
the themes of love and death that had characterised all his
work, with intervals, throughout the first three decades of
the century. Aimed at no grand synthesis or final embodi-
ment, they invite neither interpretation nor 'reading' in
terms of the psyche or soma of the artist. They seem con-
cerned with taking stock of earlier work rather than with
pushing it further; with wandering freely among his own
earlier styles rather than developing new directions.
Undoubtedly this has led commentators to accuse Picasso
of going into decline artistically during his period of inter-
national success and (like Picabia) almost unlimited
wealth.

There is, for example, the prolific '347' series of etch-
ings and engravings of March to October 1968, many of
which appear to consist of a sheer crowded profusion of his-
torical and literary characters: cavaliers, muskateers,
pages, choristers, knights in armour, Cupid, Harlequin,
Rembrandt, Punch and Judy, and characters from Spanish
fiction,[23] all of whom are jammed together in a contem-
porary space, apparently without rhyme or reason, looking
at each other quizically but otherwise *doing nothing*. Indeed
it is the pronounced *inaction* of the figures in these works of
1968 that has caused commentators to announce what
seems like a loss of modernist grace on Picasso's part in his
eighth and ninth decades. And then there are the 'copies'
— though they are more than that — of old master paint-
ings by Delacroix, Velasquez, Manet and Courbet, not to
mention El Greco, Rembrandt and Cranach; transcriptions
of works by older masters in a modernising idiom which
depend not upon the experience of the world so much as
upon the experience of art. This dependence upon other
imagery, though part of Picasso's method at most periods
of his life, is undoubtedly different in character in this post-
war period when the older painting is explicitly *quoted*
rather than concealed. Before, he deferred to older painting
as a mark of respect, partly. Now, it is a matter of artistic

Figure 46    Figure 47

113

46. P. Picasso, *347 Suite,*
*no 135, 1968*

'borrowing' rather than original invention, of ironic re-working rather than critical distancing.

In fact these inactive 'tableaux' and quotational tran-scriptions alternated, in Picasso's case, with a return to a high modernist idiom of personal memory, fantasy and sex-ual longing such as perhaps had become occluded by the momentum of the rest of his work. The very last works of his life, for example, the sensuous and wilfully formless female nudes of 1969 to 1972, demonstrated a return to hedonistic subject-matter in a new painting technique, guided by what seems to be an ungovernable lust, a ripen-ing of style easily sufficient to preserve this part of his later work from charges of repetition, self-quotation and above all of self-parody (although we have no other nonegenarian paintings of the female nude on which to base a compari-son). Post-modernism and a continued modernism seem to exist side by side in Picasso's later work — just as they had seemed to do at the time of cubism. And a similar question arises. Are we to see Picasso's distracted nomadic charac-ters in his post-war work as some kind of defection from modernism — a joining of the 'other' camp of de-centred, author-less art; or do we account for these lapses in

Picasso's modernist trajectory as the result of his momentary privatisation, his unwitting encapsulation within the restrictive boundaries of fame, wealth and exponential media bombardment?†

In favouring the latter alternative in this case we do at least succeed in placing the post-modern artist within the frame of reference of the larger environment of media saturation and privatised relations. In a way, it is not surprising that this effect should have occurred earliest, and most completely, in the case of two very rich men — Picabia and Picasso — for they were able to avail themselves of consumable experiences and commodities before most other individuals could. Now, in the last two decades, the sort of free-ranging acquisitiveness 'enjoyed' by Picabia is a more nearly universal condition in the developed West. Abundant art publishing and television — both enjoyed by Picasso from the moment they were first available[24] — are now almost universal resources. In Picasso's adopted country of France the number of television sets in use was nil in 1945. In 1950, the number was four thousand; in 1955, 261 thousand; in 1960, almost two million; and by 1973, the year of Picasso's death, the number is some thirteen million sets.[25] It seems inconceivable that the exponential rise in television viewing had no effects upon the nature of post-war art.

Let us review once again the radically altered condition of both producing and consuming art in the post-war phase. What I have called 'television culture' is far wider and more all-consuming than the literal existence of television sets and the programmes that go with them. It includes (indeed mainly consists of) a hyper-active market culture that produces surplus goods of every variety without regard for function or long-term good — only short-term profit is relevant to it. It includes pervasive patterns of

---

†      Possibly the earliest reference to this problem is Max Raphael, *Proudhon, Marx, Picasso*, Paris, 1933, English edition, London, 1980: 'If we consider Picasso's art as a whole from the sociological point of view, the following results appear: An excessive multiplicity, a disturbing abundance of the most unlike aspects, both simultaneously and successively — inevitable in an artist whose personality is the symbol of the bourgeois ruling class, because he himself and his epoch are experiencing the most contradictory tensions . . . Today a great bourgeois artist is possible only as an eclectic genius . . .' (English edition, 1980, op. cit. p. 143). Raphael's 'inevitable' may appear somewhat tendentious today; yet his assertion that Picasso embodied twentieth century bourgeois consciousness in all its confusion; that he 'time after time discovers forms in which the bourgeois class can assert and understand itself' (op. cit. p. 143) can be said to state the beginning of the problem that is being explored here.

multi-national trade which late capitalist markets require. It includes a predominantly hysterical 'low culture' of TV, advertising, promotion and entertainment which not only eradicates old patterns of participatory entertainment and enjoyment but also functions as a selling medium for late capitalism's largely worthless goods.

47. P. Picasso, *347 Suite, no 159, 1968*

To this catalogue of disasters one must add the pacifying power of television itself, which conspires to conceal political realities both at home and in different parts of the globe. The nuclear threat, rampant inequalities between first and third world nations, the effects of imperialist political-cum-trading ventures in different parts of the globe, these appear through the medium of TV merely as journalistic 'scoops' at a single moment, and are then lost sight of in favour of next week's 'story'. Television also conceals the means of its own production to the point of virtual invisibility. Seamless programme continuity, the constant 'control' exerted by interviewer, presenter, newsman; its constant refusal to provide information about the political and technological mechanics of programme-making; all conspire to give it, in effect, the appearance of a 'natural' medium whose images provide a 'natural' representation of

the world. Added to its cheapness, its availability and its notorious ability to passivise its audience, television thus soothes by omission. It encourages heterogeneity rather than fixed and intelligible viewpoints, induces confusion, rather than support for stable values and moral commitment; offers a collage of 'possibilities' rather than certainties or actualities. Post-modern art and the artistic situation of today will be singled out by future generations for its lack of moral or political direction, for its schismatic, heterogeneous quality; for its inauthenticity and for its failure to respond effectively to the wider crises of our time.

Television *per se*, however, is by no means alone in its determining influence on art — but is only one factor amongst others. The invasion of the artistic sphere by business interests is also beginning to break the boundaries of that precarious autonomy of art which Weber and Habermas noticed as typical of modernity since the Enlightenment. Major exhibitions of art are now increasingly sponsored by multi-national business corporations wishing to embellish a tarnished corporate image by contact with 'culture'. The Tate Gallery's Pre-Raphaelite show of 1984 was sponsored by S. Pearson and Son Ltd., a vast network of international businesses which also owns Madame Tussaud's, Chessington Zoo, the London Planetarium, Warwick Castle and children's Ladybird books, published by Pearson Longman. The Royal Academy's Post-Impressionism bonanza of 1979-80, as well as the vast Renoir retrospective at the Hayward in 1985, received major sponsorship from IBM. The Royal Academy's notoriously conservative German Art in the Twentieth Century of 1985 was financed by Lufthansa Airlines, Mercedes Benz, Becks Bier, Bosch, Melita, Siemans and the Deutsche Bank. The Tate Gallery's Stubbs retrospective in 1983 was sponsored by America's United Technologies Corporation, whose subsidiary Sikorsky help design President Reagan's dangerous 'star wars' missile system. (The Tate's Francis Bacon exhibition of 1985, however, attracted extreme hostility from sponsors on account of the 'anguish' with which Bacon is associated.) Scandinavian Painting was 'made possible by Volvo'. The Tate Gallery's prestigious Turner Prize is awarded by an American investment company, one of whose directors was caught up in the massive Wall Street swindle perpetrated by the master-crook Ivan Boesky. The Arts Council's ultra-modern survey of European 'avant-garde' art in 1986 was financed by a multi-national junk-food conglomerate with extensive interests in South Africa.[26]

The fact that the image of the artist himself has changed drastically in the era of post-modernism is the final

117

significant development to be chronicled here. In the older and vanishing humanist culture it was still at least possible for a few individuals to live out the life of sensibility, observation, and a measured reaction to events. Now, under the regime of television, all such achievements of the mind and spirit must be reported to the viewing millions under the twin concepts of 'spectacle' and 'personality'. In most art shows in the capitals of the West it is significant that the artist is always represented not only as producer of the works on display, but also as a list of previous exhibitions, publications, awards and favourable reviews — a neatly-packaged life-history. In New York or Milan and to a lesser extent in the older humanist centres of London or Paris, it is now also customary to greet the arrival of a new artistic 'talent' with all the razamataz normally reserved for a film star, a sporting hero or a pop musician.

In New York particularly, the image of the glamorous celebrity has taken over from the concerns of art. Jennifer Bartlett's profile in *House and Garden*, Vogue's style-conscious visit to the home of Julian and Jacqueline Schnabel, or its cover photo of Francesco Clemente, were merely among the first signs of the elevation of the artist to the status of media star. 'As artists become the subjects of increasing media hype', says a recent American report, 'high visibility and upward mobility are defining their (i.e. artists') lives. What they wear and where they live and play, as much as the art they make, are topics that attract the seemingly insatiable curiosity of a starstruck public.'[27] In fact the site of fashionable art is no longer the studio or the gallery, but the nightclub opening. The opening of the Palladium night club in New York in May 1985 was one of the most heavily publicised events of that season, in which jaded members of the old guard like Henry Geldzahler (appointed 'club curator' following his retirement as curator at the Metropolitan Museum) mixed with glamorous pop stars and instantly forgettable glitterati in an orgy of narcissistic display. Artists, rather than their art, are becoming the *crème de la crème* of the popular celebrity type. 'Artists are the focal part of the '80s', says New York nightclub owner Steve Rubell; 'they're the celebrities now in the same way fashion designers were in the '70s and rock stars in the '60s.[28]

In England, too, the image of the artist is increasingly that of a celebrity. Never before has so much Sunday-supplement space been given to the life-style of the glamorous artist, and so little to the content of his pictures or the market economy into which they are so lovingly inserted. Interviews with artists omit to an unparalleled degree any reference to the aesthetic programmes that they may be

attempting to pursue. Details of where an artist lives, and
with whom, when he gets up and what he eats, what shoes
he wears and who his friends are, these details are now
avidly sought out by the art-consuming public, who have
already been instructed by television and the tabloid press
that they contribute substantially to what or who the indi-
vidual *is*. Throughout the English-speaking world the
original Hollywood concept of stardom is preparing for art-
ists a role which they may not be able to survive.

Such a greeting was accorded recently to New York's
Day-Glo revivalist Kenny Scharf. A writer for Art News

Figure 48

48. K. Scharf, *Felix on a
Pedestal, 1982*

accompanied Scharf on a trip round New York in his
'customised' *Suprema Ultima Deluxa* automobile, recording
his gossip and the activities of his nightclub friends — their
looks, their clothes, their dance crazes — and only secon-
darily his art. 'When I was seven' Scharf told our intrepid
reporter, 'we got our first colour TV, and I used to sit real
close, and I would see these intense colours, like dots.

119

That's the kind of colour I like . . . The whole thing about
fun — I think that having fun is being happy . . . its like I
want to have fun when I'm painting. And I want people to
have fun looking at the paintings. When I think, what
should I do next?, I think: more, newer, better, nower,
funner'.[29] Scharf affirms that from his childhood, his cen-
tral memory is of watching television. Now, his paintings
are apocalyptic and bizarre. He recently did a series of pain-
tings, 'six paintings, maybe seven — I don't remember. It
was like a series or cycle — it was the story of Estelle. She's
having a pizza party, and a Martian comes out of the TV set,
and she gets a one-way ticket to outer space, and she just
floats out there, having fun. In the last picture, she's just
kind of having fun by herself, floating and watching the
world blow up'.[30] These paintings indeed contain the
'phone-doodle psychedelia, the magpie delirium, the flash-
ing characteristic dazzle' of Scharf's apparently alienated
and narcissistic life.[31]

Post-modern 'euphoria' could hardly be better
exemplified by the Kenny Scharf example — not as a new
'position' in critical theory but as a real effect, corrupting
real people in a real situation within a culture of excess. A
New York analyst writes à propos this frenzied consumer
consciousness of a 'new type of patient' who is now pre-
senting himself. The classical neurotic for whom traditional
psychoanalysis was invented typically suffered from symp-
toms which were lodged in a self that was otherwise intact.
He presented problems that were centred around inhibi-
tions in love and work, a sense of guilt, and high-level social
and sexual anxieties. The 'new patient' by contrast, has not
even progressed to the point where a stable identity struc-
ture has coalesced. 'Typically he or she suffers from feel-
ings of emptiness, isolation and futility, pre-Oedipal rage
and primitive separation, annihilation, and fragmentation
anxieties . . . which can be masked by gradiose narcissistic
fantasies which in many instances prove socially adaptive'.
The connection suggested by these examples is between
the narcissistic but fragmented personality structure and
what the writer calls 'the marked intensification of the pur-
suit of material success, power and status; an increased
preoccupation with youth, health, and glamour . . .
accompanied by difficulty in forming on-going relationships
with emotional depth'.[32]

If this analyst's experience is typical, then it becomes
clear that narcissism is to our society what hysteria was to
Freud's. Excessive alienated narcissism which may in some
tenuous sense also be socially adaptive has come to domi-
nate the personality structure which is becoming 'normal'
in the hysterical consumer societies of the West. Artists too

now find themselves increasingly under pressure to submit
to this personality-type, and to produce art which appeals
only to observers of the same or a similar ilk. And this syn-
drome lies at the heart of the post-modern artistic condi-
tion. This art responds to the conditions which surround it,
but is compliant with these conditions as well. It does little
more in the majority of cases than tell us what we already
know.

Fortunately, there are certain exceptions to these
generalisations even within our present system of art pro-
duction, and in the next and final chapter we shall examine
what these are and how they contain possibilities for an art
which is both resistant to consumer capitalism while at the
same time not yet ghettoised within perpetually inward-
looking artistic debates — versions of art about art. Some
artists are attempting in different ways to do more than
simply 'reflect' that which is given in late capitalism, but to
show how other methods of social organisation and per-
sonal relatedness may obtain in a different sort of society.
The recovery of these examples and the uses to which they
may be put is the final topic to which we must therefore
turn.

# ART TOMORROW: AN ARGUMENT FOR REALISM

In turning our attention to the art of the future, a number of qualifications must inevitably be held in mind. The first and most obvious is that we cannot predict — not even in a capitalist society whose trajectory seems inexorable — what actual works or types of work creative individuals will make in the future. That is not our purpose — only to speculate what conditions might make certain types of work more likely to occur. Secondly, it is not only the actual content of works of art that we wish to specify, although some of that can usefully be done; but the types of institutions, the processes of decision-making and financing, that will be needed for this type of cultural activity to take place. Also — overwhelmingly — we need to be specific about the purposes which art should try to serve in the society of tomorrow, or the day after tomorrow.

Let us remind ourselves of the argument so far. In the last two chapters we were concerned to show how artistic modernism was part of a wider process of societal modernisation which includes the self-improving project of science, the utopian mission of technology since its inception, and the promise implicit in the whole of secular modern life that justice and happiness are in principle possible for all. These modernisation processes, we argued, though redemptive in intention, were unable to fulfil their own promises, in spite of certain impressive gains and achievements. What is then called post-modernism appeared not as an autonomous development within the artistic sphere

alone, but as a result of the alienating pressures exerted by extreme modernisation processes elsewhere — in science, technology, and the 'low cultural' products which the technology-dependent media carry. As such, post-modernism represents not a schismatic break with modernism — a kind of anti-modernism — but a self-deceiving evacuation and dilution of earlier modernist norms. In any case, to the extent that post-modernism appears on the historical stage chronologically as a 'successor' to modernism, it partakes of precisely the dynamic of renewal and perpetual self-improvement that is the hallmark of modernism itself.

We also saw in an even earlier chapter that modernism was a kind of humanism; and for two related reasons. First, it was predominantly subjective, in the sense that it depended on, and invited attention to, the explicit action of manipulating the material of paint in the construction of images of the world. We could say that modernism was in this sense artist-centred: it attracted attention to the artist's way of seeing as presented in his manipulative, material language; and thus its meaning as redemptive form could often be elucidated by reference to the artist and his particular psychopathology. To the degree that post-modernism is paraded as anti-modernist, therefore, it takes on the guise of an anti-humanism as well — a posture which, likewise, one might wish to question.

However, none of these 'positions' are of much interest in the abstract — for they must be associated with goals to which art can aspire, or a type of society in which such goals can be achieved. Indeed the wider 'humanist' envelope of earlier modernism needs expanding — or perhaps narrowing — to embrace an explicitly political posture which aims at the transformation of events through art. This does not imply that art alone can create a transformative or revolutionary consciousness. For its efforts must be tied increasingly to events and processes in the other spheres of technology, politics and jurisprudence.

The overall political perspective implied in this vigilant new humanism is obviously socialist — one based on broad ideas of equality, the control of the means of production and the eradication of injustice throughout the world. In its way, socialism itself is a modernising theme, since the project of modernity since the Enlightenment has run concurrently with a world-wide movement towards democracy, equality and fraternity in social relations which, though impeded at many points, has had an overwhelmingly successful — if gradual — impact upon relative levels of wealth and opportunity within populations. Progressively since the end of the eighteenth century whole

nations have thrown off their feudal or aristocratic yokes, and in so doing, have forced a break, an opening, in the cycle of historical domination of certain masses of people by others.

Also, humanist socialism implies a type of agency for the individual — artist or otherwise — that accords well with his perception of himself as a *relatively* free social being, able to determine the course of events through the exercise of his own will. Thus the humanist and socialist artist can continue to think of himself as capable of exerting an influence on events, while also seeing those events as themselves partly determined. He need not carry the Althusserian burden of supposing that his own will has been 'constructed' in social life[1] — nor lapse into the existentialist position of supposing he is totally free and responsible for the nature of his entire world. What is implied in this socialist-humanist posture of relative autonomy for the individual is that art should continue to be redemptive — capable of transforming life. The ends of this redemptive process must now be social goals, however, and not merely private ones alone.

Therefore the question to be answered here is not: What will the revolution do for modernism? — the answer may not be, to abolish it[2] — but: What can modernism do for the revolution? Turning again to the modernist past, we must begin once more to balance the gains and the shortcomings of its typical works. Its rational, utopian ambitions — by which we mean 'functional' design, purified architecture, scientific sociology and its orientation to technology — have all by and large turned out to be unpopular, restrictive, even coercive forms whose hey-day in the physical environment is now probably over. At least the arguments in that quarter seem comparatively simple.

In modernist visual art of an earlier period, we noticed that the dominating subjectivity of the autographic approach to style was also a problematic, even if initially creditable phenomenon. We saw how the Symbolist aesthetic in France, with its emphasis on the uncovering of 'temperament' through style, lead directly to the modernist concept of the painting as 'another living person with whom we are conversing' — a process aimed implicity, not at the creation of a final static image, but at the completion of a *process* in which, to use Matisse's words again, 'the work comes into harmony with me'.[3]

The very idea of such a subjective form of art is open to various objections. Marx himself objected to Rousseau's maxim that 'the love of man derives from love of oneself'; on the basis that self-knowledge must never precede community, but must always develop within it. In actual fact, of

course, modernist subjectivity never entirely of the Rousseau type — I am not sure what could be — since the painting is functioning as an individual with whom the artist is communicating. The surface in early modernism is literally endowed with the qualities of a nurse-figure who can accept the fragmented projections of the artist better than the artist can keep them to himself.[4] Or consider the setting of the psychoanalytic transference, a community of two, in the midst of which subjective knowledge is generated on both sides. The modernist artist and his materials may be considered likewise a sort of proto-community, which may nourish other relationships in due course. The spectre of a subjectivity that an individual can somehow generate by himself is surely an illusion.

A more genuine weakness in modernist subjectivity arises from the fact that modernism was a minority culture. Its implied promise that all mankind could identify with the modernist impulse — become a modernist artist — was an illusion, though possibly a persuasive one. Nor could modernist subjectivity really be *taught*, except to the small number of initiates whose education and background suited them for the experience. In fact the transmission of the idea of subjectivity from generation to generation was possibly modernism's most difficult task. In fact the promises of modernist art generally, even beyond its subjective phase, constituted a shamefully inadequate prognosis for our century. Mondrian's squares which stand for 'pure universal relations' of humanity obviously offered no solace to the victims of Dachau and Auschwitz. The luxury decorations of Dufy or the later Matisse offered little comfort to the dispossessed or hungry of the world. The graceful architecture of the international style presented only an image of corporate power to the struggling nations of the third world.

One faces here an extremely difficult and yet also an extremely important critical dilemma. For, on the one hand, modernism's subjectivity — however impressive and beguiling in certain cases — was ultimately too exclusive and too limited to be of value beyond the confines of the artist himself and the intellectuals who were able to understand its workings. The very lifestyle of the modernist artist, after all — committed to the solitude of the studio and a restricted social group — was probably too unworldly to provide the real tests by which the 'self' could be truly developed.

The modernist art of both Kirchner and Beckmann, for example, entered into distinctly uneasy relations with the shattering and corrosive events of their time. Faced with the horrors of war in 1914-18, or of cultural reaction

after 1920, their modernist methods first facilitated analysis of both the self and the outer world, but then collapsed, after 1920, into mysticism or sentiment or suffered some other loss of intensity — by which time the crisis of modernism generally (de Chirico and Picabia again) was well under way.

Kirchner, for example, descended through the medium of his 'expressionist' style of elongation and distortion to undertake a savage analysis of the ills of the capitalist metropolis, in his case Berlin. In doing so, he achieved some insight into his own estranged position as a producer of culturally adventurous images; to the point of identifying himself around 1913 with the prostitutes in his pictures. Unable to truly love others, Kirchner recognised that he could make only pictures of his condition, and sell them as gratifications in return for money.[5] After his conscription into the German army in 1914 and his mental and physical collapse a year later, the practice of art helped him survive, in providing solace from his condition. But his modernity here was a mixed blessing. It helped him to achieve identifications that were probably not available elsewhere — but it had also helped precipitate his crisis in the first place. After Kirchner's modernist 'moment' of 1913-17, it then left him with nowhere to go in his paintings after 1920, and he lapsed — like Munch had done after his 'crisis' of 1907-8 — into sentimentality.

Beckmann's story is also relevant. His 'modernism', that is, his flat-surface construction and his crowded pictorial surfaces, to originated from phobias about loneliness and about the 'deepness of space', developed during his war-time service near the front line. Before the war, Beckmann had defended a sensuous, painterly style of rounded volumes and rich gradations of space. Even in 1914, he decries what he calls 'the current fad for flat paintings'. 'I try to develop my style exclusively in terms of deep space, something which . . . penetrates as far as possible into the very core of nature and the spirit of things'.[6] Then, in the war itself, his style changed completely. Beckmann is billeted near the front line in some of the fiercest fighting of the war, but continues to draw and paint the harrowing experiences around him with almost compulsive interest. In his letters from the front, he describes his artistic work as an instrument for coming closer to a 'truth' about events which only art could provide. His allegorical style falls away — he had painted pictures of the Titanic sinking, and the earthquake at Messina in Sicily — to be replaced by a more shallow, splintered and crowded manner. He writes late in 1914 of the fascinated horror he was developing for 'space, distance, infinity'. By 1915 he speaks of '. . . this infinite

space, the foreground of which one must even fill again with some sort of rubbish, so that one will not see its terrible depth . . . thus to cover up to some extent that dark black hole'. Art, he writes elsewhere, is 'self-enjoyment . . . in its highest form: awareness of oneself'.[7]

But like Kirchner before him, Beckmann then suffered a breakdown after which his art soon took on an almost unimaginably strange dimension. In fact Beckmann did not decline into sentimentality like Kirchner, but veered back into allegory, with his newly found modernist style virtually intact. But his allegories now were no longer simple statements about human folly or uncontrolled instinct; but — as his triptychs after 1933 show — quasi-mystical works of transcendent generality which responded to no actual events and which only glancingly referred to the cultural nightmare of the Nazi period which had by then begun. Modernist subjectivity, on this analysis, was simply unable to cope with the crisis into which Europe in 1914 was plunged. Having possessed all the potentialities of a genuinely revelatory style, it sank under the pressure of events, to be revived in later incarnations (American art after 1945) merely as melodrama.

Yet equally, our century stands indicted for having failed to nurture subjective life in all its richness and revolutionary potential. In a society organised differently, for example along the lines of pacifist or quietist principles with a surplus of leisure time for all, one can imagine how such a specialised type of subjectivity might have taken hold. As things were in our century, subjective modernism became intelligible to a wider public audience *only as style*, at its worst a sort of evacuated 'expressiveness' that signified only absence of control, 'freedom', and a free-floating individualism that in practice — as in the recent 'new' expressionism — possessed no critical self-consciousness at all. Faced with these examples, it becomes a matter for regret that the profounder meditative leanings of modernism could not have passed directly to a wider social franchise.

Are we to conclude then that modernism was simply unable to connect its subjectivism — fascinating and often powerful though this was — with a clear appraisal and critique of outside events? Modernism's most vigorous critical moments, after all, constitute attacks upon the body of art — as in Dada and Surrealism — more than upon the trend of public events; and, as Habermas correctly pointed out, confused its own purposes in the process. Modernism might have questioned the processes of capitalism instead — such as means-end rationality, military expansionism and the alienation of labour — the truly baleful processes of

our day.[8] In today's conjuncture, are we to re-kindle the kind of subjective art that modernism was before 1914? Or are we to lurch·to the opposite pole of realism? Or can we reconcile the demands of external reference with the subjective richness of surface that modern works of art can and do provide? In short, can the subjective dimensions of earlier modernism be reconciled with the external references demanded by a visibly socialist art?

There are various responses to this question. Firstly, one should be able to recognise that what was intelligent and liberating in earlier modernism was partly the discovery that the old Academic manner in any of its forms was not and cannot be the only manner possible for the construction of visual images. More importantly, modernism discovered — without stating it directly — that Academic art was the art of the ruling classes of Europe, and hence an art of coercion and control. For these reasons alone, it must be undesirable to abandon completely the results of the modernist experiment. Secondly, what once existed as subjective, autobiographical art — the modernism of the pre-1914 era — was, we noted, registered in the public domain predominantly as *style*. Indeed the stylistic cornucopia thus created was modernism's greatest public achievement — although its innovations became re-interpreted and re-used in later decades according to time, place and circumstance. Style in art in our century, like style in fashion, thus became a language capable of almost infinite variety and diversity, whose only weakness was its hermeticism, its tendency to privacy. These facts suggest that *modernism as style* may have uses which cannot yet be said to have been exhausted.

Secondly, one needs to recognise that certain twentieth century works of visual art combine marvellously to render the dimensions of an outside event with a visual and textural richness that only modernism could supply. Beckmann and Kirchner themselves accomplished this duality in the most powerful of their early works —

Figure 49 Beckmann's *Night* of 1918-19, for example, or Kirchner's Berlin street scenes from 1911 to 1914. But this general argument finds its most fitting and impressive early exemp-

Figure 50 lification in Picasso's great painting *Guernica,* of 1937. By 1937, cubism as an autographic, subjective style[9] had become adapted by Picasso to public purposes of a heroic kind. The bombing of an undefended Spanish village by fascist aeroplanes was understood as a symbol of ideological conflict in the twentieth century. Its re-representation in a style of fractured, expressive, broken and yet morally determined forms, together with its sub-

sequent successful popularisation as an image of resistance throughout the world, is one of the greatest public triumphs of modernist painting.

49. E. Kirchner, *Potsdam Square, Berlin, 1914*

*Guernica's* origin in an actual living circumstance of real human suffering was surely exemplary. Here was an historical moment of fantastic barbarism in which innocent victims were burned, maimed, or killed. And yet the symbols of resistance and of the determination to struggle — the raised neck of the injured horse, the redeeming lamplight of the rescuing woman, itself one of the constant features of Picasso's heavily re-worked composition — are firmly placed on view at the centre of a work of epic proportions in both physical and imaginative terms. And yet its formal ingenuity remains a dazzling example of the modernist method at its best. Picasso's linear treatment is nowhere simple. Forms constantly interpenetrate within a spatial and linear framework of great complexity and fascination: attention is forced constantly to oscillate

129

between the details and the larger masses of the design. A sense of shattering destruction is provided by the splintered drawing, but is yet pulled into a triumphant triangular tableau at the centre of the work. On a visual, organisational and also moral level, *Guernica's* power and legibility have scarcely been equalled by modernist painters anywhere.

50. P. Picasso, *Guernica*,
1937

Today, fifty years on, our task is to recuperate what was intelligent and liberating in earlier modernist art in a world that faces very different questions from those of fifty years ago — questions such as the dominance of media culture, the creeping immanence of multinational business penetrations, the obscene stockpiling of destructive weapons, the increasing predominance of 'mobile-privatised' relations and the almost complete loss of visibility of who the individual in such a society might be.

Clearly, such a re-orientation in art to objective events — to happenings and circumstances which really occur in our society as it is — raises the legitimate question of what is objective, and to whom. Socialism today articulates a theory of what is real (that is, historically relevant and progressive) — but cannot claim to possess the whole truth for all individuals at all future times. Therefore, if the artist is to function redemptively in the society of tomorrow; if he is to think of himself as a human agent capable of original perception and thought; then necessarily an account of what is 'objective' must to a certain extent be left to him to decide in the light of the circumstances of his time. Also — and here I anticipate a conclusion that we shall come to again — regional variations on the overarching socialist theme must remain his to determine in the light of local conditions.†

Of course, no limitations can be imposed from without upon what individuals may produce with the materials

and forms of their own possession. What can be specified to some extent, however, are the values that are allowed to circulate *publicly* concerning art and the functions of art within the social body. Our question about the reconciliation between modernism and socialism must therefore at some point be brought to bear on the *institutions* of art, where decisions concerning the values, the display, and the meanings of public art are made within the public domain. And here, certain factors seem relatively clear. It seems clear that any retrieval of modernism from its position of post-modern collapse must also answer to the interests of more than just a minority specialist population. A far wider constituency of persons must come to feel themselves part of this renewal of artistic effort. They must be enabled to identify with the process of making, selecting, evaluating and conserving that which is deemed valuable in the cultural process; and this must mean something other than reverting to the 'popular' culture of crafts, hobbies and sentimentalia — this version of popular culture, as noted before, having already been impoverished and endlessly diluted by the passivising processes of TV. Equally, since the urban sophisticate who craves 'crunchy' subjective surfaces will continue to exist, his taste for ambiguity and fragmentation will have to be tolerated, until such time as his consciousness can be uplifted by the growing socialist vision. But his dominion over the selection and editing process must be progressively limited, under the socialist cultural outlook being developed here. As other interest groups and other topics of concern are allowed to touch upon the creative process, his hold over the management of the arts — and his taste — must gradually diminish and fade.

Figure 51

As far as the structure of the arts institutions are concerned, the main desiderata are democracy and accountability; and decentralisation. Inevitably, the Arts Council will be one object of attention in any discussion of institutional change of the arts in Britain, and yet its basic mode of operation has not changed since it was set up in 1946, coincidentally the beginning of the post-modern era. At present, it is, of course, remorselessly undemocratic in

† We are not talking here, of course, about expressions of outrage against human catastrophe, war, murder and destitution that occur 'naturally' in the population at large, such as the extremely moving drawings and paintings that were done in the wake of the bombing of Hiroshima and Nagasaki at the end of World War Two. Works such as these will continue to be made in a variety of circumstances, and require no justification. They have been very adequately reported in a recent book by Guy Brett, *Through Our Own Eyes, Popular Art and Modern History*, London, 1986.

51. Rodney Charman,
*Poole Quay by Gaslight*

how and for whom it performs. It exists to distribute public
funds to arts projects all over Britain, and yet its com-
mittees are not elected and have no responsibility to anyone
except themselves. Governments in Britain have vacillated
endlessly on whether a Minister for the Arts should exist,
but the status quo which keeps the Arts Council in exist-
ence is still the 'arms length' principle of detachment from
Government, and yet indebtedness to it, through the
Treasury, as its only source of revenue. Further, no deci-
sion on the financing of artistic projects by the Arts Council
is ever backed up by reasons, and the general public has
virtually no idea why or how particular decisions are
reached — and no means of finding out. It goes without
saying that such an arrangement is incompatible with
socialist culture and would need gradual revision in the
steady progress towards socialism which is the inevitable
historical pattern of the future. In this future, the liberal-
centre politics of the Arts Council would disappear; its com-
mittees would continue to be experts, but would represent
*identifiable* groupings of interest; and the general criteria of
judgment would be determined either directly by a Ministry
for the Arts or, as the British Labour Party proposed in
1977, by a National Conference for the Arts and Entertain-
ment which would be a national democratic forum for arts
discussion.[10]†

Decentralisation will also be needed by a British
socialist humanist culture simply because the concentra-
tion of power in a single place — the metropolis — removes
it effectively from the interests of the mass of the popula-
tion. At present, other homogenising cultural establish-
ments such as the BBC and the 'national' press have a
parallel function of breaking down regional cultures to the
point of virtual extinction, by treating the country in prac-

tice as if it were one unit. Outmoded stereotypes such as northern 'enthusiasm' versus southern 'intellect' persist; and rapid communications and transport networks have helped solidify the general assumption that regionalism in culture is now a forgotten idea. But economic, demographic and social information shows us that homogenising national and international culture is only an overlay on longer-lasting patterns of regional variation which continue beneath. In a truly socialist culture, these regional differences would need re-finding and re-defining, free of stereotypes. Art would follow suit — but its multiplicity would be very different from the multiplicity of post-modernism, which tends always to the cynical and inauthentic. Indeed, this new heterogeneity will be based on responsible reactions to local needs, and to the multiplicity of human creativity when unleashed from domination by market interests and the stereotype of art as a commodity.†

Educationally, too, socialist humanism would need to find different ways of training artists. It is here, above all, that the connectedness of art with the assumptions of the remainder of society becomes all too prevalent. At present, the training of artists is beset by problems that are probably too numerous to mention in a brief analysis. Artistic training at school is virtually non-existent; or else artificially down-graded in importance to take equal rank with spare-time activities such as cooking and games — a clear sign of the power of art to subvert cherished values and assump-

†     For a recent policy announcement, see Norman Buchan, *Burning Down the House: Labour's Arts Policy,* Fires, No. 2, Autumn 1986, pp. 31-3. Buchan states that 'our aim is to establish a genuine and popular cultural democracy . . .'; that 'a major and central part of our development policy, in line with our general philosophy, will be in the field of community and ethnic arts. Support for organisations such as black music, video or theatre groups and projects such as the Roundhouse will be forthcoming . . . arts centres will have an expanding role . . .' (p. 33). Along with the faintly *deja vu* nature of these prescriptions, the policy as a whole is extremely short on references to types of artistic content that will be deemed worthy of support, and runs the risk of the dilutionism and lack of commitment which has been at the root of Labour Party arts policy in the past. All the same, the replacement of the Office of Arts and Libraries section of the Ministry for the Civil Service with a fully-fledged Arts Ministry, along with the democratic restructuring of the Arts Council along regionalist lines, is certainly in line with the argument being developed here.

†     Cf. Ernst Fischer, 'It is more likely that a wide variety of styles will be the new characteristic of a culture and age in which nations will merge into one; new syntheses will destroy all that is parochial and static, and no centre, either of class or nation, will predominate. In a classless society we are likely to find a *multiplicity of styles'. The Necessity of Art*, London, 1959, pelican edition, 1963, p. 223.

tions. 'Professional' art training after the age of eighteen, which begins from this already low base of draughtsmanship and art-historical awareness, re-duplicates the theoretical vacuum of the school environment, but overlays it with the philosophy of the liberal-expressive part of modernism without any attempt to engage with the problems of society at large. This failure to establish goals for the training of artists is accompanied and surrounded by the development of ultra-specialist 'discourses', which mystify the activity of art and result in serious misrepresentations of the various traditions which have historically sustained it. A small part of such a training is given over to art-historical and art-theoretical learning, but no space in the curriculum is reserved for politics, the analysis of civil institutions, or the role of the media in contemporary social formations. At the completion of his training an artist in present British society is turned out onto a labour market in which unfortunately there are no jobs — as artists, that is, as opposed to important ancillary professions like teaching or the service industries. These expensively trained people continue to survive, as artists, strictly on the margins of society, along with tarot readers, water-dowsers, gypsies and self-employed odd-job men, simultaneously embodying the values of the dispossessed and marginalised 'other', but also paradoxically embodying the American liberal quest for self-generated 'success' and magical charisma. It is indeed the aura of the artist that should now concern us more than that of the art-work.

It must be a fair generalisation to say that all the other NATO countries of Europe possess broadly comparable arrangements for the dissemination of funds to arts projects and to the training of artists. And it is no coincidence that they all — as any glance at the latest art magazines will show — promote art of an excessively open, individualistic, spectacular and less frequently challenging kind that adheres closely to the trend of the moment as promulgated simultaneously in the advertising columns — at present the trend of post-modernism.

In terms of this content rather than its institutions, the most fundamental re-orientation now needed for Western contemporary art — NATO art, if that is indeed what it is — is the long-lost virtue of *realism*. But this must also be the kind of realism demanded by socialism, for socialism cannot replace capitalism without providing images of that which it wants to destroy and that which it wants to create.

The problem however is that realism in the twentieth century belongs to just those countries whose enthusiasm for NATO modernism has been dim, if not at times entirely

absent — an antagonism which the NATO countries have done plenty to sustain. Thus the most important historical lacuna in the Western perception of art, is the complete and extraordinary failure to learn lessons from the Soviet example — as if this was somehow not also part of the European tradition in art. After the events of the October Revolution of 1917 and following the death of Lenin in 1924, Soviet art gradually redirected itself to take account of the great traditions of realism which it had nurtured in the nineteenth century. What obligations were placed upon artists by the burden of socialist intensification, asked Andrei Zhdanov, the much reviled spokesman of the new Soviet realism of the 1930s? 'It means, in the first place, that you must know life to be able to depict it truthfully in artistic creations, to depict it neither 'scholastically', nor lifelessly, nor simply as 'objective reality', but rather as reality in its revolutionary development. The truthfulness and historical exactitude of the artistic image must be linked with the task of ideological transformation, of the education of the working people in the spirit of socialism. This method . . . is what we call the method of socialist realism.'[11]

Staunchly anti-modernist in the Western European sense, Soviet art still obeys the three guiding principles of socialist realism first laid down at the First All-Union Congress of Soviet Writers of 1934; these being *partiinost'* (fidelity to party spirit), *klássovost'* (class awareness) and *naródnost'* (literally people-ness). In 1934, Maxim Gorky pronounced that the new method was a creative programme that aimed to realise revolutionary humanism. 'Socialist Realism', he said, 'affirms being as action, as creation, whose aim is the uninterrupted development of each person's most valuable qualities so as to attain victory over the forces of nature, man's health and long life, and the great happiness of living on the earth'.[12] This vision of socialist humanism fosters 'the harmonious development of the individual, the full realisation of each individual's moral and spiritual potentialities, and a truly humane attitude among people toward one another and towards nature and society', says an article by Markov and Timofeev.[13] Though frequently re-interpreted and misunderstood, socialist realism guides Soviet art training and aims practically at stabilising and affirming socialism throughout the world.

The Soviet programme for the training of artists, compared with that of the West, at least has the advantage of being planned according to explicit national goals. To take one example: the prestigious Academy of Arts in Leningrad accepts only limited numbers of students, who themselves have already received special training in school.

Now operating merely a six-year course (in the nineteenth century the course was fifteen years, with nine years spent in drawing), the Academy offers general courses in painting, sculpture, architecture, conservation, pedagogy, art history, anatomy, Marxist philosophy and political thought for three years before specialising in a limited way for the second half of the course. Except for those who will receive a three-year post-graduate training to become advanced teachers themselves, all graduates are found a job, given a small salary, and have reasonable prospects of joining the Artists Union, centred in Moscow, through which they can participate in exhibitions. Though functionaries of the state, the Soviet artist at least theoretically identifies his work with that of the state and willingly abandons the individualism and subjectivism which that same state associates with modernism in the West.[14]

It is neither possible nor desirable to establish a Soviet-style socialist realist aesthetic in the West, because the USSR is at a different stage of historical development and has different traditions of realism in its foundations.[15] But such examples remind us that alternatives exist to the 'liberal' models of art and art training now available under late capitalism in the West. They remind us too that unless art is to continue to be regarded as a 'phenomenon' that somehow happens 'naturally' by itself, in some sense paradoxically free from connections with the rest of society, NATO art will persist along its present peculiar and inexplicable course, serving no one and representing nothing other than the esoteric interests of a limited segment of an already corrupted art community.

Also, greater understanding of the genuinely popular and truly inspirational qualities of the best Soviet realism Figure 52 (the paintings of Repin, Deineka or Serov, the sculptures of Merkurov, Vera Mukhina, Kibalnikov, and others) might come to show Western artists the possibilities inherent in a tradition other than their own; which they might then come to graft on to resuscitated traditions in their own countries. The very rhetoric of socialist realism is inspirational, quite aside from its typical works. Vera Mukhina — to take but a single example — struggled to revive monumental public sculpture in the Soviet Union against the tendency of Western modernism to domesticate and personalise art. Figure 53 Her extraordinary *Worker and Collective-Farm Woman*, which was exhibited, along with *Guernica*, at the 1937 Paris World's Fair, is a gesture of heroic optimism for the capacity of socialist culture to create peace and equality on a world scale. Though detailed in outline and general conception by the Soviet architect Boris Iofan, it was Mukhina who won the competition and it was her acuity as a sculptor that

136

52. Vladimir Serov, (b.
1910) *The Winter Palace
Captured*

brought the project to such impressive completion.†Though
Mukhina had trained with Bourdelle in modernist Paris
from 1912 to 1914, her commitment to post-Revolutionary

†      Some insight into the workings of the socialist realist aesthetic in
practice are contained in the following report on the Paris competition
by D. Arkov: 'In comparing these (competition) models one can see . . .
an identical sculptural assignment presented variously, as through the
eyes of the different sculptors. In one instance the pair had stiffened in a
majestic pose: allegory had triumphed over the reality of life in these
cold 'classical' forms. In another model the gestures were exaggerated,
the fervour of the swift forward thrust of the dynamic figures, which
were to be an embodiment of the youth and strength of the socialist
country, was replaced by superficial exaltation. Several of the models
presented the group as a self-contained sculpture independent of its
architectural surroundings: in one case this was a monument which
could be set on any pedestal, in another the figures clashed with the
overall appearance of the pavilion, protuding beyond the building and in
every respect contradictory to the style and theme the architect had
envisaged. Mukhina found the only possible solution to the problem
. . .' in Vera Mukhina, *A Sculptors Thoughts*, Moscow, n. d. p. 12. The
statement demonstrates the baselessness of the Western prejudice that
socialist realism is a matter of artistic formulas; as well as the sorts of
considerations that go under the name of 'aesthetic' in this branch of
Soviet culture.

137

Sovietism was absolute. 'I wanted the figures to express the young and forceful spirit of our country, to be light, rushing onward, full of movement and determination. They had to be joyous, yet powerful in their forward stride . . . our success was due to the selfless effort of the workers, engineers and sculptors, united in their devotion to their work and to their common achievements and hardships . . . the psychological impact of the figures silhouetted against the Paris sky once again proved the great power of Art. I shall never forget', writes Mukhina, 'the sight of French workers stopping before the giant heads, which were still on the ground, and saluting them — for an artist's greatest aspiration is to be understood'.[16] Understanding has a public dimension for this paragon of Soviet realist sculpture.

But this realism must be tempered, in the aesthetic atmosphere of tomorrow, with those 'modernist' stylistic and expressive devices that were part of *Guernica* and similar examples of socialist modernist art that already exist. The category of 'the aesthetic' will come to contain a mixture, and surely a fertile one, of two paradigms that have already existed independently in the art of the twentieth century. Firstly, one postulates a degree of aesthetic pleasure which stems from the most basic realisation that the content of a work of art is relevant to the gradual ascent of the social body towards socialism. Its characters, actions and events must meet the needs of the people for identification, projection, and then the introjection of progressive ideas and principles, the 'aesthetic' function of which arises merely from the fact that such identification is in itself uplifting and ennobling. Partly, aesthetic pleasure arises here from the beauty of the vision which works of art arouse as to the future possible condition of mankind. For unmitigated despair and despoliation are *in themselves* thematically unaesthetic; whereas the celebration of human capacities can be aesthetically germane. As Soviet critics always say, bourgeois Western formalism 'has no theme'.

But secondly, the type of aesthetic participation in the picture that arose so vividly within earlier Western modernism must be nurtured and developed. I already mentioned the fact that the sophisticated urban taste for 'crunchiness' of surface — itself a vital part of the delectation-apparatus of modernism — is likely to diminish and fade with the gradual decline of the art bureaucracy in its present constitution. At the same time, participatory perceptual activity which is part and parcel of minimum engagement with a work of art must be sustained at some level for fear of letting art slide backwards into becoming passively consumed confectionery such as is already widely

53. Vera Mukhina, *Worker and Collective Farmer, 1937*

available in kitsch. Early subjective modernism flourished on the assumption of a recovery of the Kleinian 'depressive' position in which aspects of the mother-figure are destroyed, mourned, then 'repaired' constructively in a working-through of the sense of loss — a process to which the shattered surfaces of the picture were essential. Perceptual *activity* on this more subjective level must continue to be part of a vivid and ambitious socialist art.

Thus the task of a humane socialist modernism from an aesthetic point of view is to combine these two dimensions of aesthetic pleasure and awareness: modernist reparation being filled rather than emptied of content; with socialist realist subject-matter being progressively modernised and made consistent with the biological desire for overcoming of the sense of loss and the development of the beginnings of a new order. Equally, certain 'effects' which are today taken as aesthetic in the market-place of fashionable art — such as abstract colour-combinations devoid of content, ugliness for the sake of sensationalism, the uncontrollably bizarre or peculiar — will have to be renounced as art moves forward to occupy more substantial territory.

This brings us conveniently to the actual paintings and sculptures which will merit support in the humanist socialist community of the future.

At the moment — and this is something, ironically, that post-modernism has helped to bring out — the traditions of European art are far more strongly equipped to fertilise a socialist modernism than anything that is happening in the United States. The problems of painting in New York in the 1980s — with is fanatical consumerist hysteria and its capacity for turning experiences into sellable goods — have already been mentioned. Aside from artistic failures like Kenny Scharf and the other denizens of the East Village art scene, fashionable figures like Keith Haring have transformed the popular arts of graffiti and street protest into thousand-dollar art works with considerable investment potential. Having once been the urban underdog's response to the anonymity of the city, graffiti was transformed overnight to become a 'sensation' in the Sunday Supplements and living rooms of the rich. Only a few artists have proved capable of retaining some level of insight against the blandishments of the American city. The Dutch artist and former COBRA member Karel Appel, for example, still paints immensely vigorous pictures of New York itself, frequently of the city under threatening skies, which give a compelling and truthful image of the balance between culture and nature. The much younger Sue Coe, to take another example, is an English artist who takes a viciously jaundiced view of New York life, in a style that derives all its

Figure 54

power and authority from German art of the 1920s — a European precedent to which few native Americans have real access. It may even be that the immigrant status of European artists working in the city is a necessary ingredient in this phenomenon of critical engagement with the American scene.

Figure 55

54. Karel Appel, *Black Clouds over the City, 1984*

In Britain, an immediate and unproblematic source of strength is to be found in its tradition of caricature. In the eighteenth and early nineteenth century virtually every aspect of English life was brought under the mirror by artists of outstanding stature such as Hogarth, Rowlandson and Gillray. Considerable sections of the population developed a genuine demand for satirical prints of high life, low life, morality, politics, and public affairs. Based upon medieval sources and upon popular artists of the European tradition such as Bosch and Breughel, these prints were copiously displayed as wall decorations in the home, in workshops and in inns. In the 1790s they were collected in folios and could be hired out for the evening, or could be seen in exhibitions in print shops for a low fee.

Figure 56    Figure 57

Figure 58

    The decline of caricature in the 19th century was arrested in some branches of early European modernism, in which artists like Kirchner, Grosz, Dix and Meidner indulged in distortions of 'real' appearances in a manner very close to that of the older caricatural tradition — and with the comparable purpose of ridiculing the very appearances which they sought to portray. Although English art was almost completely bypassed by the full impact of modernism until 1945, its native capacity for caricature was kept alive in a strong tradition of newspaper cartooning and satirical journalism between the wars; and members and supporters of the Artists International Association such as the cartoonists Fitton, Boswell and Holland and the Marxist historian Francis Klingender, also nurtured a deep respect for the traditions of British satirical drawing. Even

141

under post-modernism a sense of caricature surfaced in the late 1970s and early 1980s; but this was quickly absorbed in an international craze for quotations and pastiche.

55. Sue Coe, *Airstrip One, 1986*

It is worth recording briefly how this happened. When painting and sculpture began to emerge again after the period of conceptual art of the late 1970s, it seemed to discover new sets of conventions with which to carry its newly-found sense of ebullience and anger. Painters like Phillip Guston in America or the Who Chicago? school of iconoclasts, or Graham Crowley and Bruce MacLean in Britain, or Gerard Garouste in France, or Cucchi or Clemente from Italy (both by that time working in the USA) began going back to cartoon imagery, to absurd and extreme situations, breaking open the picture plane with ironic and (as it seemed at the time) extraordinary gestures of malpractice; becoming known as what Peter Plagens in a contemporary article in *Art in America* called 'the academy of the bad'.[17] For a brief moment around 1980 or 1981 it seemed that these artists were indulging in a serious and planned descent into ugliness; messing up artistic conventions in order to find a level of representation which was openly disgusting, dirty, profane — not unlike what could be found in Gillray or Hogarth. I certainly believed at the time — and still do — that this foray into the unspeakable and the foul was in its way exemplary. In the first place,

56. W. Hogarth, *Scene in the Fleet Prison (Rake's Progress), c 1735*

143

57. T. Rowlandson, *Death Helping an Old Lover into Bed, c 1814-16*

some sense of chaos seemed essential on the subjective level as a way of preserving art from prettiness, charm and pretence. (It is even to be found in the surfaces of classical statuary if we accept Rilke's definition that 'beauty is the beginning of terror that we are still just able to bear'.[18])

But primarily this display of bad manners seemed exemplary because it summarised a deep sense of disgust at the prevailing circumstances within our decaying culture: it spluttered forth a protest, intense but keenly felt, at the absurdity and restrictiveness of life under the regime of advanced capitalist consumerism. Bad manners too, I felt, constituted a gesture of opposition to those still deeply entrenched conventions of bourgeois life such as politeness and deference, caution and thrift, which still stand as 'official' virtues in late twentieth century liberal democratic culture. Like Gillray or Hogarth, Daumier or Goya, Jarry or even Beckett before it, this art possessed at least some of the challenge and abrasiveness of a powerful satirical style.

In the years that followed, however, a kind of formalism seemed to overtake the basic premises of 'bad mannered' painting and sculpture. It became linked by critics, and by artists themselves, with an attempt to resuscitate expressionism — becoming returnable at virtually every point to earlier paintings and sculptures by Kirchner, Soutine, Nolde, Malevich (in his pre-cubist works), and so forth. And this post-modern historicising of the work seemed to me to suddenly deprive it of most of its force. The ever-influential *Art in America* devoted two consecutive issues to something it called 'The Expressionism Problem',

indulging in new attempts at defining the earlier historical moment as well as validating most of the newer work.[19] Three years later, early in 1986, it quietly dropped the issue in favour of another neo-movement, this time a return to geometric abstraction.

58. James Gillray, *Two French Gentlemen, 1799*

Secondly, the powerful sense of disgust which had made the original 'bad' work so interesting had become diluted to the quality of mere whimsy. Suddenly, a whole generation of artists was exploiting the licence offered by 'bad mannered' art to return to something camp, nostalgic or kitsch. Milan Kunc, to take an extreme example from Germany, merely transferred banal chocolate-box imagery onto canvas — thus producing a parody of something that was already a parody. East Village artists in the United States offered art-works that were blatant copies of earlier masters like Léger and Picasso. In Britain a group of younger artists comprising Adrian Wiszniewski, Stephen Campbell and Mario Rossi began to represent the human agent as a dreamer engaged in nostalgic reverie for the past; a past that is so culturally specific, however, that its meaning is only available to the artist and his immediate friends. As numerous recent TV appearances attest, these artists enjoy seeming lost in an unreal world of mysterious events which for some reason has followed them into the present from the past. Echoes of their earlier lives in

Figure 59

Figure 60

145

Scotland, Poland or elsewhere dominate the works of these so-called New Image artists — a fact which appears to encourage their being avidly purchased by the Chase Manhattan Bank in New York for its wealthy and anonymous buyers. Frequently attired in 'new conservative' clothing and hairstyles, the *dramatis personae* of these paintings have been incapacitated from making emotional or intellectual contact with any of the live issues of their day. Lost, befuddled or dreaming, these characters subsist in a no-man's land of confusion and unreality. And yet they continue to be fêted as the spectacular success-stories of young art of the 1980s.

Figure 61

59. Milan Kunc, *Two Suns, 1985*

But neither escapism nor universal pessimism can carry the burden of a truly socialist, humanist art. The Hungarian philosopher of art Georg Lukács once launched an attack on modernist literature precisely on the basis of its unreality. The burden of his complaint was that it presented man's isolation and alienation as a *condition humaine*, a universal and timeless prison which it was the

newly-discovered task of this modern literature to relate. This perception of man in literature, Lukács argued, was inferior because it lacked two things; in different degrees, and depending upon which author was being discussed. First, it lacked a statement of the actual specific background of man: his actual circumstances of daily life within capitalism. With some exceptions, Lukács argued, modern literature replaced such specificities with abstract or unidentifiable circumstances; with surroundings which could belong to any time or place. Second, Lukács proposed that most modern literature, even where it identified specific conditions of life for the characters of a drama, and even when it identified these with the corruption of society at the time, failed to represent any *terminus ad quem* for the writing: any future concrete possibility of different conditions of life. These shortcomings were particularly visible in the modernist device of resorting to what Lukács called 'psychopathology' — that is, the depiction of extreme conditions, madness, retardation and despair. This could only contribute a protest against capitalism, according to Lukács, when the *terminus ad quem* was present; not when it was lacking. 'For then the protest is an empty gesture, expressing nausea, or discomfort, or longing. Its content — or rather its lack of content — derives from the fact that such a view of life cannot impart a sense of direction'.[20]

Lukács is surely right in inveighing so thoroughly against the 'ontological dogma of the solitariness of man'[21] — Kafka is his main opponent here — and right also in objecting to the absence of hope in the 'extreme' productions of early literary modernism. It is probably also true, however, that Lukács' own hero figures in literature, which include Thomas Mann, Thomas Wolfe and Brecht (in certain of his works) can have no precise equivalent in the field of visual art.

60. Adrian Wiszniewski, *Sending a Letter to my Love,* 1985

And yet it is equally clear that Lukács' criticism has

61. Steven Campbell, *The Fall of the House of Nook with tree blight, 1984*

already had a decisive impact on British art. In the 1950s, for example, there existed a 'moment of realism' when certain artists, notably John Bratby, Peter de Francia, Edward Middleditch, Jack Smith and Derek Greaves were defended by John Berger precisely for having perpetrated a socialist and a humanist art of the kind Lukács proposed. These paintings revealed streets, interiors, industrial and urban landscapes, men and women in actual conditions; they should, Berger argued, make the spectator 'more aware of the meaning and the significance of familiar and ordinary experiences'.[22] They might, he wrote elsewhere, help people 'to know and to claim their social rights'.[23]

Berger's emphasis here on 'the familiar and ordinary' is derived directly from Lukács, who argued vehemently that art should concern itself not with the exotic or the strange, but with the *typical*.

A type, according to Lukács, is not merely an average character, nor solely an individual one; but an embodiment in character or situation of all the humanly and socially essential qualities of a particular historical moment. In the artist's discovery of typical situations, said Lukács, the most important trends of social development could receive adequate expression. Here, Lukács builds upon one of the classic texts of Marxist aesthetics, Engels' letter of 1888 to

148

Margaret Harkness, the author of the novel *City Girl, A Realistic Story,* in which he comments that realism implies, 'besides truth of detail, the truth in reproduction of typical characters under typical circumstances.'[24] But typicality, for Lukács, must be more than a frozen moment of the actual. It must — this was Lukács' objection to allegory — possess the element of time, history and movement. Thus while Kafka depicts man as constantly isolated, Thomas Mann defined man's isolation as products of a specifically modern situation, and holds up the perspective of socialism as a way of overcoming it through change.[25]

In fact English realist painting of the 1950s was swept away soon afterwards by a tide of abstraction from America, heavily promoted precisely as the free world's 'alternative' to Soviet-style realism. However artificially, the battle-lines were already drawn up between realist and abstract artists. What is this realist movement, Berger asked in 1956? It was a 'protest against . . . the kind of pathological self-deception which claims that the 'action' paintings included in the American exhibition of the Tate have anything to do with art'.[26]

The dilemma of the 1980s is how much of this former realism can be resuscitated and built upon as a foundation for future art. If we look again at that English realism of thirty years ago, we certainly find in it characteristics which tie it to a time, a place, a circumstance; and which therefore cannot be transferred. Its method was after all naturalistic as well as realistic, a devotee of appearances and the pre-modern idea of the picture as a window onto reality. The modernist insistence on richness of surface, on 'crunchiness' of design, was for the most part lacking in a country that, after all, had scarcely experienced modern art, given England's relative isolation before 1945. To continue those suppressions in the circumstances of today would be to under-estimate the extent to which taste and the comprehensibility of languages has changed.

But most importantly, the appearance of the world itself has changed since 1956, as have its dominant capitalist institutions, industries and media forms. So have its modes of feeling — both objective and subjective. A critical realism of the future will have to discover these changes and find ways of embodying them in art, at the same time as linking itself with the modern and pre-modern traditions which came before. Thus the limitation in Lukács' aesthetics of realism, if there is one, is that it takes no account of the vivacity of modernist *style*. Here were bold, forthright procedures for art — perhaps too many of them — which could do many things not available through classic socialist realist methods. Perhaps the least of these was to put on

149

display the distinctive procedures of the human agent in the
personification of the artist. Perhaps the most of them was
to be able to conjoin disparate events and circumstances
within a single frame of reference, thus opening up the pos-
sibility of temporal sequences embracing the past, the
present and an optimistic future within the scope of a single
visual work. Modernist style in its most public forms — as
the example of *Guernica* once again attests — provides a
flexible instrument for the connection of multiple temporal
and spatial viewpoints within the scope of the rhetorically
powerful image.

We may come a step closer towards defining the
desiderata of a future socialist art which is also humane and
modernist if we look at certain artists who are practising in
Britain today, who by the definition of the specialised cul-
ture which surrounds us are 'important' artists of the time.
Both of my two examples aim at a sort of critical realism,
but neither achieves it. One analyses the nuclear situation,
but fails, as I argue, to produce art. The other indulges in
subjective experience but does not connect his findings
with life. Thus their shortcomings are equal and opposite.

Terry Atkinson is the artist who analyses the nuclear
situation and tries to speak intelligibly about the horrors of
the capitalist-military nexus. He makes paintings which are
not paintings — or not only. For he resorts to various
devices to remove himself from the modernist tradition of
painterly expressive art. His paintings are predominantly
done from photographs, projected onto the surface and
then filled in sketchily with gouache, giving a deliberately
poor paint quality and a thinness of surface which is blat-
antly unattractive to the eye. Secondly, his paintings are
shown never alone, but always in tandem with captions,
many of which are lengthy or humorous; always ironic.
Figure 62     Thus *Happy Snapshot 6* of 1984 shows his two daughters
posing for the camera while on holiday in Paris. The caption
reads: *After having seen Manet's strong work Ruby and Amber
wonder which bunkers are earmarked for his pictures. They pon-
der as to whether in the cities where the Manets are, only the neu-
tron bomb will be used.* In an earlier painting about apartheid,
a suited man stands with a long-snouted animal on a lead, in
Figure 63     the manner of an official carrying out a task. Here the cap-
tion reads: *Postcard from Trotsky in heaven to the South
African Government in Pretoria, dated 1976. Dear Verwoerd,
All of the old Bolsheviks are here sitting in heaven on God's right
hand. God seems to be having some trouble with Lenin. Lenin
keeps trying to persuade him that no decent God should have a
chosen people, as this is a classical instrument of capitalist-
imperialist expansion. I warn you now, Verwoerd, if Lenin ever
gets his way you'll never get to heaven. It turns out after all, you*

*see, that life even in heaven is one long materialist and ideological struggle. Meanwhile here's a snapshot of the arse-end of the historical process — it shows one of your bureaucrats setting the first aardvark in its homeland. Fraternal greetings to the working class of South Africa. P.S. It's currently going round heaven that Lenin's got God reading 'Das Kapital', and that God is thinking of getting the heavenly state to wither away.*

Amusing? Undoubtedly. Pointed? Of course. But if we set the humour and the satire aside we have little from these works which might engage the mind *as art.* The colour and the drawing in Atkinson's works, intentionally made banal, remain unable to address the spectator in any sensuous, materially rich way — in a way that invites prolonged attention or speculation. In fact the displacement of meaning onto the relationship between image and text functions counter-productively to reflect attention back onto the artist merely as humorist of the joke. Neither popular caricature nor epic painting, Atkinson's efforts to *avoid* all previous categories aims at a sophisticated art-world audience which it probably cannot reach. And yet he remains for all that, singular in his attention to themes and subjects that other artists will not touch.

62. Terry Atkinson, *Happy snapshot 6, 1984*

Mention of satire and politics brings to mind another example — this time a team of artists — that came to prominence in specialised artistic culture in the 1980s. Vitaly Komar and Alexander Melamid produce vast canvases painted in a highly realistic style which are littered with the persona of modern political history: Churchill, Roosevelt, and particularly Stalin. The paintings are, of course, satirical, and sometimes agreeably so. One work shows President Reagan as a centaur, galloping mock-heroically past the observer with a swirl of red drapery in his

151

upraised hand. Here was surely a painting technique and a subject-matter that could produce a powerfully satirical and popular art?

But one quickly noticed that Komar and Melamid in fact belong to the wrong political side. The majority of their works are designed precisely to *parody* the great style of socialist realism which has proved so inspirational to the Russian people. And they take a typically American view of the Russia to which this method belongs. In fact Komar and Melamid — themselves Russians who took part in the notorious Izmailovsky Park exhibition in Moscow in 1974 which was bulldozed by the authorities — fled to the West via Israel in the late 1970s and became immediately lionised by right-wing magazines such as *Newsweek* for their 'dissident' opinions. Immediately they were colluding with dominant American phobias concerning the Soviet Union, such as that the Soviet state is a secret society; that its search for socialism had the character of a religious quest; that Socialist Realism was always Party art;[27] and importantly, that Stalin himself invented Socialist Realism — an event they parody in another pastiche painting entitled *The Origin of Socialist Realism*, which shows Stalin being inspired by a classical muse.

Figure 64

63. Terry Atkinson,
*Postcard from Trotsky in heaven to the South African Government 1982 in Pretoria, dated 1976*

Of course, Komar and Melamid were fêted in Britain and America precisely for their post-modernity; their parodic, carnivalesque tone which recognised the 'fact' that there can no longer be any individual style, only a kind of unco-ordinated raiding of art history.[28] Their politics, how-

ever, were overlooked; as was the alienation which seemed to accompany their vaunted 'post-modern' credentials. Their sarcastic, confused pinching of artistic styles was itself even a matter for praise. *Art in America* proclaimed in the course of eulogising the Russian duo that all the major ideas of international political debate — even these were fake: 'The dictatorship of the proletariat, state capitalism, consumer product paradise: it's all junk, hologram-scenery passing before the eyes of the engineered soul'.[29] Komar and Melamid's 'achievement' was to have ascended to the ridiculous heights of disengagement that one associates with superficial East Village art; a coterie to whom even a nuclear explosion is just another 'representation'.

64. Komar & Melamid,
*The Origin of Socialist
Realism, 1982/83*

My second British example, however, takes an opposite direction from Atkinson, attempting to articulate sub-

153

jective life in a way that makes an interesting variation on the original modernist subjectivity of the surface. Ken Kiff attempts to use the language of fantasy to describe the relations between himself and his analyst, together with the visions and realisations that arise within the context of that special setting. His pictures are vivid, bright and sometimes moving accounts of the vicissitudes and revelations of fantasy. But they are flawed by this tendency to represent merely the illusions offered by the transference, without any of its wider social causation. A work like *The Feminine* *as Generous, Frightening and Serene* of 1982-83 is a case in point. Kiff represents this conjunction in subjective life as a 'universal' condition, which it is not — or not quite. The identification of the female characters is his alone; they are the females of his own life-history who possessed these qualities in particular ways and in particular degrees. We are not told of the class origins of these attitudes, or the particular familial conjunctions which allowed them to be combined in those particular ways. For all its power as an image, the painting finally evades the truth about the origins and causation of this vividly subjective parable. In the art of the future, there must be no subjective representation which does not at the same time terminate in a problem of social relations, of class, of lived values in the exterior world.

Figure 65

The same inability to ground images in the *typical* events and characteristics of their time lies also at the root of other artists in Britain who attempt to confront the social and political (that is, personal) issues of the day. Lisa Milroy depicts the consumer paraphenalia of the immediately post-war world — records, dancing shoes, sunglasses — as attractive yet forgotten symbols of the illusions of the Macmillan era; but she presents no link between that world of illusions and our own nostalgia for that time — a nostalgia which is itself a creation of the market. Milroy's pictures function ambiguously between a real regret at the passing of lost objects and a purely media-induced nostalgia for a period known as the 'fifties'. In the future, these paintings will be well-nigh unintelligible. Alexis Hunter, like Ken Kiff in this respect, represents her questing figures (as in *Considering Paradise*, 1982) as timeless, mythological creatures who merely allegorise a situation without basing it in the web of typical structures of her time. An artist like Tony Bevan moves in an opposite direction, since he paints gluesniffers and truant teenagers in the depth of personal misery or deprivation. These, of course, are among the important typical figures of our culture. The trouble is that Bevan offers no hope for these outcasts in the form of a better society to come. They exist in a literal void, as vic-

65. Ken Kiff, *The Feminine as Generous, Frightening and Serene, 1982/3*

tims, unredeemed by even the smallest sign of the transformations of which society is capable.

Figure 66

The fact is, of course, that professional artists in the West are not orientated towards the achievement of a publicly inspirational art — as opposed to work that simply happens to be shown in public. Most professional artists are genuinely confused about the 'showing' of art in any form. Much of it is vaguely intended for public consumption, yet in the full awareness that the public cannot be familiar with its special and privately developed languages. Unwanted by the public, the vast majority of these works return to an artist's studio or store-house to be stockpiled against the day — which in most cases will never come — when an already over-specialised institution comes to mount a retrospective of the artist's life and work. Or, in limited numbers, these works may be given as tokens of friendship, or in exchange for services rendered. Only in the latter case do privately-inspired works circulate back to those private origins from which they came — as tokens, perhaps, of the artist's existence at that moment or in that

particular place. Most artists in their public selves remain fixated however on 'art history'. As the recent Gulbenkian Foundation Report on the Economic Circumstances of the Visual Artist attests, the definition of 'professional artist' favoured by most interviewees was that of someone who had gained a place in this mythical continuum known as the history of art, with the help of a 'reputation' constructed by museums, critics and institutions of art.[30]

There are nevertheless positive signs in all of these examples of an art which *combines* analysis, realism and hope — in a dialectic of that which is typical now and of that which might eventually come to pass. In the course of elaborating his 'critical realism' Lukács spoke of his hope for an art 'that presents the totality of man, the whole man in the totality of his social world'. The goal of 'proletarian humanism', for Lukács, was 'man in his wholeness, the restoration of human existence in its totality in actual life, the practical, real abolition of the crippling fragmentation of our existence caused by class-society . . .'[31] Interpreted in a certain way, I see no better standard by which to gauge the art of the present insofar as it offers prospects for the art of the future.† But its contexts will have to change, in ways that we have already partly specified. New decision-procedures for the legitimation of public art will need developing at the highest governmental level. New institutions for the display and consumption of art will supplant the alienating white box of the modern gallery in the pro-

---

†     It is of course invidious to attempt to list examples of present-day art which seem to offer prospects of meeting this condition. Of a previous generation I might have mentioned works by Renato Guttuso or Asger Jorn, and some by Jean Dubuffet, in addition to those already mentioned. Of today's generation the matter should be easier to assess, given the amount of work on public view at any one time. In a new exhibition being planned by Michael Wooton, Christopher Tunwell and myself for 1987-8, we choose the title 'Critical Realism' for a range of work which not merely shows the typical events and personalities of our time but which also combines a critical attitude with signs of man's capacity to overcome his conditions through humour, struggle and a refusal to connive with power games of the rich and glamorous. Artists like Denzil Forrester, Graham Crowley, John Keane, Bob Robinson and John Yeadon fall into this category as painters; together with the prints of Anthony Davies, the caricatures of Fluck and Law, or the satirical cartoons of Gerald Scarfe and Steve Bell. Sue Coe and Sonya Boyce are also doing powerful works, especially, on the evidence of recent work, the former. The Glasgow painters Ken Currie and Peter Howson have some strong examples. The colour photographs of Paul Graham and Paul Reas are admirable in their efforts to confront everyday reality in working-class life with the skills of the best documentary photographer. Likewise the veteran war reporter Don McCullin. These examples could be multiplied, up to a point. They show that the seeds of a strong realist tradition in British art to be still very much alive, despite what is often assumed.

cess of reconnecting art with the life-world to which increasingly it will have to refer. Humanitarian realism which refers directly to typical structures in the world will have to be endowed with the full richness of expressive potential that was developed in earlier modernism — not at the expense of that objective reference, but as its servant.

66. Tony Bevan, *Tender Possessions, 1986*

We can probably only speculate at what enrichments could take place in the uses of art in subjective life — what would be a continued development of the modernist project

of self-understanding in secular forms. The private transfer of no longer exhibitable works is obviously not enough. To begin with, society as a whole must possess groupings of interest devoted to subjective clarification in a sense that extends beyond the production of visual images, but into which the production of images may fit. Secular forms of the confessional such as the encounter group or the psychoanalytic relationship already provide such contexts, in a limited form. Art may be able to enrich these contexts at the personal level, and assume the status of a quasi-medical tool, along with other techniques of 'holistic' curing — or just plain exploration. Very far from being an international effort controlled by marketing men, however, the type of 'progress' this private modernism arranges will be quiescent and pacific, a search for meaning rather than a utopian plan. It will have little traffic with existing forms of cultural production such as presently exist under the regime of television and the other mass media forms.

On the other hand, the realist reorientation of publicly consumable art on the model of Lukács' theory of typical representation raises other unfamiliar issues, some of which have no obvious or immediate solution within the resources of aesthetic theory in its present form. What is called the 'expressive' potential of modernist style is not, let us be candid, an uncontroversial 'plus' or added benefit that can be slapped on come what may, automatically capable of transforming worthy subject matter into visually compelling forms.

One immediate problem here is that we know too little at present about the emotional and rhetorical power of cubist, expressionist, futurist and surrealist modes; their psychic and affective origins, their national variations, even their class appeal. Much depends, in short, upon what a particular audience can know and understand about the causes and purposes of a particular stylistic device. Secondly, it is difficult to foresee under such radically altered conditions what role is likely to be allotted to — or selected for — the person of the artist as a public figure. What secular priestly role will be reserved for artists in the society of the future in which hopeful, committed and yet realistic art will be encouraged and admired? What kind of interest will it be legitimate for the public to take in the 'persona' of this artist figure, which is radically different in kind from the fawning pubescent admiration that our existing society lavishes upon pop stars, media personalities and certain politicians? How will the vision of the critical realist artist be seen to be linked to the particular inflections and peculiarities of his (or her) style? Will the reign of the art market continue to inflect in wholly negative ways the

acceptable meanings which are circulated in our society under the label of art? There are probably not questions to which answers can be worked out by sociologists, educationalists, planners or other experts. In a truly participatory culture, decisions on what works of art are being made, and how, and for whom, will be opened for discussion by all concerned — not *en masse* but in groups of a size and constitution which is commensurate with the question under review. New arrangements for the dissemination and display of art, no longer concentrated in the metropolis alone, will need developing with the growth of local participatory culture devoted to realist celebration and reconstruction of the norms of social life. The nationalisation of the art market will do away entirely with reckless profiteering and the creation of absurd pseudo-reputations based on the gullibility of the rich. Participatory control of the means of artistic production will replace the effete and glamourised subject-matter of unreality and confusion that dominates the art market today. Representations of living individuals in real historical situations will come to instruct and give pleasure to a wide and involved public body which has already, and by other means, become oriented to the ideals of equality, fraternity, liberty and historical progress through peaceful means.

Such idealism may today seem far-fetched in a culture consumed by over-specialisation, alienation and the worthless multiplication of goods. But even at present we possess the means to create artistic forms which are rich in both public relevance and inner certainty. We only lack confidence in being able to say how the two may be brought together. The eradication of the rigid boundary between subjective expression and the facts of social life has proved intractable, perhaps, to modernism. But modernism, unlike its postmodernist successor, can at least lay some claim to the task, and may even be said to have made some progress with it. If modernism can be redirected towards the real and the typical, just as the typical may be subjected to the still immensely ambitious regime of the modern, then such a conjunction of purposes may be achieved. At present, the existence of such a culture may seem a long way off. But the hope for such a transformation must continue to be kept alive.

# NOTES

## Chapter 1: New Problems for Criticism

1. B. R. Mitchell, *European Historical Statistics*, London and Basingstoke, 1981, p. 701.
2. Perry Anderson, *Modernity and Revolution*, New Left Review, Vol. 144, 1984, pp. 96-113.

## Chapter 2: Modernism and Subjectivity

1. H. G. Gadamer, *Truth and Method*, New York, 1976, Chapter 1.
2. Goethe, *Dichtung und Warheit*, Part II, Book 7.
3. Novalis, *Gesammelte Schriften*, Berlin 1837, II p. 99.
4. K. A. Scherner, *Das Leben des Traumes*, Berlin, 1861.
5. R. Vischer, *Drei Schriften zum Aesthetischen Formproblem*, Halle, 1927, p. 27.
6. R. Vischer, *Drei Schriften zum Aesthetischen Formproblem*, Halle, 1927, pp. 53-54.
7. T. Lipps, *Aesthetik*, 1903, 1906; the reference is to the 2nd edition, Hamburg and Leipzig, 1912, Vol I, p. 2.
8. See C. B. MacPherson, *A Political Theory of Possessive Individualism*, Oxford, 1962, pp. 48-9, 142.
9. H. F. Ellenberger, *The Discovery of the Unconscious, The History and Evolution of Dynamic Psychiatry*.
10. C. G. Carus, *Psyche, zur Entwicklungsgeschichte der Seele*, Pforzheim, 1846. London, 1970, p. 206.
11. On this theme see Lionel Trilling's essay *The Fate of Pleasure*, in *Beyond Culture*, London, 1966, pp. 57-88.
12. K. Marx, *Grundrisse*, 1857-8, Introduction (Pelican edition 1973), p. 84.
13. K. Marx, *German Ideology*, London, 1970, p. 83.
14. J. Berger, *Ways of Seeing*, London, 1973.
15. T. J. Clark, *The Painting of Modern Life: Paris in the art of Manet and his Followers*, London, 1984.
16. Wordsworth, *Preface to Lyrical Ballads*, 1800.
17. J. W. M. Gibbs, (ed), *Early Essays by John Stuart Mill*, London, 1897, p. 222; cited in M. H. Abrams, *The Mirror and the Lamp: Romantic Theory and the Critical Tradition*, Oxford, 1953, p. 24.
18. J. W. M. Gibbs, (ed), op. cit., p. 208; Abrams, p. 23.
19. Delacroix's notes: see Achille Piron, *Eugene Delacroix, Sa vie et ses oeuvres*, Paris, 1865, p. 421; R. Schiff, *Cezanne and the End of Impressionism*, Chicago, 1984, p. 27.

20. C. Baudelaire, *The Salon of 1846*; in E. Holt, *A Documentary History of Art*, Vol III, London, 1957, p. 181.

21. E. Zola, *Mon Salon, 1866*; in Holt, op. cit., p. 380.

22. Octave Mirbeau, *Vincent Van Gogh*, L'Echo de Paris, March 31st, 1891, p. 1. An early exponent of the idea of style as the 'autographic mark' in art is Giovanni Morelli. See his *Italian Painters*, 2 vols, London, 1892-3 (orig German ed, 1889).

23. Impressionism itself — even the work of Monet and Cezanne — was seen in symbolist terms by several critics in the 1890s. See Stephen Schiff, *Cezanne and the End of Impressionism*, Chicago, 1984, p. 7-8, who cites S. Levine, *Monet and his critics*, NY, 1976 and G. Seiberling, *Monet's Series*, NY, 1980 in his support.

24. P. Gauguin, *Noa-Noa*; version reprinted in J. de Rotonchamp, *Paul Gauguin 1848-1903*, Paris, 1925, p. 246-7.

25. P. Gauguin, *Noa-Noa*, in op. cit., p. 245.

26. Odilon Redon, *A Soi-meme, Journal 1867-1915*, Paris, 1922, p. 29.

27. H. Matisse, *Notes of a Painter*, 1908; in J. Flam, *Matisse on Art*, Oxford 1973, p. 38.

28. E. Michel, *Gustave Moreau et ses élèves*, Lettre d'Evenepoel a son père, Paris, 1923, p. 24-5.

29. H. Matisse, letter to Pierre Matisse, Nice, June 7th, 1942; Schneider, *Matisse*, London, 1984, p. 75.

30. H. Matisse, Interview with Guenne, 1925; Flam, op. cit., p. 55.

31. G. Diehl, *Henri Matisse*, p. 81; cited in Schneider, op. cit., p. 215.

32. Cross, for example, reported the 'anxious, madly anxious' mood of the summer of 1905 when he was working with Signac in Collioure.

33. D. Giraudy, ed., *Correspondence H. Matisse — C. Camoin*, Revue de l'art, No. 12, 1971, p. 18.

34. F. Vallaton, *La Grande Review*, Paris, October 25th, 1907, p. 920; Barr, *Henri Matisse*, New York, 1966, p. 96.

35. H. Matisse, *Statement to Teriade*, 1935; in J. Flam, *Matisse on Art*, Oxford, 1973, p. 74.

36. H. Matisse, op. cit., p. 74.

37. See note 22 above.

38. M. Berman, *All That Is Solid Melts into Air*, 1983, p. 15; quoted by Perry Anderson in his *Modernity and Revolution*, NLR, Vol 144, 1984, p. 97.

39. E. Kris *Psychoanalytic Explorations in Art*, London and New York, 1953.

40. E. Kris, *The Principles of Caricature* in *Psychoanalytic Explanations in Art*, op. cit.; p. 197-8.

41. E. Kris, op. cit., p. 198-9.

42. E. Kris, op. cit., p. 197.

43. E. Kris, op. cit., p. 152.

44. A. Ehrenzweig, *The Hidden Order of Art*, Paladin, 1970, p. 82.

45. A. Ehrenzweig, op. cit., p. 89.

46. A. Ehrenzweig, op. cit., p. 90.

# Chapter 3: Beyond Post-modern Aesthetics

1. Steinberg, *Other Criteria*, Oxford, 1972, p. 84.

2. Steinberg, op. cit., p. 91.

3. The best-known early architectural text is Venturi and Rauch, *Complexity and Contradiction in Architecture*, New York, 1966.

4. C. Jencks, *Late-Modernism and Post-Modernism*, Architecture of Cuba, 1978, reprinted as Chapter 1.2 of Jencks, *Late-Modern Architecture*, London, 1980, quotations for this source, pp. 19-20. See also C. Jencks, *The Language of Post-Modern Architecture*, New York, 1977.

5. The quotations here are from F. Jameson, '*In the Destructive Element Immerse'*: *Hans-Jurgen Syberberg and Cultural Revolution*, October 17th, Summer 1981.

6. Giancarlo Politi, *Interview with Francesco Clemente*, Francesco Clemente in Belfast (catalogue), 1984, n.p.

7. Whitechapel Gallery, London, September 19th to October 26th, 1986.

8. Institute of Contemporary Arts, London, July 16th to August 31st, 1986.

9. Colin Self, *ICA Catalogue*, 1986, op. cit. p. 9.

10. J-F. Lyotard, *The Post-modern Condition: A Report on Knowledge*, Manchester, 1984, p. 76.

11. F. Jameson, *Post-Modernism, or the Cultural Logic of Late Capitalism*, New Left Review, 146, July/August, 1984, p. 55.

12. The reference here is to W. Benjamin, *The Work of Art in the Age of Mechanical Reproducibility, Zeitschrift fur Sozialforschung*, V, I, 1936; in *Illuminations*, (ed Harendt) 1970, pp. 219-254. The point about the recuperation of the aura is to be found in Douglas Crimp, *On the Museums Ruins*, October 13th, 1980.

13. R. Barthes, *The Death of the Author* in *Image-Music-Text*, Glasgow, 1977, p. 148.

14. M. Foucault, *What is an Author?* in J. V. Harari, *Textual Strategies, Perspectives in Post-Structuralist Criticism*, Ithaca, NY, p. 979, pp. 141-160; quotation p. 144.

15. Foucault, op. cit., p. 159.

16. Foucault, op. cit., p. 142.

17. J. Lacan, *The Mirror-Phase as Formative of the Function of the 'I'*, New Left Review, no. 51, September-October 1968, pp. 73-83. This paper first appeared in French in 1949 and is reprinted in *Écrits*, Paris, 1966.

18. According to Francois Gilot, Picasso was in many ways a hypochondriac who became frightened at the least sign of an illness.
    Gilot reports that 'Pablo always felt you should use people for things that lay outside their area of specialisation. Since Lacan was a psychoanalyst, Pablo had adopted him as his general medical practitioner. He took his troubles to him and Lacan prescribed very little, saying, as a rule, that 'everything was fine'; F. Gilot and C. Lake, *Life with Picasso*, London, 1964, p. 160.

19. J. Lacan, *Écrits*, Paris, 1966, p. 689. A coherent summary of Lacan's formulations on language and the subject is to be found in R. Coward and R. Ellis, *Language and Materialism, Developments in Semiology and the Theory of the Subject*, London, 1977, Chapter 6.

20. G. Deleuze and F. Guattari, *Anti-Oedipus, Capitalism and Schizophrenia*, New York, 1977, passim.

21. Jameson, *In the Destructive Element Immerse: Hans-Jurgen Syberberg and Cultural Revolution*, October 17th, 1981, pp. 113-4.

22. Anders Stephanson, *Interview with Fredric Jameson*, Flash Art, 131, December 1986/January 1987, p. 69.

23. Jencks, op. cit., p. 32.

24. R. Krauss, *Re-Presenting Picasso*, Art in America, December 1980, p. 96.

25. See C. MacCabe, *James Joyce and the Revolution of the Word*, London, 1979.

26. M. Leja, '*Le Vieux Marcheur' and 'Les deux risques': Picasso, prostitution, venereal disease and maternity*, Art History, Vol. 8, No. 1, March 1985.

27. C. Duncan, *Virility and Domination in Early 20th Century Vanguard Painting*, Artforum, December 1973, pp. 30-39.

28. Eg Zervos, II**, 403; Daix, *The Cubist Years 1906-14*, London, 1979, no. 592.

29. Eg Zervos, II**, 420, 427, 426; Daix, op. cit. 588-590.

30. Eg Zervos, II**, 771, 772, 774; Daix, op. cit. 517-9.

31. Daix, op. cit. 519.

32. Eg Zervos, II**, 409; Daix, op. cit. 525.

33. Eg Zervos, II**, 413; Daix, op. cit. 521.

34. Eg Zervos, II**, 330; Daix, op. cit. 563.

35. 1912; Washington University, St. Louis.

36. 1911; Museum of Modern Art, New York.

37. Zervos, II**, 342; Daix, op. cit., 480.

38. Zervos, II**, 352; Daix, op. cit. 485.

39. Daix, op. cit. 535.

40. Daix, op. cit. 608.

41. 1913; Museum of Modern Art, New York.

42. M. Milner, *The Role of Illusion in Symbol-Formation*, in M. Klein & others, (eds.), *New Directions in Psycho-Analysis*, London, 1955.

43. M. Klein, *The Importance of Symbol-Formation for the Development of the Ego*, 1930, p. 23.

44. M. Klein, op. cit., p. 237-8.

45. F. Gilot and C. Lake, *Life with Picasso*, London, 1964, p. 72.

46. Daix, op. cit. 802.

47. Steinberg, op. cit., p. 91.

48. Steinberg, op. cit., pp. 88-90.

49. F. Guattari, *Molecular Revolution and Class Struggle*, in *Molecular Revolution, Psychiatry and Politics*, English edition, 1984, p. 257.

50. G. Deleuze and F. Guattari, *Anti-Oedipus*, op. cit. pp. 56-7.

51. T. Eagleton, *Capitalism, Modernism and Post-modernism*, New Left Review, 152, July-August 1985; reprinted in T. Eagleton, *Against the Grain*, London, 1986, p. 146.

52. Eagleton, loc. cit., p. 145.

53. E. Mandel, *Late Capitalism*, p. 194; citing Julius Rezler, *Automatic Industrial Labour*, New York, 1969.

54. See F. Jameson, *Post-modernism, or the Cultural Logic of Late Capitalism*, Review, 146, July/August 1984, p. 55.

55. Jameson, op. cit., p. 57.

56. Jameson, op. cit., p. 88.

57. Jameson, op. cit., p. 57.

# Chapter 4: Modernisation and Specialisation

1. J. Roberts, *The Triumph of the West*, London, 1985.

2. F. Braudel, *The Structures of Everyday Life: The Limits of Possible*, London, 1981, pp. 311-15.

3. F. Braudel, op. cit., p. 316.

4. F. Braudel, op. cit., p. 323.

5. J. Habermas, *Modernity versus Post-modernity*, New German Critique, 22, Winter 1981, p. 8.

6. A similar point is made by P. Bürger, *The Significance of the Avant-Garde for Contemporary Aesthetics*, New German Critique, 22, Winter 1981, p. 20.

7. For a study of the Louvre and its imitators see C. Duncan and A. Wallach, *The Universal Survey Museum*, Art History, Vol 3, No. 4, 1980, pp. 448-469.

8. See G. Bazin, *The Museum Age*, NY, 1967, pp. 141-67.

9. H. C. White and C. A. White, *Canvases and Careers: Institutional Change in the French Painting World*, New York 1965, p. 84. The Whites estimate assured that 3,000 male artists could be identified in Paris, and another 1,000 in provincial centres, of which approximately half were active at any one time.

10. H. C. and C. A. White, op. cit., pp. 156-7.

11. These figures are from *The Art in America 1986 Annual Guide to Galleries, Museums and Artists*, pp. 110-140.

12. Op. cit., pp. 181-223.

13. I owe this reference to A. Brighton, *Modernism and Professionalism*, Aspects, Autumn 1985.

14. See C. Painter, Aspects 1979.

15. These were published in *The Fine Art Trade Guild Journal*, No. 63, September 1986, pp. 18-22.

16. Giancarlo Politi, Interview with *Francesco Clemente*, in Francesco Clemente in Belfast (catalogue), Belfast, 1984, n.p.

17. This quotation is from Lisa Tickner (quoting Victor Burgin) in her essay *Sexuality and/in Representation: Five British Artists, in Difference*, New York, 1984, p. 20.

18. Tickner, op. cit., p. 29.

19. Paul Taylor, *Cindy Sherman*, Flash Art, no. 124, October/November 1985, pp. 78, 79.

20. This is D-H. Kahnweiler, *Der Weg Zum Kubismus*, Berlin, 1920 (written in 1915).

21. Gombrich, *Psychoanalysis and the History of Art* in *Meditations on a Hobby Horse*, London, 1974.

22. Matthew Collings, *Interview with Julian Schnabel*, Artscribe International, September/October 1986.

23. Quoted in N. Pevsner, *A History of Building Types*, London, 1976, p. 121. my italics.

24. Habermas, op. cit., pp. 10-11.

# Chapter 5: The Impact of Television Culture

1. H. Matisse, *Statement on Photography*, Camerawork, no. 24, New York, October 1908; Flam, op. cit., p. 40.

2. H. Matisse, *Notes of a Painter*, op. cit.; Flam, p. 37.

3. F. Léger, letter to Kahnweiler, December 11th, 1919, cited in Kahnweiler, *A Tall Red-Headed Norman*, in *Homage to Fernand Léger*, Special Issue of the XX Siercle Review, Paris, 1971, pp. 4-5.

4. R. Williams, *Television: Technology and Cultural Form*, London, 1974.

5. J. Mander, *Four Arguments for the Elimination of Television*, Brighton, 1977.

6. M. Horkheimer, *Art and Mass Culture*, Studies in Philosophy and the Social Sciences, IX, 2, 1941; reprinted in Horkeimer, *Critical Theory: Selected Writings*, New York, 1972, pp. 277, 276.

7. M. Horkheimer and T. Adorno, *The Dialectic of Enlightenment*, 1944; London, 1979 edition, p. 154.

8. I analysed the visual meaning of typefaces in early Art and Language texts in *Textual Art*, Artscribe, 1, 1976; reprinted in *Artist's Books*, Arts Council exhibition catalogue, London, 1977.

9. See D. Gordon, *On the Origin of the Word 'Expressionism'*, Journal of the Warburg & Courtauld Institutes, 1966.

10. R. Williams, *Towards 2000*, London, 1983, p. 141.

11. Williams, op. cit., p. 141.

12. A. Malraux, *Museum Without Walls*, London, 1976, (first edition 1947).

13. *John Armleder*, interviewed by Christoph Schenker, Flash Art, no. 130, October/November 1986, p. 68.

14. Op. cit., p. 69.

15. Dan Cameron, *Armleder, Martin, Deacon*, Flash Art, no. 130, October/November 1986, p. 75.

16. Giacinto di Pietrantonio, *Structured Painting and Painterly Design*, Flash Art, no. 130, October/November 1986, p. 67.

17. Apollinaire, *12 Opere de Giorgio de Chirico*, Valori Plastici, Rome, 1919; cited in W. Bohn, *Metaphysics and Meaning, Apollinaure's Criticism of de Chirico*, Arts, March 1981, footnote 9.

18. G. de Chirico, *Memories of My Life*, London, 1955, p. 55.

19.  I analysed de Chirico's contribution to post-modern sensibility in *Late de Chirico*, Art Monthly 87, June 1985.

20.  Preface by Picabia to *Exposition Francis Picabia* at Leonce Rosenberg, Paris, December 1930; reproduced in W. A. Camfield, *Francis Picabia*, 1979, p. 239.

21.  Picabia, 'Ils rien mourraient pas tous . . .' *Paris-Journal*, May 23rd, p. 4, Camfield, op. cit., p. 203, fn. 24.

22.  F. Picabia, Avenue Moche, *Bifur*, no. 2, Paris, July 25th, 1929; in Camfield, op. cit., p. 233.

23.  Such as the *Comedia de Calisto y Melibea* of 1499, by Ferdinand de Rojas.

24.  John Richardson in *The Catch in Picasso* (New York Review of Books, July 19th, 1984) says that Jacqueline bought a television in to ward off boredom in the long hours when Picasso was working, and that Picasso himself became addicted to the television game of Catch — a form of wrestling which may, according to Richardson, have stimulated some of the erotic poses in   ·
Picasso's later graphic work.

25.  B. R. Mitchell, *European Historical Statistics*, London and Basingstoke, 1981, p. 701.

26.  See my report in *The Hayward Annual*, Art Monthly, 96, May 1986.

27.  Deborah Phillips, *Bright Lights, Big City*, Art News, Vol. 84, no. 7, September 1985, p. 82.

28.  D. Phillips, op. cit., p. 82.

29.  Gerald Marzorati, *Kenny Scharf's Fun-House Big Bang*, Art News, September 1985, pp. 77-8.

30.  Gerald Marzorati, *Kenny Scharf's Fun-House Big Bang*, Art News, September 1985, pp. 77-8.

31.  Op. cit., p. 76.

32.  Joel Whitebrook, *Reason and Happiness: Some Psychoanalytic Themes in Critical Theory*, in R. J. Bernstein (ed.) *Habermas and Modernity* 1985, p. 150.

# Chapter 6: Art Tomorrow: An Argument for Realism

1.  For a devastating critique of Althusser's position see E. P. Thompson, *The Poverty of Theory*, in *The Poverty of Theory*, London, 1978, pp. 193-399.

2.  This is the conclusion reached by Perry Anderson, *Modernism and Revolution*, NLR, 1984, p. 113.

3.  See Chapter 2, above, note 36.

4.  The metaphor is W. R. Bion's. See his *Learning from Experience*, London, 1962; and P. Fuller, *Art and Psychoanalysis*, London, 1980, Chapter 3.

5.  See D. E. Gordon, *Ernst Ludwig Kirchner*, Cambridge, Massachusettes, Ch. III.

6.  M. Beckmann, *Das Neue Program*, Kunst und Kunstler, XII, Berlin, 1914, pp. 294 ff; translated in V. Miesel, ed, *Voices of German Expressionism*, New Jersey 1970, p. 107.

7.  M. Beckmann, Letters of October 11th, 1914, May 25th, 1915 and April 12th, 1915; in *Briefe im Kriege*, Berlin, 1920, pp. 18, 63 and 38.

8.  Habermas, op. cit., pp. 9-11.

9.  See Chapter 2, above.

10. See *The Arts and the People: Labour's Policy towards the Arts*, London, 1977.

11. A. Zhdanov, *on Literature*,

12. Gorky, *Pervyi Vsesoiuznyi s"ezd sovietskikh pisatelei* : Stenographich otchet, 1934, p. 17.

13. D. F. Markov and L. I. Timofeev, *Socialist Realism*, Great Soviet Encyclopaedia, N.Y. & London, 1980, Vol. 24, p. 245.

14. A useful recent account is Jamey Gambrell, *Report from Moscow*, Art in America, May 1985, pp. 47-57.

15. See C. Vaughan James, *Soviet Socialist Realism*, London, 1973, Ch. 1.

16. Vera Mukhina, *The Pavilion Figures*, 1938; in *A Sculptors Thoughts*, op. cit., pp. 34-43; quotation pp. 34-42-3.

17. P. Plagens, *Academy of the Bad*, Art in America, November 1981.

18. Rilke, Duener Elegies, 1906; quoted by Segal, op. cit., p. 384.

19. These were *Art in America* December 1982 and January 1983.

20. G. Lukács, *Realism in our time*, 1956; English edition 1981, NY, p. 30.

21. G. Lukács, loc. cit.

22. J. Berger, Catalogue to the *Looking Forward* exhibition, London, 1952.

23. J. Berger, New Statesman, June 6th, 1959.

24. Marx and Engles, *Selected Correspondence*, English translation, Moscow, n.d., pp. 478-9.

25. G. Lukács, *Balzac und der frazösische Realisms*, Berlin, 1952, preface; and *Einführung in die aesthetischen Schriffen von Marx und Engels*, 1945.

26. J. Berger, New Statesman, January 1956.

27. See Komar and Melamid, *In Search of Religion*, Art Forum, May 1980.

28. See Peter Wollen, *Komar and Melamid*, (catalogue essay), Edinburgh, 1985.

29. Gary Indiana *Komar and Melamid Confidential*, Art in America, June 1985.

30. *Gulbenkian report on the economic situation of the visual artist*, 1984, pp. 7, 21.

31. Lukács, Preface to *Balzac und der französische Realismus* 1951.

# INDEX OF NAMES

*Photographic Acknowledgements*

Acknowledgements are recorded for permission to reproduce the following plates:

25, Columbus Museum of Art, Ohio: Gift of Ferdinand Howald; 41, Galerie Tanit, Munich; cover, Anthony D'Offay Gallery, London; 34, Ludwig Collection, Aachen, Courtesy Galerie Michael Werner, Köln-Mary Boone/Michael Werner Gallery, New York; 14, The Sidney & Harriet Janis Collection, Gift to the Museum of Modern Art, New York; 65, Mr Ken Kiff and Nicola Jacobs Gallery; 19, The Blue Four, Galka Scheyer Collection, Norton Simon Museum, Pasadena, California; 30, 52, 53, Novosti Press Agency, London; 11, Eugene M. Schwartz, New York; 1, 36, 38, Galerie Bischofberger, Zurich; 56, Sir John Soane's Museum, London; 24, The National Gallery, London; 42, John Gibson Gallery, New York; 27, Venture Prints (Studios) Limited; 28, 51, Solomon & Whitehead, Lichfield; 60, Adrian Wizniewski/Nigel Greenwood Gallery, London; 40, Gilbert & George, London; 63, Terry Atkinson and the Whitechapel Art Gallery; 57, Henry E. Huntington Library and Art Gallery, San Marino, California; 46, 47, 50, DACS, 1986; 64, D. James Dee, Courtesy Ronald Feldman Fine Arts, New York; 61, Southampton City Art Gallery; 8, Stadtische Galerie im Lenbachhaus, Munich; 66, Matt's Gallery, London; 6, 13, The Hermitage Museum, Leningrad; 62, Gimpel Fils Ltd, London; 59, Edward Totah Gallery, London; 55, Sally Baker and Sue Coe, New York; 54, Arnolfini Gallery, Bristol; 35, 43, Phyllis Kind Gallery, Chicago; 33, Stedelijk Museum, Amsterdam; 12, Metropolitan Museum of Art, Bequest of Gertrude Stein, 1946; 2, Lisson Gallery, London; 48, Tony Shafrati Gallery and Mr and Mrs Ara Arslanian, New York.